THE IMPRESSIONISTS

THE IMPRESSIONISTS

Eileen Romano

PENGUIN
STUDIO

PENGUIN STUDIO
Published by the Penguin Group
Penguin Putnam Inc., 375 Hudson Street,
New York, New York, 10014, U.S.A.

Penguin Books Ltd, 27 Wrights Lane,
London W8 5TZ, England

Penguin Books Australia, Ltd, Ringwood,
Victoria, Australia

Penguin Books Canada Ltd, 2801 John Street,
Markham, Ontario, Canada L3R 1B4

Penguin Books (N.Z.) Ltd, 182-90 Wairau Road,
Auckland 10, New Zealand

Penguin Books Ltd, Registered Offices:
Harmondsworth, Middlesex, England

First published by Penguin Studio, a member of Penguin Putnam Inc.

First printing, February 1997
10 9 8 7 6 5 4 3 2 1

Originally published 1996 by Arnoldo Mondadori Editore, Milan, Italy

English text by Peter Eustace CSA snc, Verona, Italy

Copyright © Leonardo S.r.l., Milan 1996
All rights reserved.

Library of Congress Catalog Card Number: 97-68577

Graphics design by Renato Curti and Filippo Spanò
Printed and bound in Spain by Artes Graficas Toledo
D.L.TO:1473-1997

ISBN: 0-670-87529-5

Contents

Note

Color plates of twenty-four paintings by Degas, Renoir, Cézanne, and Monet follow page 80.

INTRODUCTION

This book by no means attempts to investigate the history of art; on the contrary, it starts from the assumption that the paintings of the Impressionists are already well-known to the public at large. Instead, the intention is that of slipping behind the scenes to illustrate the society in which these artists lived—the schools and the ateliers they frequented, and the masters who preceded them (including the photographers who were an unending source of inspiration for topics and techniques; it is no coincidence that the word Impressionism was taken from the title of a painting by Monet, *Impression: Soleil Levant (Sunrise),* and seems to be an allusion to photographic processes), the galleries where they were able to display their works, the support they received, and their detractors (the official artists of the Second Empire, critics, and visitors to the first exhibitions).

The book examines the period between 1874 (when the first exhibition of the Impressionists was held at the studio of the photographer Nadar) and 1887 (the eighth and final show), after which the group split up, each member then following his own way forward. This is the reason why figures such as Vincent Van Gogh and Paul Gauguin do not appear, except indirectly; they did not belong to the group in its early years and were only considered "Impressionists" in the broadest sense of the term. By illustrating the protagonists in overall terms, this book aims to complement the many art books already dealing with this well-known and much-quoted movement.

THE IMPRESSIONISTS

ART AND ART PATRONS IN THE SECOND EMPIRE

Art during the Second Empire was an official, protected, organized, and hierarchical institution. Careers were made in much the same way as in the army or the civil service. There were ranks, promotions, and recompenses. The career of budding artists involved training at the Ecole des Beaux-Arts, the Prix de Rome, study at the Villa Medici, admission to the Salon and the award of medals, a professorship at the Ecole and, lastly, election as a member of the Académie des Beaux-Arts, or even the Académie Française. In return, prize-winning artists received commissions from the State—decorations of monuments, theatres, universities, courthouses, and even churches by way of compensation for the paintings taken away during the Revolution and by then exhibited in the Louvre.

Following the dictates David outlined at the end of the 1700s, Classicism was dominant and the most popular genres were historical scenes, biblical or mythological compositions, portraits and nudes and, lastly, landscapes—which were less well suited to large-scale public frescoes and only became important after 1861, when Napoleon III purchased a painting by Corot. The number of commissions, already high during the Second Empire, became astonishing during the Third Republic, when work began to rebuild and restore the numerous monuments destroyed or damaged during the Paris Commune in 1871; so much so, that in its determination to establish itself, the Republic even took the stance of patron of the arts in the same manner as Francis I or Louis XIV. The Palais Garnier—home to the Opéra Parisienne—which was still unfinished in 1870, the Town Hall, the Sorbonne, the courthouses, the Théâtre-Française, and the Treasury were to provide work for thirty years to hundreds of artists, painters, and sculptors.

The ceremony during which medals were awarded to the artists taking part in the 1861 Salon. The engraving was taken from a photograph by Richebourg. The Salon was set up in 1667 by Colbert and took its name from the Salon Carré, in the Louvre, where the exhibitions were initially held. It played a fundamental role in artistic life in the nineteenth century because it was one of the few places where artists could display their works. Moreover, it was here that the Ministry of Fine Arts purchased paintings to be hung in public buildings or even in the Musée du Luxembourg, the antechamber of the Louvre (the government only began making acquisitions from private galleries after 1890). The Salon became an annual event under Louis Philippe; by the time of Napoleon III, it was held in the Palais de l'Industrie, which was built in 1853 to house the Universal Expositions and later demolished to permit the building of Avenue Alexandre III. Three quarters of the jury was made up of artists who had won medals in the past and one-quarter of persons appointed by the administrators. The Salon was held from the 15th of April to the 1st of May (although the dates were sometimes changed). The number of paintings,

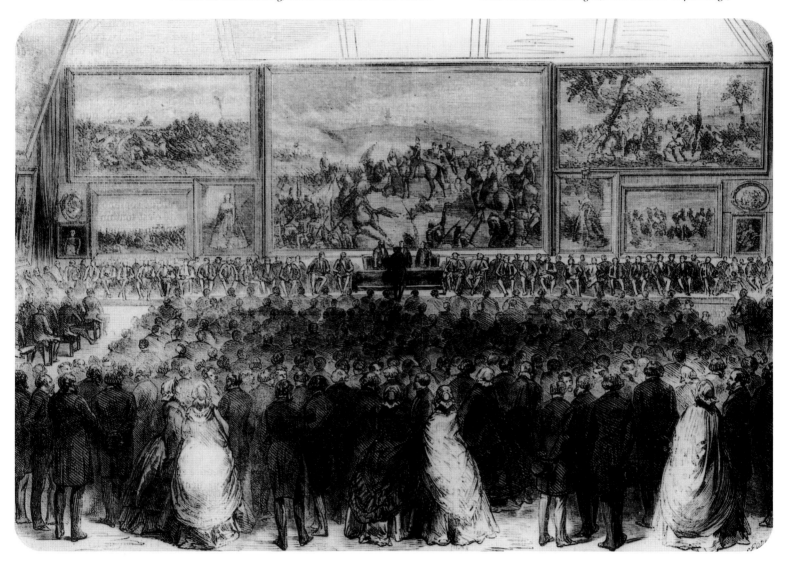

arranged in alphabetical order by artist, varied from year to year but usually involved 3,000–4,000 works. The press gave the Salon major coverage and published many caricatures by the best artists (Nadar, Cham, Daumier). Aspiring writers honed their skills in reviewing the Salon (mention need only be made of Musset, Dumas, Gautier, Zola, the Goncourt brothers, as well as Baudelaire); this was a tradition which went back to Diderot.

The Salon was extremely well attended by the public at large (up to 4,000 visitors a day).

The admission fee was one franc and, as well as the catalogue, reproductions of the paintings (usually engravings) were also on sale.

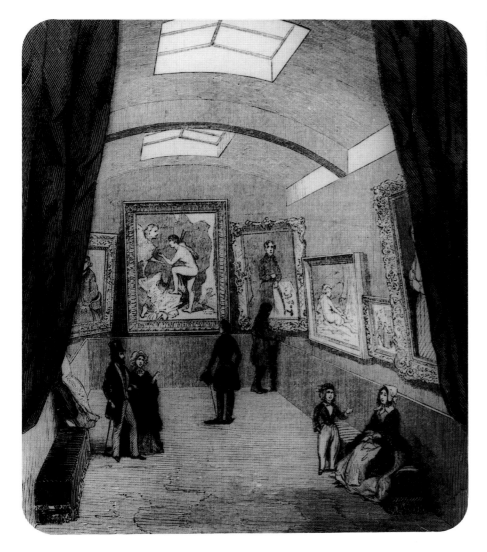

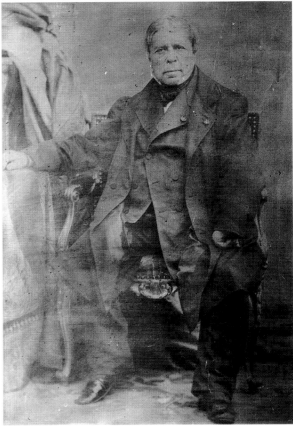

Jean-Dominique Ingres (1780–1867). (*Left*) An engraving depicting the hall dedicated to Ingres in the exhibition set up in the gallery of a bookseller near the Bazar de la Bonne Nouvelle in 1846. The exhibition, organized by Baron Taylor to raise funds for the Society of Artists Mutual Fund, was a retrospective show of Classicism from the beginning of the century.

This was probably one of the first true thematic exhibitions of the period. Canvases by David, Girodet, Gérard, Gros, Prud'hon, and Géricault were displayed alongside eleven paintings by Ingres. On the death of Ingres—the champion of Classicism in the second half of the 1800s—the modern movement, until then kept on the sidelines, finally began to establish itself.

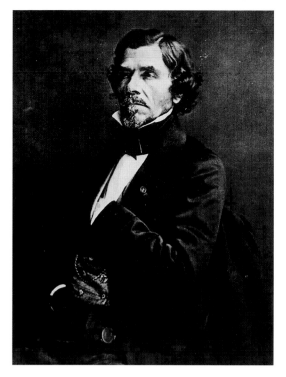

Eugène Delacroix (1798–1863) in a photograph by Nadar. (*Below*) The atelier of Delacroix at 58 Rue de Notre Dame de Lorette in an engraving from *Illustration*. In 1873, Armand Silvestre—highlighting the modernism of Monet, Pissarro, and Sisley—remarked that Delacroix "stands at the origins of this new school" (which, obviously, was not then called "Impressionism"). The leading Romantic figure and bitter enemy of Ingres, the painter who liberated form and colour from a kind of Classicism that had often become too stiff, Delacroix was an instigator of the revolution initiated by Monet and soon to be supported by the Impressionists. The admiration of Delacroix by all the Impressionists, without exception, was one of the most stable and lasting ties of the entire group.

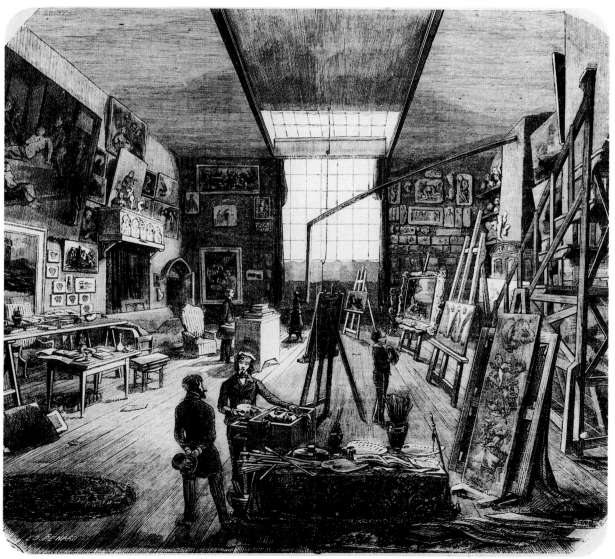

(*Below, left*) Camille Jean-Baptiste Corot (1796–1875), photographed by Charles Désavary at Saint-Nicolas-les-Arras in June 1873.

(*Below, right*) A caricature of the 1865 Salon by Daumier: "Just look how corrupt society is! Everyone merely gazes at more or less monstrous scenes yet no one ever stops in front of a painting which is the very essence of beauty and purity in nature!"

Corot was one of the leading landscape painters in France in the 1800s; his innovation, shared with the Barbizon School, was painting from life, en plein air, in

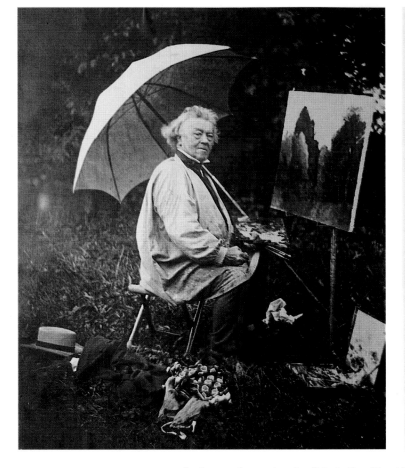

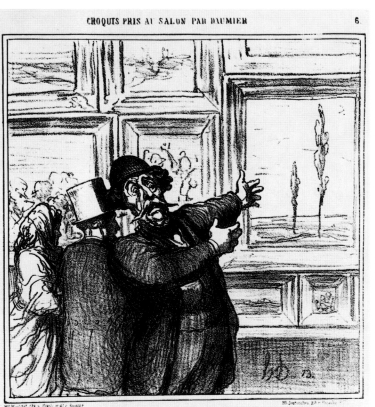

order to reproduce nature in all its truth without losing "the first impression that moved us."

He was long considered by critics in the early 1900s to be the founding father of Impressionism. Although the Impressionists never denied their admiration of his art, so much so that in 1867 Bazille even wanted to invite him to take part in a group show he was planning, Corot never returned their favours: by nature shy and independent, he never supported Manet at the Salon and argued with Pissarro, who had been his pupil for a while.

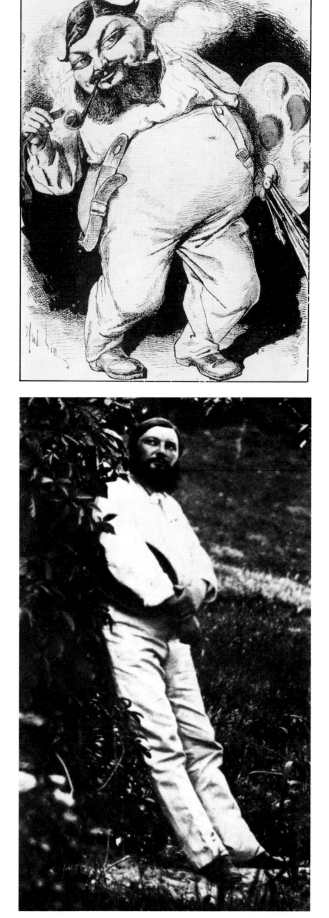

(*Left*) Gustave Courbet (1819–1877) in a caricature by André Gill, and in a photograph as a young man. In the caricature the artist, who was well-known for his revolutionary thinking, is depicted lighting his pipe with the ribbon of the Legion d'Honneur that he had just refused to accept.

A caricature by Daumier of the 1865 Salon: "Venus again this year ... Venus and only Venus! As if all women were like that!" The founder of realism in painting played a fundamental role in the development of the Impressionists.

They discerned in Courbet a new theme, which broke completely with the traditions of the Salon. Courbet marked the definitive and spectacular schism between official art and pure and free art. His motto, "Paint what you see, what you feel, and what you want," was immediately taken up by the Impressionists. Over and above a palette of lighter colours, he also taught them modern and more realistic themes.

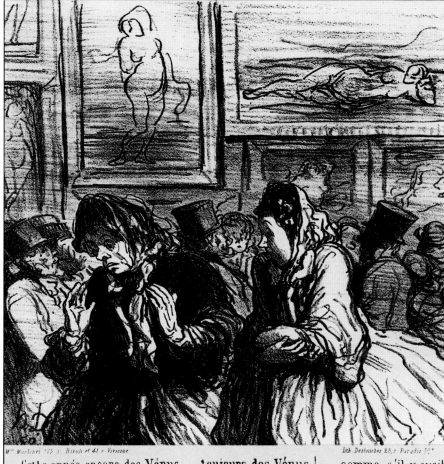

_ Cette année encore des Vénus ... toujours des Vénus !... comme s'il y avait des femmes faites comme ça !...

The Italian section at the Universal Exposition in 1867. The first Universal Exposition was held in London in 1851 at the famed Crystal Palace, the second in New York in 1853, and the third in Paris in 1855, an experience repeated in 1867. Unlike the Salon where artists were not allowed to exhibit more than two paintings at a time (in the period in question), the Universal Expositions organized full-scale exhibitions that enabled the public to see paintings never exhibited before, since they had been commissioned by private collectors. In 1855, Ingres displayed forty paintings and Delacroix thirty-five.

Only the retrospective, posthumous exhibitions organized in exceptional circumstances by the Ecole des Beaux-Arts (Ingres in 1867, Corot in 1875, Manet in 1884), brought together paintings in such numbers. The Universal Expositions were also the place where the public and artists could see foreign works; mention need only be made of the Far East section in London in 1862 and its impact on the evolution of art and the birth of Impressionism, or British and American landscape paintings on show respectively in 1855 and 1867.

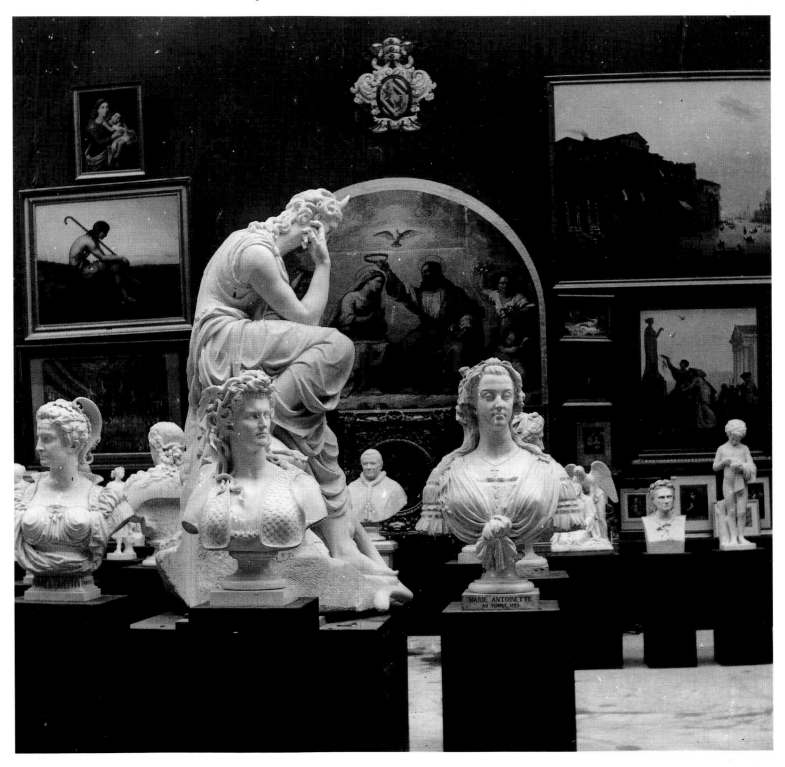

Three engravings of the exhibition of the Campana Collection at the Palais de l'Industrie, which was purchased by the State in 1861. (*Above*) *View of an Etruscan Burial Chamber*; (*Below*) *An Etruscan Tomb Known as the Tomb of Lydia* (with statues of Claudius and Caesar and a low relief depicting Mars and Apollo).

With the Second Empire, the State once again became interested in ancient art; the Campana Collection caused a great commotion. Giovanni Pietro Campana was Director of the Monte di Pietà in Rome and had put together an imposing collection of Italian "primitives," majolica of the 1400–1500s, Renaissance and Baroque paintings, as well as a huge collection of archaeological finds. In the wake of financial problems, he was obliged to sell the collection. Ingres, having recently entered the Senate, violently opposed the further breaking up of the collection, which the State had purchased in 1861, when it had already been somewhat dismantled. Napoleon III managed to acquire 343 paintings (the initial core collection comprised 646) and a series of Greek and Etruscan objects; following the heartfelt advice of Ingres, he displayed the collection intact in the Musée Napoléon III. The collection is currently housed in Avignon.

Exhibition of the works loaned by the Villa Medici to the Ecole des Beaux-Arts in 1873. The artists who won the Prix de Rome spent five years at the Villa Medici. They were required to send paintings to the Ecole so that the benefits gained during their period of study could be assessed. These pieces comprised studies, heroic nudes, and a large final painting. They also had to send a number of models of antique statues and copies of frescoes. Ingres, who was one of the most famous directors of the Villa Medici (1835–1841), produced a copy of the *Last Judgment* in the Sistine Chapel that was only slightly smaller than the original, together with copies of the frescoes in the Logge of Raphael.

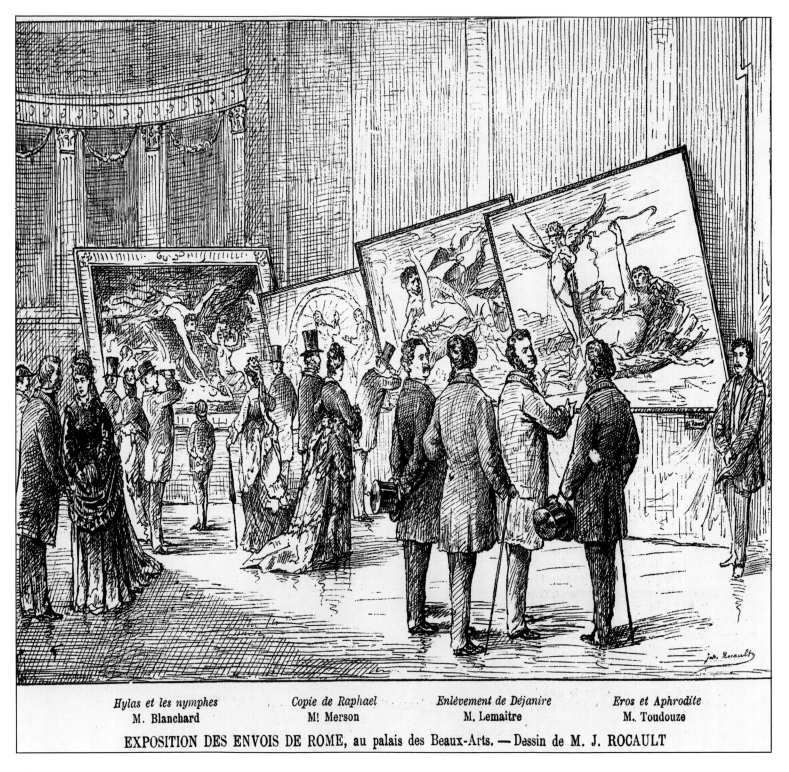

| *Hylas et les nymphes* | *Copie de Raphael* | *Enlèvement de Déjanire* | *Eros et Aphrodite* |
| M. Blanchard | M! Merson | M. Lemaître | M. Toudouze |

EXPOSITION DES ENVOIS DE ROME, au palais des Beaux-Arts. — Dessin de M. J. ROCAULT

(*Above*) Opening of the exhibition of paintings for the new Opéra. Hall of the Beaux-Arts, 1874. (*Below*) The inauguration of the exhibition at the Beaux-Arts. Artists were allowed to varnish or lacquer their paintings on April 28, 1866. This process (hence the term "vernissage") enhanced the brightness of the shades. The life-style of artists depended on the commissions provided by the State which, as already mentioned, were enormous between the end of the Second Empire and the beginning of the Republic. Amaury Duval compared the situation of artists between 1825 and 1878: "Then, painters were held in much the same consideration as church mice. People still laughed in theatres when a father asked his daughter's loved one 'And what is your trade?' 'I'm a painter.' Since then, everything has changed and painters can ask for the hand of the most sought-after heiress and rank alongside the richest and happiest businessmen."

(*Above*) A photograph of the 1861 Salon by Richebourg. Once the paintings were consigned, intense behind-the-scenes maneuvering began immediately. Artists had to win an award if they were to be admitted to the privileged circles of those who would benefit from the most important official commissions. "The meetings of the jury regarding these 'awards' dragged on for weeks," wrote Jacques-Emile Blanche. "These gentlemen, under close escort, could be seen passing from one gallery to another. The curtains were drawn across the hall and the chairman rang a bell. These were solemn formalities and hundreds of artists tried to find out their destiny through the clerks of the Ministry of Fine Arts and wandered around the Palais de l'Industrie hoping to receive the medal or honourable mention that would ensure them a year of prosperity."

(*Right*) A caricature published in *Charivari* in 1889. "Seeing the way everything has been hung this year, why not hire a pair of stilts on the way in? One could at least see everything from every point of view."

Pourquoi, avec la façon dont certains tableaux sont placés cette année, ne pas installer un bureau d'échasses? Ça varierait les points de vue de toutes les manières.

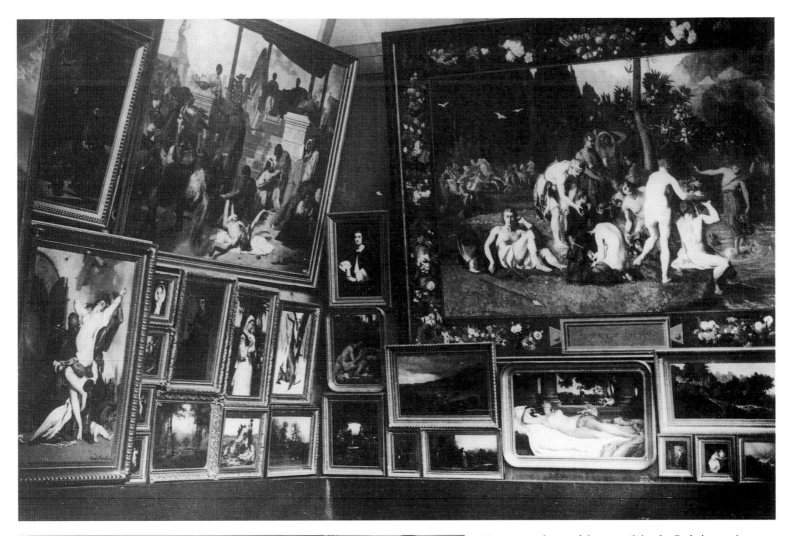

Two more photos of the 1861 Salon by Richebourg. Jean Moréas drew up a very amusing list of the kinds of paintings on show in the Salon. "Biblical beggars with blackened complexions, raging Abrahams, Christs as grim-faced as shopkeepers, corpulent Cardinals, long-suffering, wilting martyrs, scandalously mammalian and gloomy mercenaries, weeping Venuses, languid nymphs, suburban Napoleons, and an entire carnival-like repertory of the Malaquais quayside all painted in crusted Prussian blue, bitumen, and sienna earth ..."

Manet: The Refusé

Manet was born in Paris in 1832 into a very well-to-do family. He began studying with the classic-influenced painter Thomas Couture, whose composition depicting the decadence of the Romans swept all before it during the 1847 Salon. He attended lessons between 1850 and 1856, at the same time as he was frequenting the Académie Suisse and copying the masterpieces in the Louvre (including, until 1848, the paintings of Goya, El Greco and Velàzquez in Louis Philippe's Spanish collection). But "such eternally Greek legs left him cold," as critic Champsaur wrote. "One day, as he was arguing with himself over his inability to come up with something new or different, he encountered an old beggar in the street and was immediately fascinated. It was a revelation. Manet said: 'For goodness sake, why don't I paint things as I see them, dirty, downtrodden, wrinkled, with the light embracing their rags?' He invited the beggar up to his studio and painted his first picture. Well, ladies and gentlemen, this is Impressionism. Instead of taking inspiration from Praxiteles or Raphael, the new painters are inspired by nature."

The anecdote, whatever its authenticity, is interesting but not entirely true: it is true that Manet supported a realistic vision of painting that came to him from Spanish art—reviewed and adapted through the influence of Courbet—and it is also true that the paintings of the Impressionists were based on the representation of nature as found, without idealizing it. But it cannot be said that Manet was entirely an Impressionist, even though his contemporaries often looked up to him as the originator of the movement.

Following his success at the Salon des Refusés in 1863 (where he exhibited his famous *Déjeuner sur l'herbe*), he gathered around himself at the Guerbois or La Nouvelle Athènes cafes a rather disparate group of young artists "united in the common dislike of official art and the desire to search for truth beyond the canons of officialdom," as the leading historian of Impressionism, John Rewald, wrote. "But since all or almost all of them were seeking truth in different directions, it was logical that they were not considered as a 'school.'" In any case, Manet did not take part in any of their eight exhibitions between 1874 and 1886. There were many reasons for this: his financial status was such that he never had to worry about finding other sources of income (the first exhibition of the Impressionists was dictated by the need to find new patrons); he really hoped to be recognized by and admitted into the circles of official art; and, lastly, he did not entirely agree with the opinions of the group—he never eliminated black from his palette, another influence of Spanish art; he considered landscapes to be a minor genre since his tastes were too exclusively focused on the modernity deriving from the predominant influence of Charles Baudelaire (in 1879, he suggested painting frescoes in the Council Hall of the new Hôtel de Ville [Town Hall] based on the theme of Le Spleen de Paris: the halls, the stations, the port, the underground world, the races, and the gardens). He felt more at home with poets and writers, especially Baudelaire, who defended him from the outset, Emile Zola, and Stéphane Mallarmé. However, he remained in contact to the very end with most of the exponents of Impressionism. He died in 1883 of gangrene of the foot. The Ecole des Beaux-Arts finally paid tribute to him by organizing a posthumous retrospective exhibition on January 5, 1884 with 116 paintings, 31 pastels, 20 watercolours, 12 etchings and prints.

A photograph of Manet when a young man.
George Moore, an English writer who lived for some time
in Paris and was friendly with Manet, described him in
Reminiscences of the Impressionist Painters. Moore
remarked on Manet's square shoulders, which he was wont
to show off when he walked across the Nouvelle Athènes
coffee-house, admired his finely cut facial features and his
strong chin, with its prominent beard, his aquiline nose and
bright eyes, his imperious voice, the elegance of
his compact figure, and his careful but simple
dress. Moore was struck by the frank passion
of his ideas, his simple and open words, as
clear as water, at times a little harsh, at
times even bitter. Manet was not only
the intellectual leader of the group
but also, after Pissarro, the oldest: in
1869 he was thirty-seven, Degas
was thirty-five, Fantin-Latour
thirty-three, Cézanne and Sisley
thirty, Monet and Renoir twenty-
nine, Bazille not quite twenty-
eight. He was on very good
terms with Berthe Morisot
(who was to become his
sister-in-law), was great
friends with Degas
(although they argued
at times), and was well-
disposed toward Renoir.
He was usually generous
in providing financial
help to those in need.

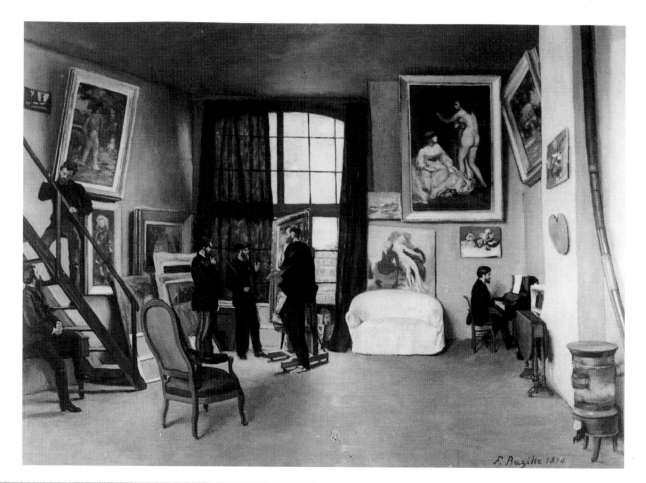

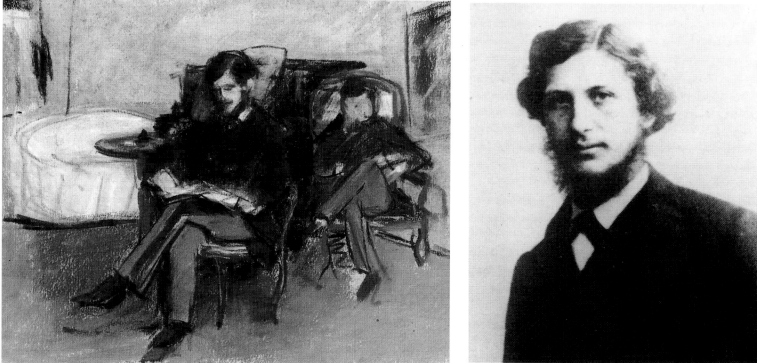

TWO MEETINGS IN THE ATELIER OF 1870. (*Opposite, top*) Frédéric Bazille, *The Artist's Studio in Rue de La Condamine*, 1870. The tall figure in the middle is Bazille (1841–1870), facing Manet in the bowler hat, while critic Edmond Maître is playing the piano. The three figures on the left are variously identified as Renoir, Sisley, Monet, or Zola. The walls are hung with a still life by Monet and two female figures by Renoir.

(*Below*) Fantin-Latour, *Studio in the Batignolles Quarter*, 1870. Manet is sitting at the easel. From left to right: Scholderer, Manet, Renoir, Astruc (seated), Zola, Maître, Bazille, and Monet. Bazille was a fundamental figure in Impressionism. He was the first to support the idea of a movement and annual group shows. He could have become what Manet never was, but his role as leader was short-lived, for he died in the Franco-Prussian war of 1870. Monet, in organizing the first Impressionists exhibition in 1874, did not enact his idea.

(*Opposite, bottom*) Bazille (photograph at right) and one of his sketches depicting Arthur Rimbaud and, in the foreground, Maître—curious testimony to Rimbaud's involvement in the world of art in Paris in 1870.

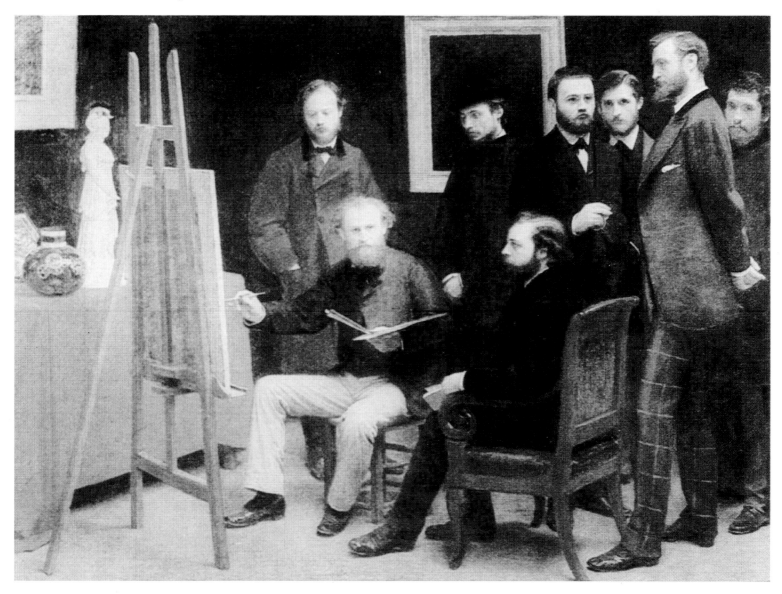

L'EXPOSITION D'ÉDOUARD MANET, — par G. RANDON.

LE TEMPLE DU GOUT.

Fatigué de voir, par une opposition systématique, ses œuvres repoussées des exhibitions officielles, M. Manet a pris le parti d'en appeler au public des décisions du jury; quels qu'ils soient, il veut des juges, il en trouvera.— Prix d'entrée : 1 franc par personne.

PHILOSOPHE.

Malédiction ! tête et sang !! on se permet de manger des huitres sans m'inviter !!!

LOLA DE VALENCE,
ou l'Auvergnate espagnole.

Ni homme, ni femme; mais qu'est-ce que ce peut être?... je me le demande.

BATEAU DE PÊCHE ARRIVANT VENT ARRIERE.

Quel diable peut donc pousser l'artiste à faire et surtout à nous montrer des machines comme ça, quand rien ne l'y oblige?

LE FUMEUR.

Il y a des gens qui préfèrent ceux de Téniers ou même de Van Ostade : c'est affaire de goût; quant à moi, j'aime infiniment mieux celui-ci... pour le Journal amusant.

LE STEAM-BOAT (MARINE),
ou la vapeur appliquée à la navigation dans un plat d'oseille.

Two panels of caricatures by Georges Randon of the exhibition of Manet's work at the Salon des Refusés in 1863. The jury of the 1863 Salon was more severe than in previous years and the number of refusals was very high: it rejected three-fifths of the 5,000 paintings presented by 3,000 artists. Never in living memory had there been such a proportion of rejections. The anger in art circles grew to the point of even reaching the Emperor's ears, who "with the intention of allowing the public to judge the legitimacy of such complaints, decreed that rejected works should be displayed in another part of the Palais de l'Industrie." So was born the Salon des Refusés. (Bottom, right) a photograph of Charles Baudelaire, who defended Manet and inspired him with his *Les Fleurs du Mal* and *Prose Poems*.

PORTRAIT DE MADAME B...

Je ne dis pas que ce ne soit pas ressemblant, mais cette pauvre dame, comme son amour-propre doit souffrir de se voir afficher ainsi!

OLYMPIA.

— Madame...
— Qu'y a-t-il?
— Un messié qui li vouloi pali madame... pou zaffaire.
— Fais entrer.
(Il paraît que chez certaines *dames* c'est comme ça que ça se joue.)

PORTRAIT DU TINTORET.

J'autorise M. Manet à reproduire ma binette, à condition qu'il ne la montrera à personne.

TINTORET.

LE DÉJEUNER SUR L'HERBE,
ou *le Triomphe de la vertu.*

La vertu de ces messieurs, disons-le entre nous, ne doit pas leur coûter beaucoup; ils ont même l'air de dire comme l'Auvergnat : Nous chommes bien tranquilles là dedans.

(*Above*) Photograph of the Salon d'Automne in 1903: the paintings selected by the jury. (*Below*) the cemetery of the paintings rejected by the Salon in the 1870s. Manet was the undisputed protagonist of the Salon des Refusés in 1863. His *Déjeuner sur l'herbe* (opposite, bottom left) was admired by few and the source of great hilarity for many. The painting of a nude woman sitting in a glade with two men fully dressed in modern clothes was inspired by Classicism (it was clearly a reference to an engraving of Raphael). But the inclusion of the nude figure, then considered to be a quite separate genre, in a modern setting shocked contemporaries.

(*Below*) Berthe Morisot (1841–1895) in her studio. Manet's sister-in-law and model, she was the only woman in the group of Impressionists. Berthe and her sister, Edma, began painting in 1857. When they decided to tackle landscapes, they went to Corot, whose teaching was fundamental. Berthe Morisot met Manet and was his model for some time. After a short period during which her paintings were clearly influenced by Manet, in 1874 she took part in the first exhibition of the Impressionists, turning her back on the Salon—where she was nevertheless still well-accepted—and also taking a separate stance from Manet, who had asked her not to be involved. On the death of Edouard Manet, Berthe and her husband Eugène Manet promoted the last exhibition of the Impressionists. Berthe Morisot died in 1895. Her daughter Julie Manet, collector Rouart (whose son married Julie), and Degas organized a retrospective show of 300 of her paintings at the Durand-Ruel Gallery.

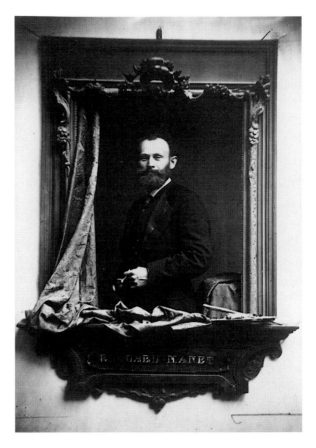

(*Left*) A curious portrait of Manet. The photograph is framed by real curtains and a shelf with the tools of the artist's craft. The same picture appears again at the extreme left of the bottom row on the opposite page. This is a collage of portraits of various artists who were well-known in the 1870s. Such "mosaic portraits" were a form of advertising that became popular in 1854 when Disdéri patented visiting cards. Manet yearned for official recognition and his "bourgeois desire," as the aristocratic Degas called it, was heavily criticized by the Impressionists. "My dear," Manet said to Degas one day in his own defense, "if honours had not been invented, then I wouldn't invent them; but they exist. And we should take everything that may come out of the mass ... if and when we can. It's a landmark ... It's another arrow in our quiver. In this dog's life of ours, where everything is a struggle, we need all the weapons we can get. I've never received decorations. But it's not my fault and I can assure you that if I could I would have them and that to have them I will do everything possible!" (Quoted by De Nittis in *Notes et Souvenirs*.)

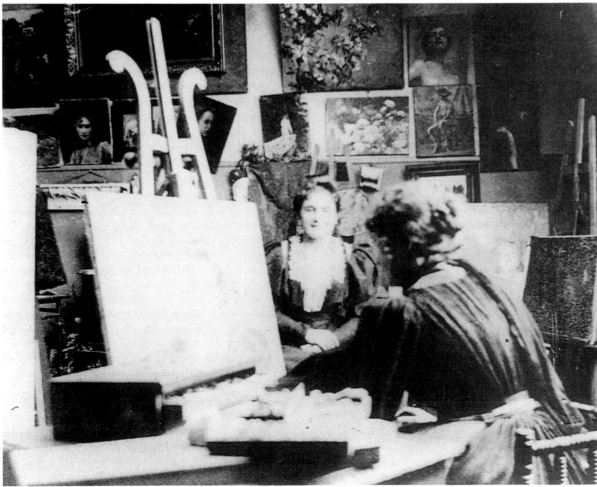

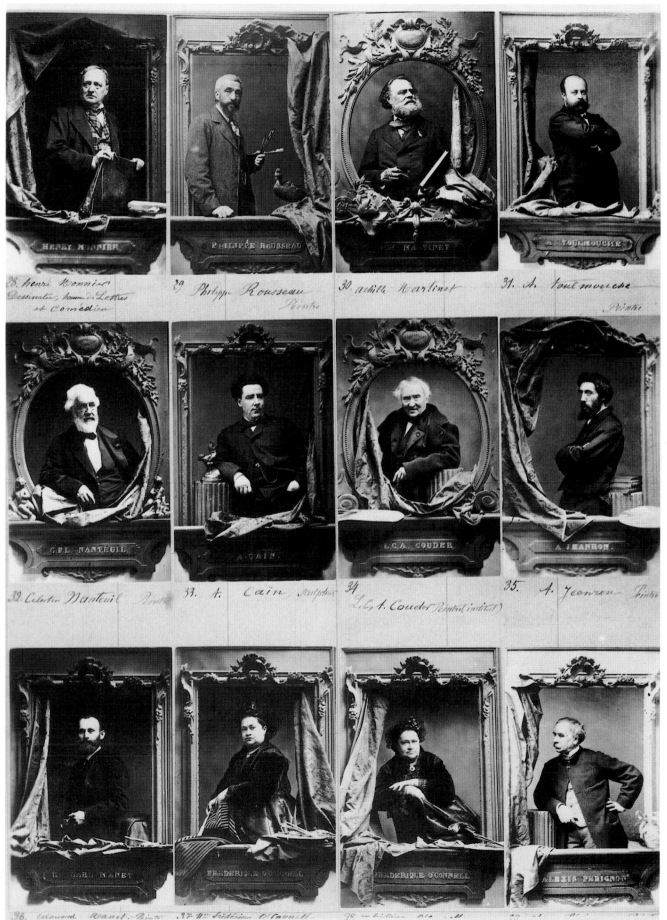

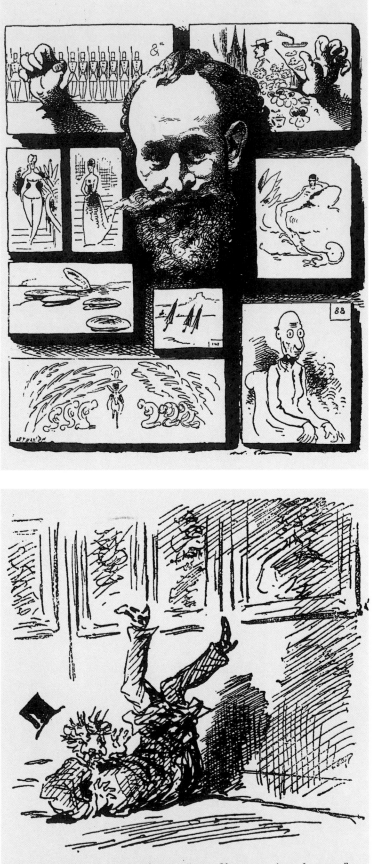

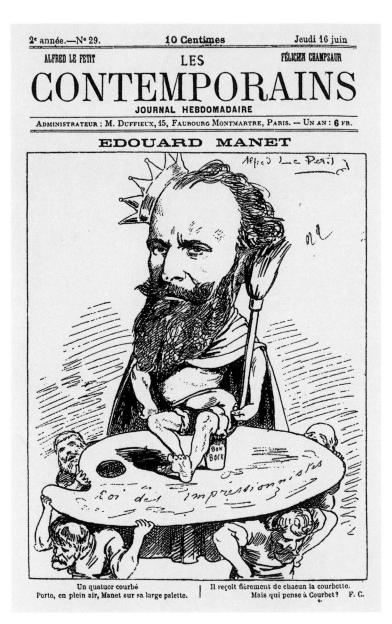

M. Manet lui-même, pris d'une crise de nerfs à la vue de la peinture indépendante.

(*Opposite, left*) The cover of the magazine *Les Contemporains* depicting Manet as the "King of the Impressionists" and the victor of the 1876 Salon. (*Opposite, bottom right*) A caricature published in the magazine *Eclipse* in 1879 in which Manet is shown throwing a fit in front of the work of the independent artists (i.e., the Impressionists).

(*Below*) A photo of (left to right) Méry Laurent, Manet, and Mallarmé in 1872. Manet's *Execution of Maximillian* is visible hanging above the piano. When Manet died in 1884, Théodore Duret, an art critic and Manet's friend, wrote: "For years, everything that an artist could expect to experience in terms of vituperation at the Salon was Manet's fate among critics and the public at large, but at every Salon he continued to establish his personal style ... This much-derided artist found supporters, fascinated young artists, trained disciples, and influenced the school of his times. It was Manet who did away with opaque shadows in contemporary painting, and it is thanks to him that artists have learned how to use light and sharp shades to paint sunlight. Manet was set to become the undisputed master of the modern school when he died so prematurely...."

THE PROTAGONISTS

Who were these young artists "united in the common dislike of official art and the desire to search for truth beyond the canons of officialdom" and what did they have in common?

At the end of the 1860s, the members of the group were relatively young unknowns (the oldest, Pissarro, was born in 1830; the youngest, Renoir, in 1841). They came from the most diverse social backgrounds (Degas was an aristocrat, Renoir the son of a tailor) and the most far-flung places (Normandy, the south of France, London, even the Antilles).

What brought them together was a reaction against the academic art of the Second Empire. They did not recognize themselves in the dominant classicism of the times and were equally never well received by the juries of the Salon. All of them experienced the shame of rejection at least once. They all shared unconditional admiration for Delacroix, who opened the way toward a new interpretation of the use of colour and form.

Their works share a deep appreciation of nature, light and its infinite variations (hence the use of a lighter and more luminous palette and the elimination of bitumen so much in vogue in classical painting; the use of coloured shadows, blurred outlines, and faster brush-strokes that were deliberately less precise and more allusive). Lastly, all these painters were fascinated by modernity and sought a new approach more pertinent to their own times (trains, stations, trips to the country, bars, the circus, etc.).

These, in outline, were the common elements, since—in reality—each artist had his own view of art, to the extent that they never really formed a school as such.

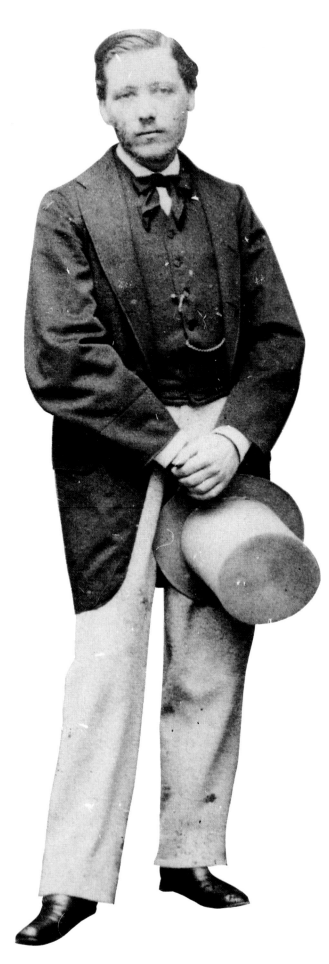

(*Left*) Edgar Degas (1834–1917). Aristocratic, irascible, independent, Degas was the least "Impressionist" of the group. He enrolled at the Ecole des Beaux-Arts on the suggestion of Ingres, whom he admired, and was perfectly willing to accept the idea of painting historical scenes (a heresy for the modern school). He dropped out of the Ecole and left for Italy in the same way as painters of the previous century and copied works in the museums or the frescoes of the Quattrocento. He didn't work en plein air ("You know what I think of painters who work in the streets; if I were in Government, I would organize a brigade of gendarmes to keep an eye on those who paint from real life ..." he once said). He promoted the idea of an open group show that was not too revolutionary in its approach.

(*Above*) Claude Monet (1840–1926), the true founding father of the movement. A pupil of Boudin, he soon devoted his attention to landscapes and already enjoyed some degree of notoriety before the group was formed, so much so that he was able to sell his paintings for 12,000 francs.

(*Below*) Pierre-Auguste Renoir (1841–1919). Unanimously considered as one of the leading exponents of the group, Renoir invented his colourful and luminous style before 1869. He began his career as an apprentice in a ceramics-decoration studio. As well as painting cups, plates, and lampshades, he also made fans, copying scenes from Watteau, and decorated twenty or so coffee-houses. He enrolled at the Ecole des Beaux-Arts in 1862 and took part in the 1864 Salon with a painting he later destroyed.

(*Right*) Berthe Morisot. She joined the group late, and did not take part in the meetings at the Café Guerbois or the Nouvelle Athènes (her presence would have proved awkward). She supported the movement wholeheartedly until the end of her life, and her own style moved closer to that of Renoir.

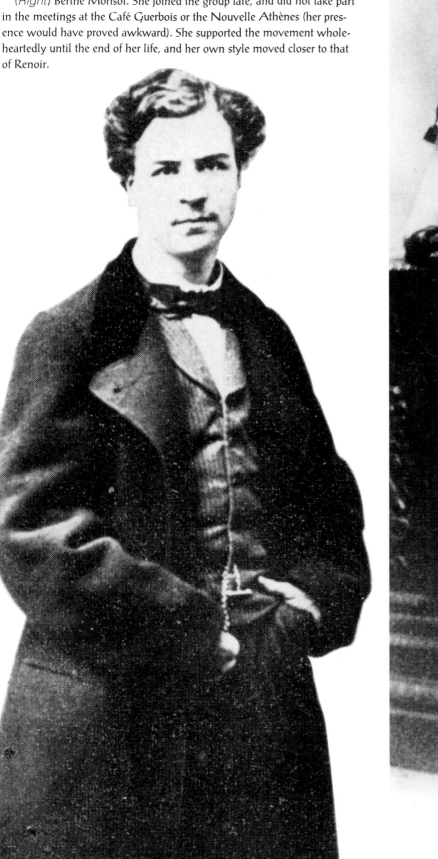

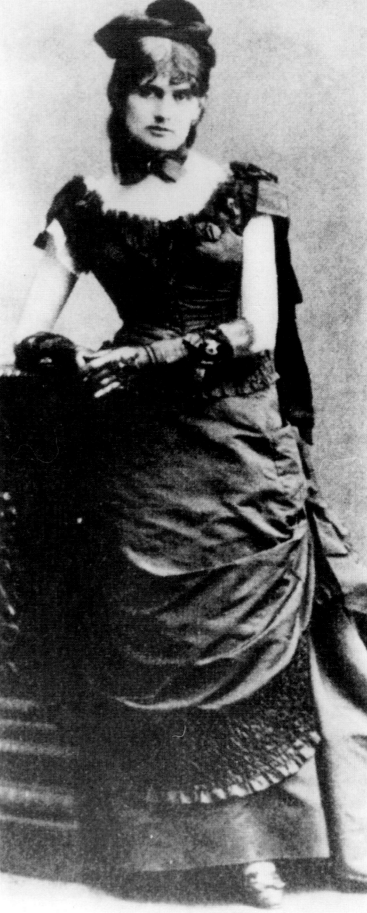

Camille Pissarro
(1830–1903) in a photo-
graph taken in the 1890s.
He was born into a family
of modest means in the
Antilles. The senior mem-
ber of the group, Pissarro
rarely went to the
Guerbois café (he lived
outside Paris), but when
he did make an appear-
ance he was always a
welcome and esteemed
guest. Socialist, anarchist,
and atheist, he was more
aware than the others of
the social problems of the
times. Together with
Sisley, he was the artist
who devoted himself most
to representing nature and
was especially fond of
country landscapes.

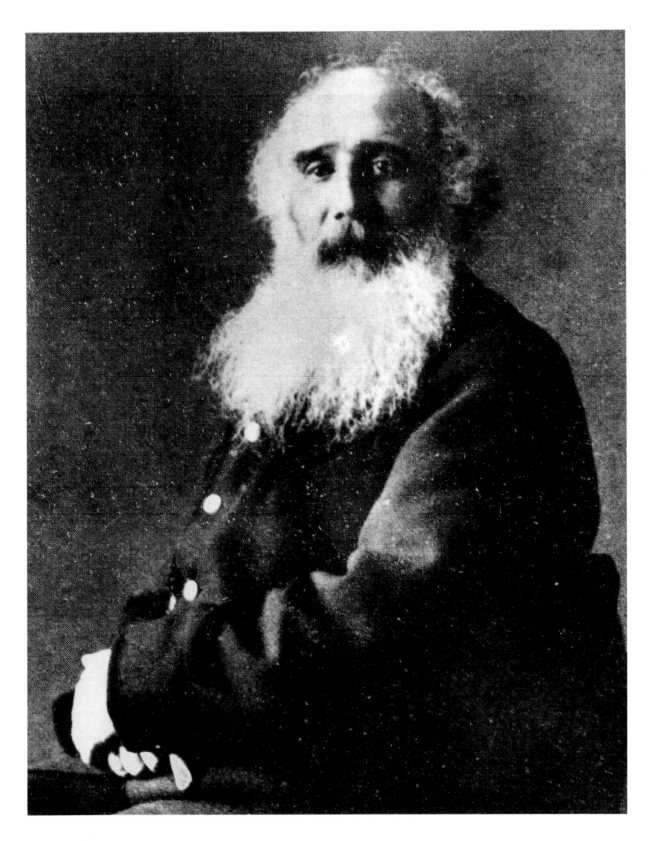

Alfred Sisley (1839–1899) photographed in 1875. Although born to an English family, he spent most of his life in France. He joined the Gleyre atelier where he met Bazille, Renoir, and Monet. Unlike the other members of the group, he painted little prior to 1870. He took part in the 1866 Salon but was rejected at the 1867 Salon. At the auctions held at the Hôtel Drouot, his paintings never sold for more than 30 francs. After the death of his father, Sisley lived in poverty. He died of cancer of the throat. A year later, one of his paintings was sold at the Hôtel Drouot for 43,000 francs.

Paul Cézanne (1839–1906) around 1860. Cézanne was undoubtedly the most important Impressionist painter, for his art gave rise to the most significant artistic developments. He met Pissarro and Monet at the Académie Suisse. Hated by Degas (who nevertheless bought his paintings), rejected by the Salon, despised by his father, Cézanne was immediately admired by his colleagues. Monet considered him to be the greatest artist of the age and Pissarro was always proud to have been the first to have met him.

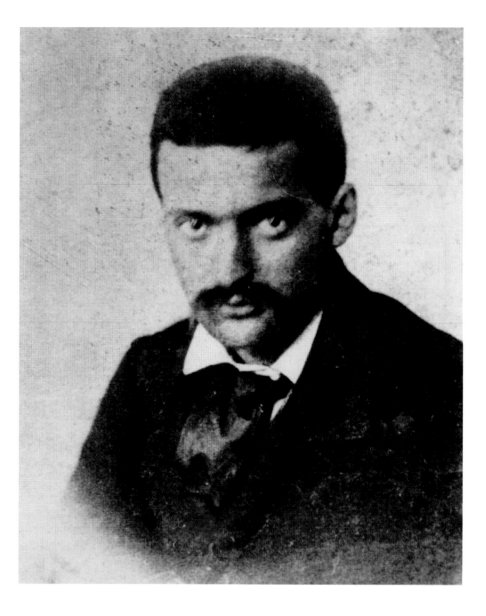

FROM THE ATELIER TO THE CAFÉ

The only way to become an artist at the end of the Second Empire was to attend lessons at the Ecole des Beaux-Arts. The Ecole offered free lessons for students who passed the exams, but suffered the serious drawback of entrusting the courses in rotation to all teachers, thereby compromising the coherence of its method. The teachers thus organized private courses where students could study under their personal guidance. Students of the Ecole also took part in compulsory courses and had to sit periodical exams (as in the case of Renoir and Degas). What exactly was taught at the Ecole des Beaux-Arts? The artistic criteria were those introduced half a century previously through the teachings of David and developed but not liberalized by Ingres. "The Ecole restricts itself to having students copy the so-called academics, i.e. a nude male figure, always illuminated by the same light, always in the same setting and always in the same pose that could be defined as torture paid by the hour," wrote Viollet Le Duc in 1864. A great deal of time passed before students were allowed to take brushes in hand, and at this point they were asked to paint historical scenes. Teaching at the ateliers was paid for and varied in accordance with the preferences and character of the professor. Students could decide whether to study in the atelier of a professor employed at the Ecole des Beaux-Arts or in an independent studio. However, there were also private studios, such as the Académie Julian, where professors of the Ecole des Beaux-Arts went once a week to correct students' work.

Monet, Renoir, Sisley, and Bazille attended the lessons of Gleyre, who only asked for ten francs as a contribution toward the rent and the fees of the models. Here, students drew or painted with live models every day in the morning, except Sunday, and two hours in the afternoon, except Saturday. Models were male one week and female the other.

The courtyard of the Ecole des Beaux-Arts around 1860. The Ecole des Beaux-Arts was built on the ruins of the old Capuchin convent. Teachers were appointed from among the members of the Académie des Beaux-Arts, the stronghold of classicism. Delacroix stood as a candidate six times but was always turned down. At the end of the course, students had to take part in the competition; they climbed up to the "loggia," where they were to remain for two consecutive days to produce a theme-based historical painting (such as: Antiochus, having heard of the illness of Scipio, released his son from prison so that the joy of seeing him again might return him to health). In the 1860s, the Ecole began to lose its grip on students, who moved to the independent ateliers.

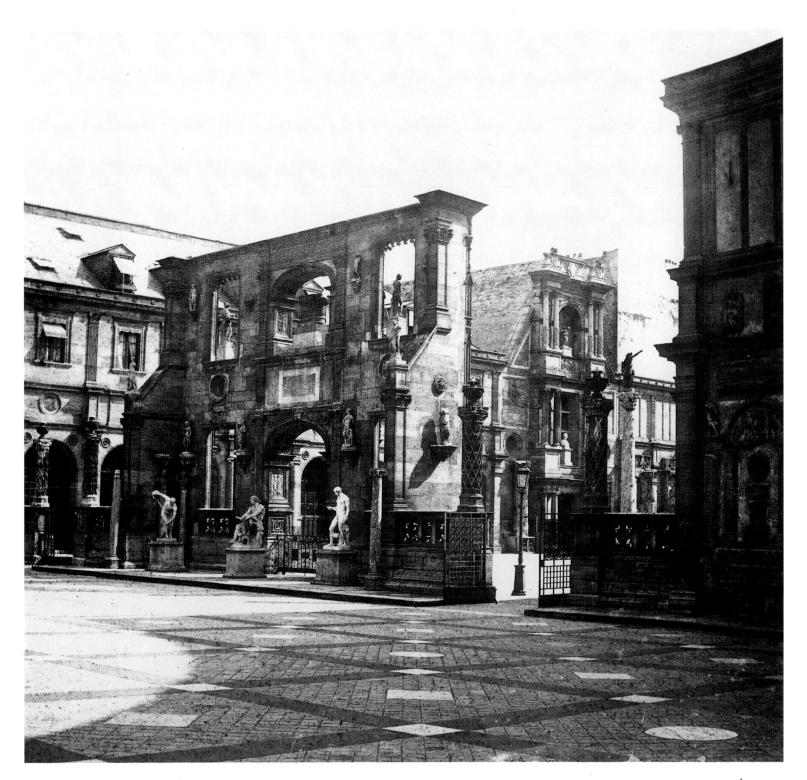

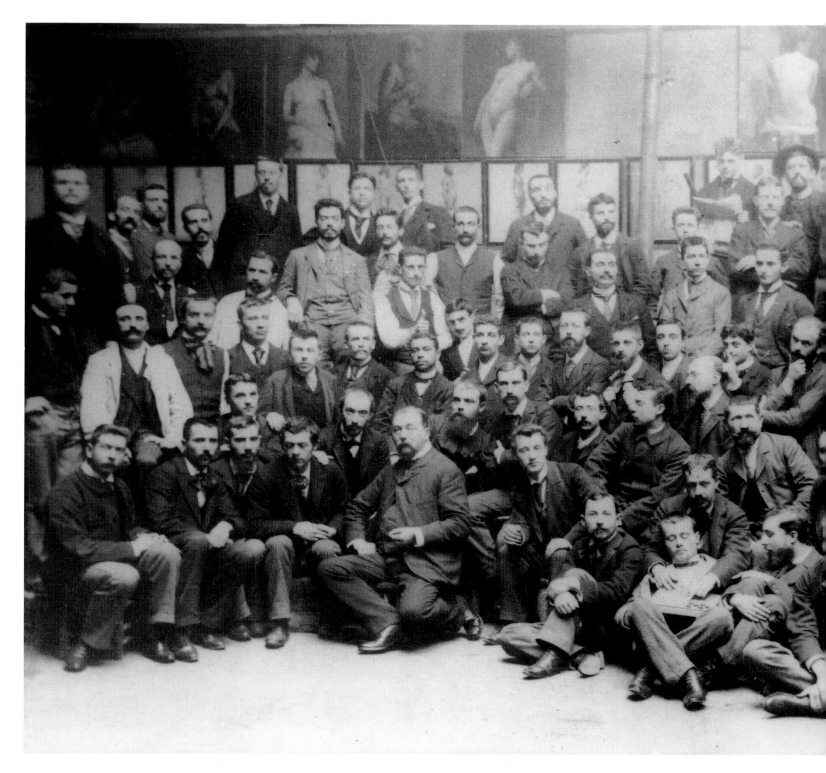

Two photographs of the students at the Ecole des Beaux-Arts. George du Maurier describes in *Trilby*, a famous novel published in 1895, the kind of students who attended the Ecole. They included "dullards who had been drawing or painting for more than thirty years, who by now closely resembled their teachers. Youngsters who in one or two or three or four years, if not ten or twenty, would undoubtedly make some kind of name for themselves ... others clearly doomed to misfortune or failure, to the hospital or an attic, the river, or the mortuary, or worse still to the tramp's bundle, the street or even father's bank. Irresponsible children, soil them all and leave it at that, with their laughter, their banter and their jokes ... little carnival kings, blithe spirits, hooligans and victims, diligent and lazy, good and bad, clean and scruffy (mostly the latter), all more or less animated by a certain esprit du corps and, at the end of the day, united in their work by friendliness and joy...."

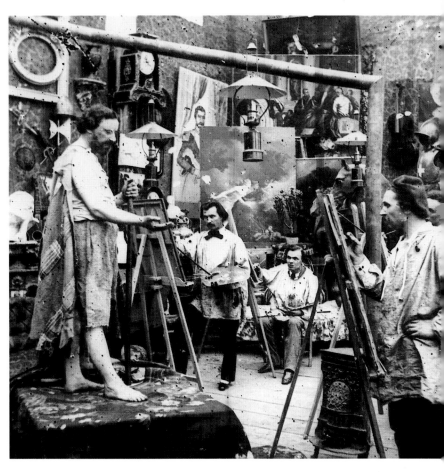

(Above) A photograph of the Académie Julian. There were no entrance exams, corrections, or professors who imposed their own preferences in this atelier; freedom was total. Old Julian, who was Swiss, had been a student of David. The term "academy" was a rather pompous term for a large room on the second floor of an old house. The grey-painted walls were covered within arm's reach by scrapings of palettes, blotches, and caricatures. In the middle of the room, toward the wall, was the dais for the models crossed by a metal bar and with a rope hanging from the ceiling that the models could grasp in order to take up difficult or uncomfortable positions. Chalk models were aligned on the shelves along the other walls. Students surrounded the dais on three sides and sat on stools which were proportionally taller the further away the student was from the dais itself. The fee was forty francs a month, which entitled students to attend every day except Sunday, from eight in the morning to five in the afternoon in winter and six in the morning to ten in the evening in summer. Male models posed for three weeks. The fourth week was set aside for female nudes. The men were generally older and posed as Silenus, satyrs, Jove, or old Anchises. The occasional younger models posed as Achilles, Hector, or Milone da Crotone, while the very young stood as Antinous. Children posed on very rare occasions.

(Right) Two photographs of artists and models at the end of the Second Empire—the Painting and the Drawing Course.

(Opposite) Photograph of a sculpture studio toward the end of the Second Empire.

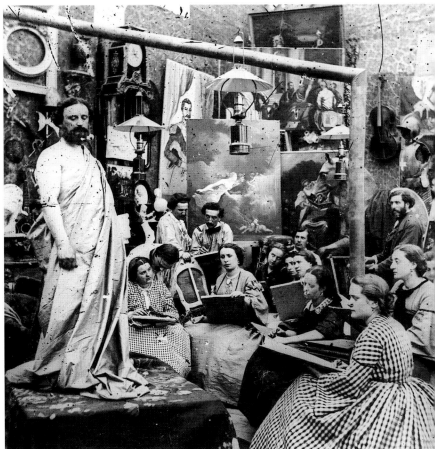

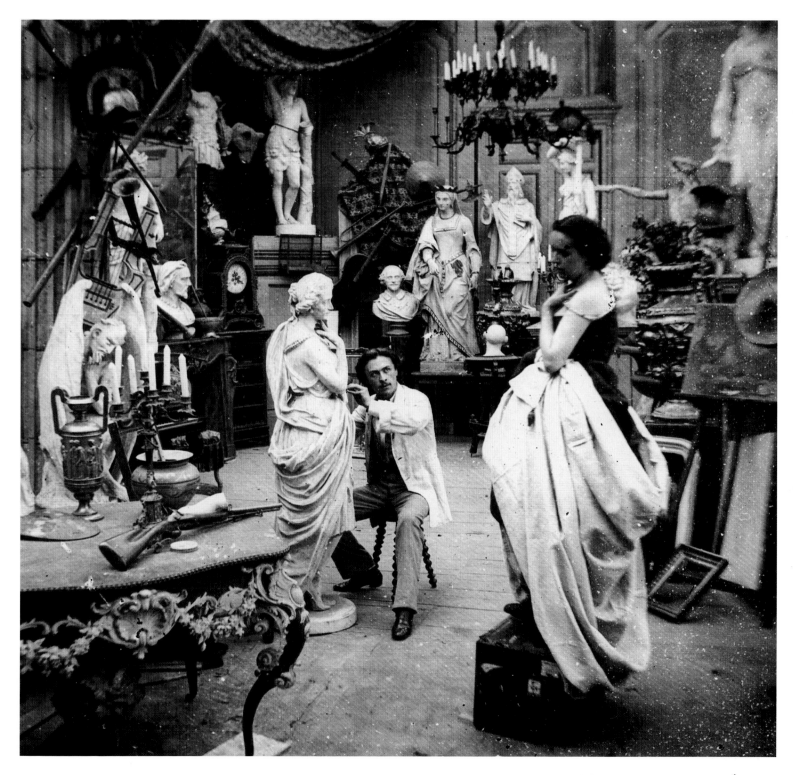

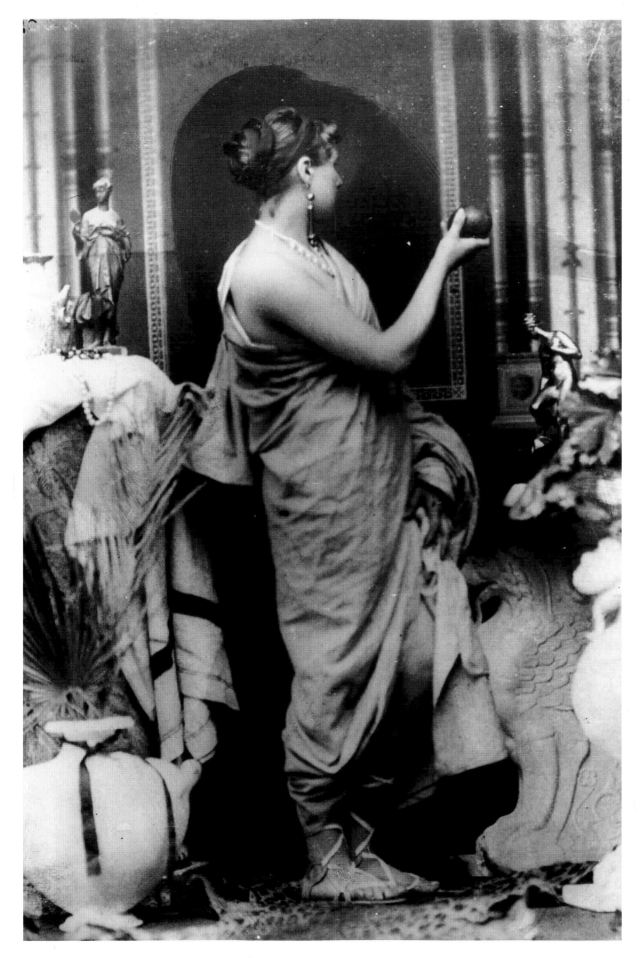

An artists' model at the end
of the nineteenth century.
Aspiring models gathered
in various places: Place
Clichy, rue de Seine; once a
week, usually on Monday,
full-scale markets were held.
The majority of models
were Italian, for the academ-
ics considered their bodies
more suitable for large-scale
historical, biblical, or
mythological compositions.

The Impressionists made
little use of professional
models. They were too
expensive and in any case
they preferred to find mod-
els among friends, family, or
even on the streets, in bars,
or places of entertainment.

(*Opposite, above*)
"Come on, Parancourt,
remember that you're not in
the bathroom any more. Put
on the Achilles costume
and pose for your wife and
daughter, Clara." This cari-
cature is a parody of the
widespread fashion for art
in the second half of the
1800s.

In the plentiful literature
about the Impressionists as a
group or as individuals,
clashes with the master of
the atelier as regards models
are very common. Mention
need only be made of
Monet's discussion with his
teacher Gleyre: "He sat
down, made himself com-
fortable, and carefully
observed the painting. I can
still see him turning round,
slanting his serious head
with a satisfied air,

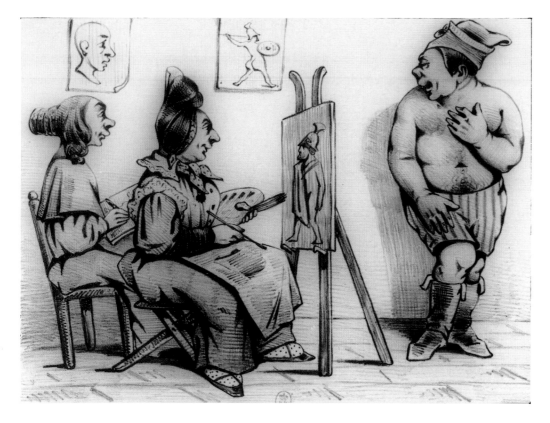

smile, and hear him tell me: 'Not bad, not at all bad, you know, but it is too like the model. Here you have a sturdy fellow, with huge feet, and you paint him exactly as he is. This is no good, no good at all. Remember, young man, that when you paint a figure, you must bear antiquity in mind. Nature, my friend, is fine for studies but is not the least bit interesting." There was evident opposition between the concept of idealizing nature and that of copying it exactly as it was found. The clash over models for the Impressionists was the first step toward developing their artistic intentions.

(*Below*) A photograph taken at the end of the century at the Centre International des Beaux-Arts. The artists in this instance were women. Many women attended the ateliers, including Berthe Morisot and the American painter Mary Cassatt, friend and pupil of Degas. We may also mention another famous American (but not for her painting): Fanny Osbourne, the future wife of Robert Louis Stevenson, who in 1875 left California, alone with three children, to learn outdoor painting in Paris.

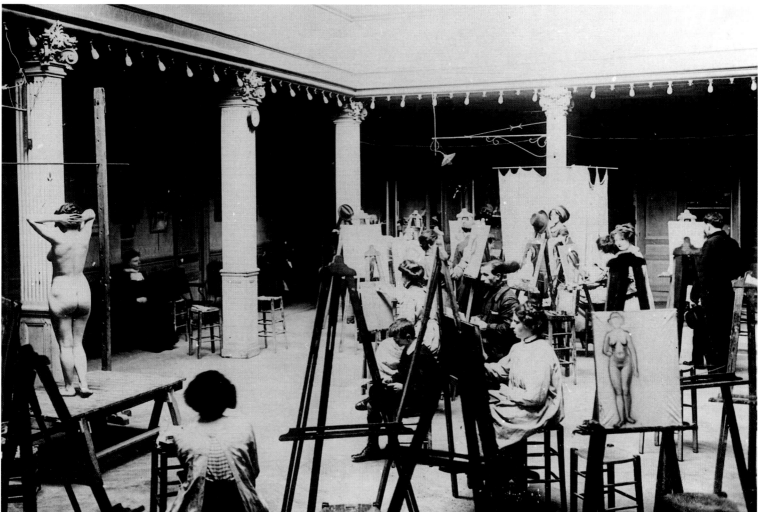

The frog pond in the forest of Fontainebleau in a photograph taken in 1870. In the wake of the outdoor scenes of Corot and Millet, the romantic landscapes of Théodore Rousseau, and the Barbizon School, the Impressionists also travelled to the forest of Fontainebleau to paint in the open air. It was a way of escaping the fossilized teaching of the Ecole des Beaux-Arts and use a lighter palette in an attempt to depict the sky, trees, and country folk in their natural setting. The Grand Tour to Italy had fallen out of fashion. With the coming of the railways, artists began to move about to rediscover the French landscape.

(*Below, left*) The old inn "Aux billards en bois," one of the places where Diaz, Pissarro, Degas, Sisley, and Cézanne often met, in rue Saint Rustique in the eighteenth arrondissement of Paris.

(*Below, right*) the Nouvelle Athènes café in a sketch by Degas.

(*Bottom, right*) a sketch of the Guerbois café by Manet dated 1869.

In the gas-light period, artists laid their brushes aside at dusk and often spent the late afternoon and early evening in one of the many coffee-houses where painters, writers,

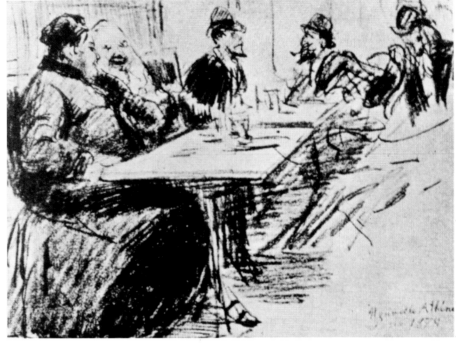

and their friends met. Manet discovered the Guerbois around 1863 (it remained popular until 1870). Standing in rue des Batignolles 11 (now Avenue de Clichy 9), the café was next door to the Hennequin shop where Manet went to buy his paints. The Guerbois was a suburban café with a garden and pergola, which hosted weddings, banquets, and billiards. It was not an elegant coffee-house, unlike the Tortoni in Boulevard des Italiens, but was convenient because most artists lived in the neighbourhood.

The Nouvelle Athènes café, on the corner of the Place Pigalle and the boulevard, had an enclosed winter terrace, overlooking the square, where strollers could be watched. At that time, Place Pigalle was a kind of artistic forum. A great many artists, writers, and journalists lived nearby and spent their evenings in the café.

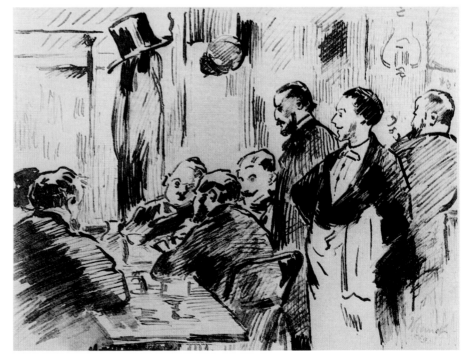

PHOTOGRAPHY AS A SOURCE

The invention of photography in 1839 came as a major shock. Twenty years later, it had become an established component of visual education. Perhaps this helps to explain why the Impressionist painters (with the exception of Degas) were not prompted to discuss photography, unlike their predecessor Delacroix, who even went so far as to say that had he been younger photography would have turned his art upside down. He was impressed not so much by the precision of photography as by the "flou" effect (the blurring of images)—that is, the coexistence in the same picture of these two opposite elements, one of the most fascinating aspects of photography as a whole.

The relationship between the pictorial work of the Impressionists and photography would merit systematic and in-depth exploration—in particular, for example, their relationship with one of the great discoveries of photography in the early 1850s—namely, the perfection of sufficiently rapid techniques (such as wet collodian plates) capable of capturing the fleeting shades of skyscapes; or their relationship with industrialized photography, which came strongly to the fore in the 1860s, giving rise to photographic "portraits" of stations, moving trains, bridges, aqueducts—subjects that later became central to the interests of the Impressionists in their paintings; or, lastly, their relationship with amateur photography depicting scenes of middle-class life (women in gardens, staircases, tool sheds, daily scenes that had no pretense to grandeur), which could well have provided some kind of inspiration and in any case drew the attention of the Impressionists to the topics that later became their main interest. And who can say that the concept of the "impression," common to both Impressionist painting and photography (where, naturally, the term has a more technical connotation) may itself indicate the existence of some kind of link between the practice of painting en plein air and the language of photography?

It may even be said that this is what Proust was thinking when he wrote in his *Remembrance of Things Past*: "Those 'admirable' photographers [and their ability] to achieve singular images even out of something otherwise well-known, images different to those we are used to seeing, singular but authentic, and precisely for this doubly fascinating because they surprise us, they distract us from our customary habits and, at the same time, turn our thoughts inwards by recalling impressions for us."

Two engravings that depict the Hall of Photochromy at the 1855 Universal Exposition and visitors to the exposition. The word most often used to express the emotion felt when viewing daguerreotypes was "vertigo." It is difficult for us to understand entirely how the invention of photography startled the social world of the 1800s. For the first time, everyone who could not otherwise afford a portrait or a miniature could at last see themselves in a durable form other than merely in mirrors. Photography was immensely successful, and it is no coincidence that the real boom in photography came with the photographic visiting card patented by Disdéri in 1854.

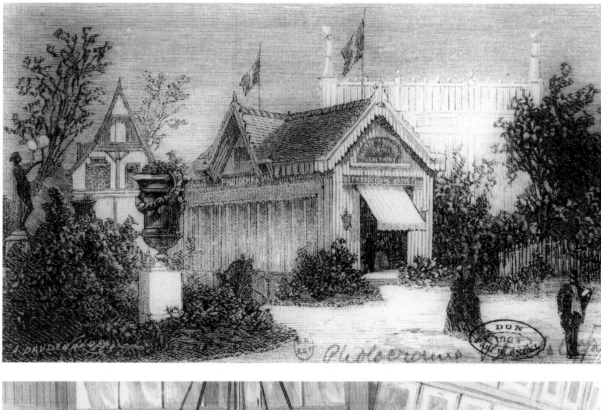

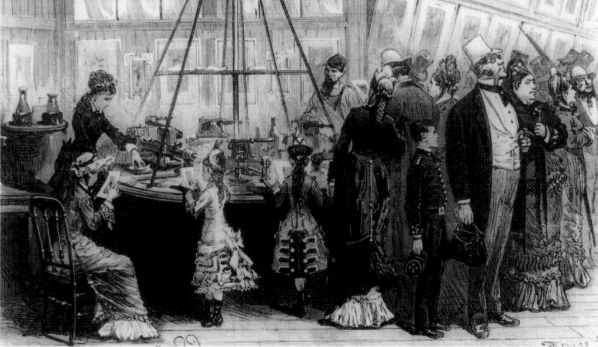

Edouard Baldus, *The Mill at Enghein*, 1855. The first photographers were often mediocre painters—as Nadar, himself a rather untalented painter and designer, recalls in his memoirs *When I Was a Photographer*. Just like the painters of their generation, especially the artists of the Barbizon School, photographers had the same ambitions and worked with the same models, which explains why they also worked so much in the forest of Fontainebleau. It is surprising, nevertheless, to realize that many photographs, such as this one by Baldus, achieved a distinctly "impressionistic" interpretation of landscapes (despite the absence of colour) ten years in advance of the movement in art.

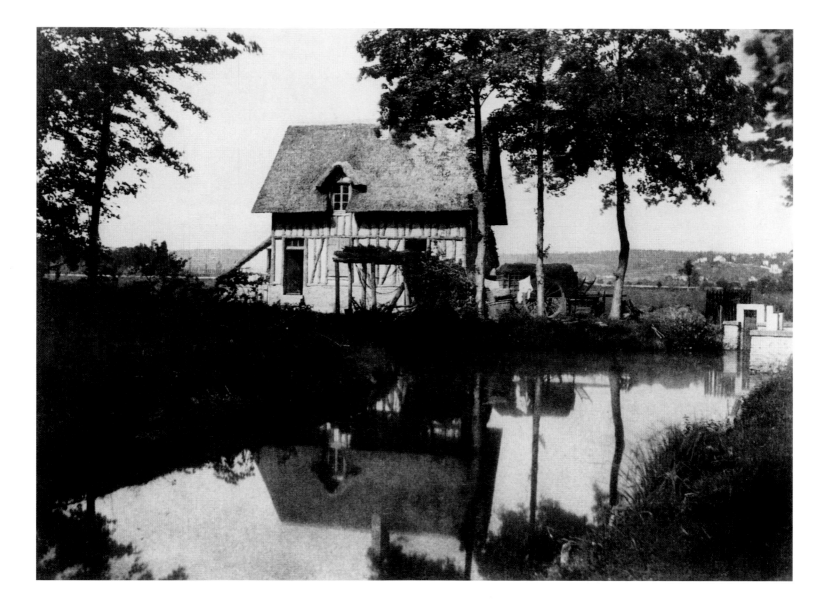

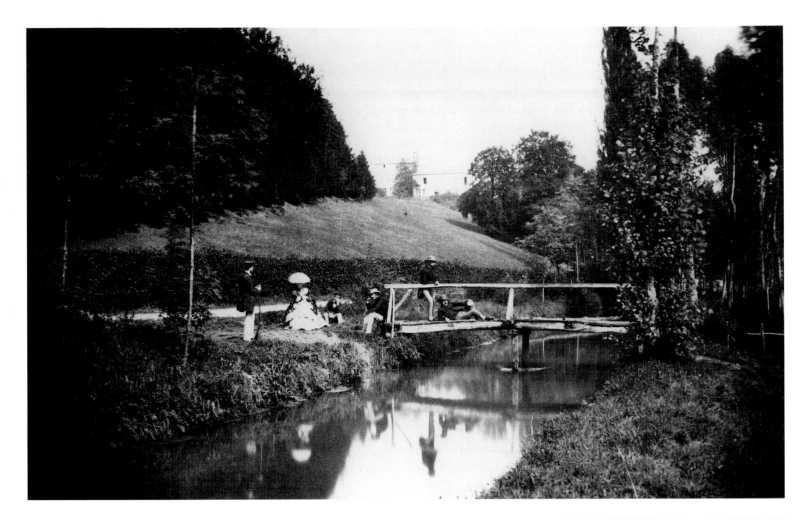

(*Above*) Another photograph by Edouard Baldus, *Group of People at the Château de la Faloise*, 1857.

(*Right*) *Women in a Garden*. The photograph, dated 1865, is part of an album that belonged to a painter-decorator of the Sèvres Manufacturing company. It is likely that these two photographs also provided ideas for the Impressionists. In addition to the theme of the trip to the country that was widely taken up by the Impressionists, photography also provided a "spontaneous and fragmentary composition and a tendency toward simplifying depth," two aspects that were later an element sought after in Impressionism.

The spread of photography made a giant leap forward when Blanquart-Evrard introduced the paper-based reproduction technique of the English photographer Fox-Talbot in 1847 (a process that was much less expensive than the metal-plate technique used in daguerreotypes), and began to publish a series of albums, many of which were devoted to nature studies (trees, streams, rocks, woods, etc.). These albums were amply exploited by all painters.

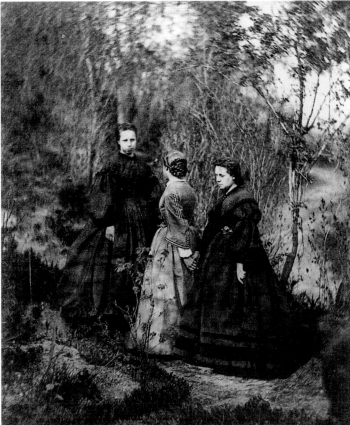

Gustave Le Gray, *The Steamboat, Le Havre, 1856.* The seascapes of Le Gray were a technical tour de force for the times. Over and above the brightness of the sky, he was also able to capture the compactness of the waves. Some of his photographs were exhibited at the Crystal Palace in London in 1856, and were much admired by Queen Victoria and the public at large. They have often been defined as pre-Impressionist because of the instantaneous impression they evoke.

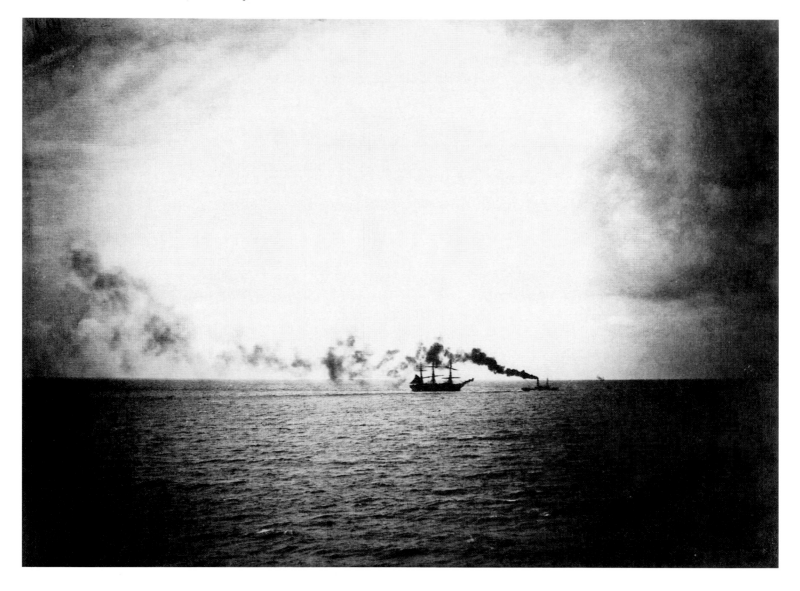

Edouard Baldus, *The Station at Amiens*, 1855. At the same time as the appearance of photography, France was also extending its railway network. Many presidents of these large companies spontaneously decided to commemorate the building of stations with photographic albums. In 1851, Baron James de Rothschild commissioned Edouard Baldus to produce the first album of this kind for the railway line from northern Paris to Boulogne. Four years later, Baldus produced a similar album for the Paris-Lyons-Mediterranean line. Once again, a photographer anticipated a topic that was later taken up by the Impressionists.

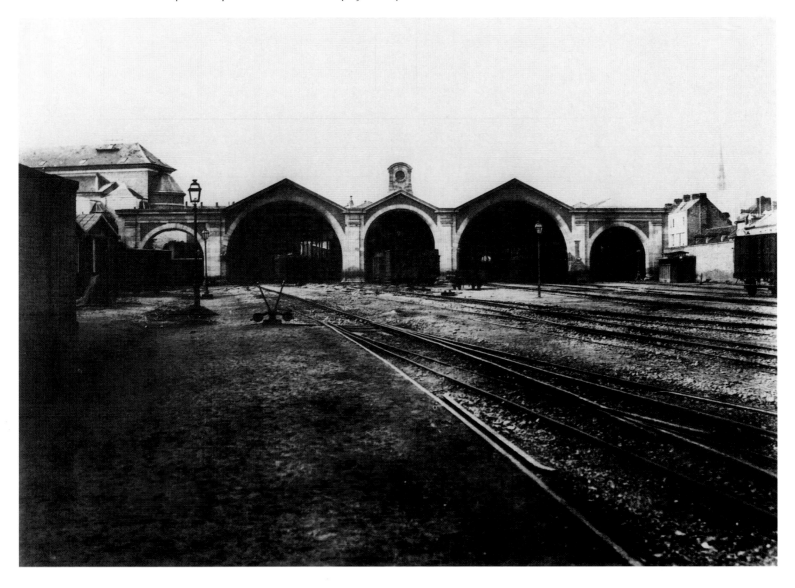

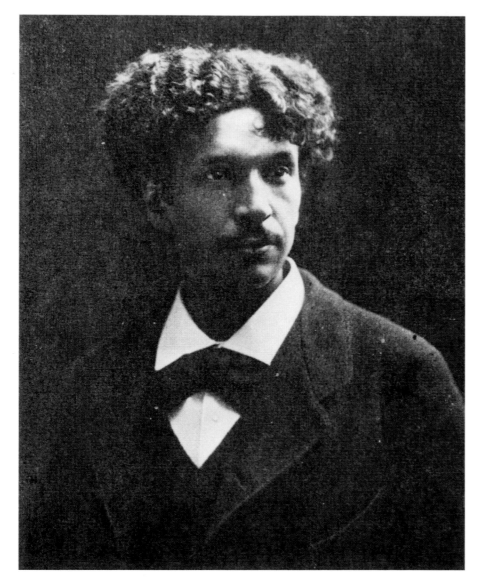

Charles Cros (1842–1888) in a photograph by Nadar. Poet, amateur painter, and inventor, Charles Cros was one of the most fascinating and inventive personalities in the entourage that developed around the Impressionists. In 1867, he presented a project to the Academy of Sciences regarding the "reproduction of colours, forms, and movements" and, in 1869, informed the Société Française de Photographie of his "General Solution to the Problem of Colour Photography." Renoir and Manet were intensely enthusiastic about his photographic experiments and the latter, in 1882, commissioned him to reproduce a number of paintings. "The Impressionists felt that developments in photography were extremely important in the life of the period," wrote Jean Renoir in the biography of his father; "their friend Charles Cros viewed photography as a means for studying the problems inherent in separating light and expanding experience of Impressionism."

Verneuil, *Picnic on the Waterside*, 1868. Commercial photography made its appearance as early as the 1850s, the forerunner of present-day postcards. Reproductions were on paper, the viewer was in wood with a small lens, and prices were relatively inexpensive. Occasionally, stereoscopic photography simply reproduced in miniature the large compositions of the masters of photography. In other instances, they involved specially created views. About 1857, certain topics began to make their appearance, such as members of the middle class and their trips to the countryside, picnics on river banks in and around Paris, entertainments, and gardens. Many of these themes were also taken up by the Impressionists.

(*Left*) Prince and Princess Metternich, 1860, in a photograph by Disdéri, the famous and fashionable portrait photographer of the Second Empire.

(*Right*) E. Degas, *Princess Pauline de Metternich*, around 1861, London, National Gallery. Practically all painters (even the most reluctant, such as Ingres) used photographs for their artistic work.

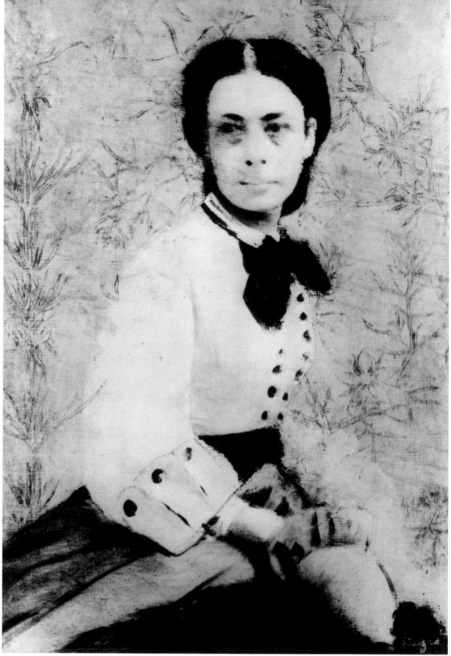

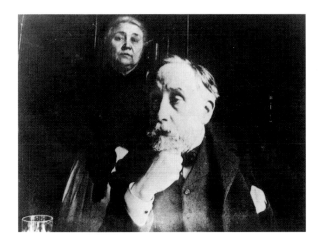

(*Above*) Degas and his housekeeper, Zoé Closier, about 1890–1895. Degas began taking photographs himself around 1885. There still exist some of his photographs of ballerinas and women bathing, which he later used for his paintings. But he also loved taking photographs of his friends, either alone or in groups, usually in interior settings. Photography was fundamental to Degas' painting. It taught him how to frame images and capture movement. His niece, Jeanne Fèvre, in her small book, *Mon Oncle Degas*, spoke of his "Kodak eye" that immediately saw everything involved in daily life: the gestures of a washerwoman, women ironing, the stylist, the flower-girl.

(*Right*) Renoir and Mallarmé (standing) in a photograph by Degas taken in 1895. The pose lasted fifteen minutes and to take the shot, Degas illuminated the scene with nine oil lamps. The mirror reflects the wife and daughter of Mallarmé and the artist's camera. As in his paintings, Degas preferred "to achieve portraits of people in their familiar and typical gestures and especially to give the face the same range of expression as the body."

Robert Demachy, *Landscape*, about 1904. Robert Demachy was the leading figure among the French "pictorialists." The movement, begun in England, brought together amateur photographers who aimed to give photography an artistic base. Thanks to new printing processes (such as dichromatic gum), Demachy was able to produce prints with a tonal quality similar to that of painting (hence the name of the movement).

He also undertook research into light and the atmospheric vibration of the Impressionists, as well as their own pictorial themes: landscape compositions, skies darkened by industrial fumes, the quaysides of the Seine cluttered with barges.

Alfred Stieglitz, *Snapshot - Paris*, 1911. Alfred Stieglitz (1864–1946), like Robert Demachy, was influenced by the Impressionists. He founded the American pictorialist magazine *Camera Work* and opened the Photo-Secession Gallery at 291 Fifth Avenue, New York, where he organized exhibitions of both paintings and photography. In March 1911, he organized the first personal show dedicated to Cézanne in the United States. "The first watercolours I saw seemed neither more nor less realistic than a photograph," he said when he opened the crate shipped from France that contained twenty watercolours. There was

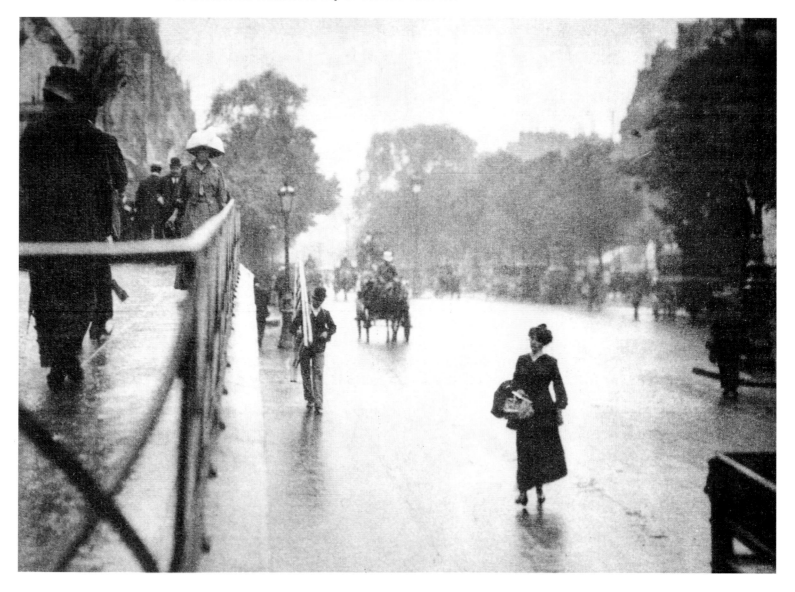

another exceptional visitor: photographer Man Ray, at the time little more than twenty years old. "I was terribly excited ... Just a few strokes of colour on white paper. The watercolours seemed unfinished and this was the quality I appreciated the most over and above the use of the white base of the paper as an integral part of the composition. It was astonishing."

IMPRESSION: SOLEIL LEVANT (SUNRISE)

And it was appropriately in the studio of a photographer, Nadar, at 35 Boulevard des Capucines, that the impressionist group exhibited for the first time on April 15, 1874. Claude Monet a year previously had once again taken up the idea that Bazille had toyed with since 1867: to organize an exhibition of a group of artists as a reaction to the Salon and financed by themselves. Monet's project was approved by the group because, as Rewald explains, "the economic boom which France had enjoyed after the disastrous war had turned into a recession. Falling back into uncertainty after a few years of relative stability, the friends were all the more stimulated to appeal to the public at large through an event which promised them greater prestige than participation in the Salon, not the least because it would have allowed them to exhibit more than the three canvases permitted by the jury."

The "Limited Company of Artists, Painters, Sculptors, Engravers et al" was founded on December 27, 1873. It comprised the Batignolles group (except for Manet, who preferred to take traditional paths) and some other artists who helped to bring the overhead down. Nadar loaned his studio free of charge. The exhibition remained open for a month and brought together 165 works by thirty exhibitors. The entrance fee was one franc and the catalogue fifty centimes. It was open from 10 a.m. to 6 p.m. as well as in the evening from 8 p.m. to 10 p.m. (an innovation for the period). There were 30,500 visitors over the four weeks of the show (175 on the first day, fifty on the last, some days no more than two).

Ten days after the inauguration of the show, one of the first of the few reviews appeared (many critics refused to review the exhibition, maintaining that the paintings "were horrible, stupid and dirty things; painting totally lacking in common sense"). Louis Leroy, in *Charivari*, published a damning article entitled "Exhibition of the Impressionists." He borrowed the title of his vituperative article from a painting by Monet: *Impression. Soleil Levant (Sunrise)*.

SOCIÉTÉ ANONYME

DES ARTISTES PEINTRES, SCULPTEURS, GRAVEURS, ETC.

PREMIÈRE

EXPOSITION

1874

35, Boulevard des Capucines, 35

CATALOGUE

Prix : 50 centimes

L'Exposition est ouverte du 15 avril au 15 mai 1874,
de 10 heures du matin à 6 h. du soir et de 8 h. à 10 heures du soir.
PRIX D'ENTRÉE : 1 FRANC

PARIS
IMPRIMERIE ALCAN-LÉVY
61, RUE DE LAFAYETTE
—
1874

MONET (Claude)

A Argenteuil (Seine-et-Oise).

95. Coquelicots.
96. Le Havre : *Bateaux dè péche sortant du port.*
97. Boulevard des Capucines.
98. Impression, *Soleil levant.*
99. Deux croquis.
 Pastel.
100. Deux croquis.
 Pastel.
101. Deux croquis.
 Pastel.
102. Un croquis.
 Pastel.
103. Déjeuner.

Mademoiselle MORISOT (Berthe)

7, rue Guichard, Passy-Paris

104. Le Berceau.
105. La Lecture.
106. Cache-Cache.
 Appartient à M. Manet.
107. Marine.

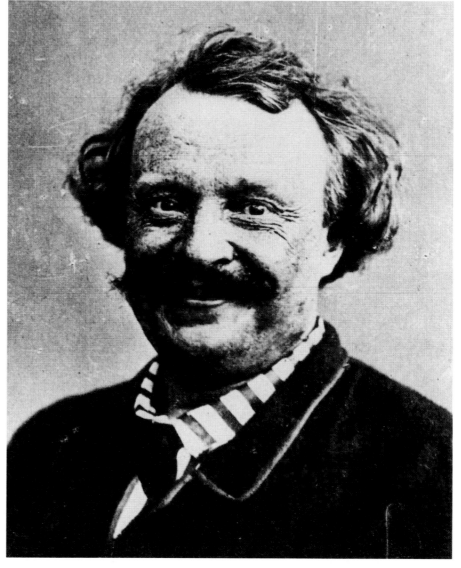

(*Above, left*) Title page of the catalogue for the 1874 exhibition held in Boulevard des Capucines in the old studio that Nadar had just left. (*Below, left*) a full page from the catalogue listing the works of Monet exhibited (five paintings and seven pastel sketches), including *Impression. Soleil Levant (Sunrise)*. It is interesting to note that "Impression" is in plain type and the other two words in italics. Cézanne exhibited three paintings; Berthe Morisot a total of nine paintings, watercolours and pastels; Renoir six; Pissarro and Sisley five; Degas a total of ten paintings, drawings, and pastels. (*Above*) a portrait of photographer Nadar.

The interior and (opposite) the exterior of Nadar's studio in Boulevard des Capucines. The studio had a series of large rooms on two floors, with dark red walls and with windows for sunlight just like an apartment. There are no photographs or engravings of the 1874 exhibition, but the paintings hanging on the doors in the photograph give some idea of the arrangement.

The position of each painting was drawn at random to avoid the inevitable arguments over the best location. In the wake of the violent criticism by Louis Leroy, a friend of the group who had offered to help out during the show wrote a note to Dr. Gachet (owner of Cézanne's *Modern Olympia*): "Sunday—it is my turn today to keep an eye on the exhibition. I glance every now and then at your Cézanne, but I can't warrant its safety. I'm worried it might be returned to you in bits and pieces."

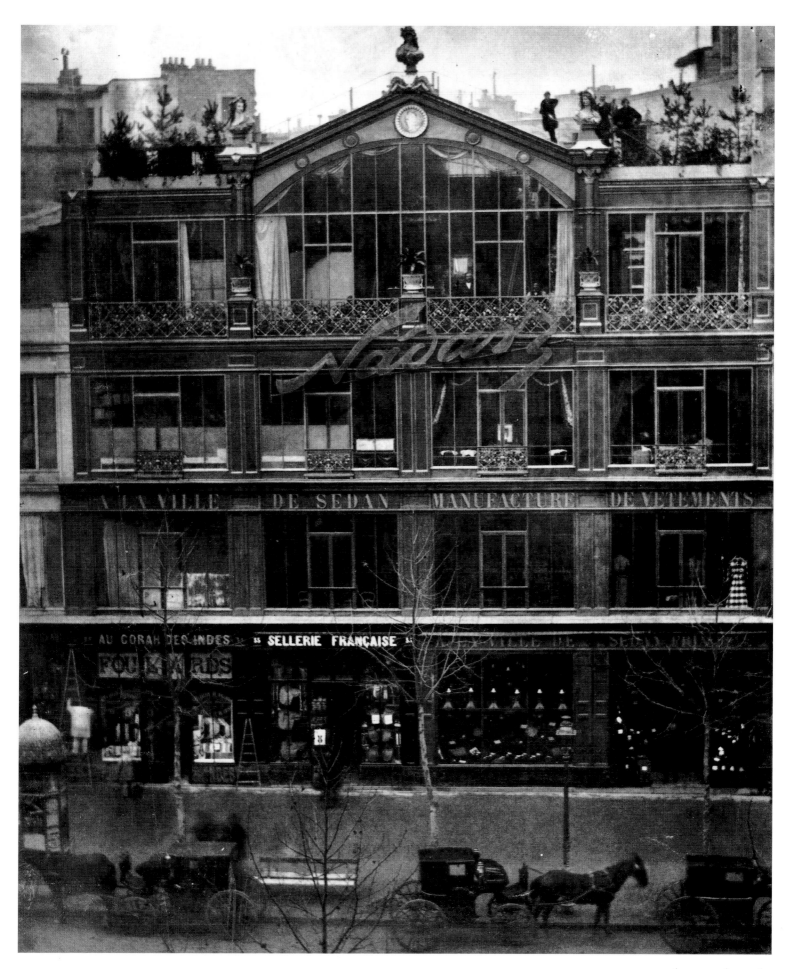

Engraving showing the public queuing up to visit the official
Salon in 1874 at the Palais de l'Industrie on the first Sunday
opening. Attendance was extremely good that year, and the
general public wholeheartedly supported the jury of the Salon.
Four thousand paintings were exhibited in twenty-four halls.
For the first time, the paintings were hung in only two rows.
Zola calculated that there were 30,000 visitors on the first
Sunday opening (when entrance was free of charge);
daily attendance varied between 8,000 and 10,000 people.
By the end of the show (six weeks), more than 400,000
visitors had passed through the gates.

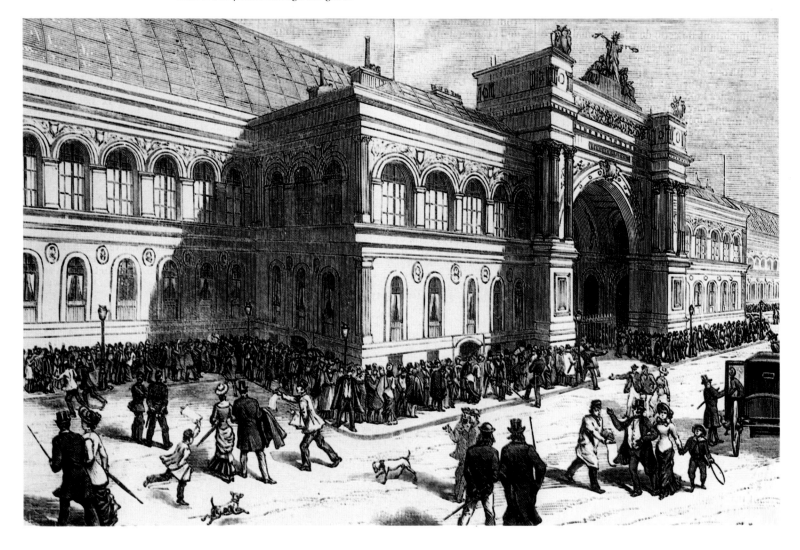

An engraving of the painters who won awards at the 1874
Salon. From right to left, top to bottom: Gérôme, Robert
Fleury, Neuville, Bouguereau, Carolus-Duran, Cabanel,
Carrier Belleuse, Corot, Chaplin. As the Salon went its
usual way, the Impressionists drew up the balance sheet of
their own exhibition: 9,272 francs for general expenses
(layout, lighting, posters, caretakers, insurance, wages, etc.).
Income (entrance fees, sale of catalogues, 10% commission
on sales of paintings): 10,221 francs. Each exhibitor
received less than the annual enrolment fee in the company
(61 francs).

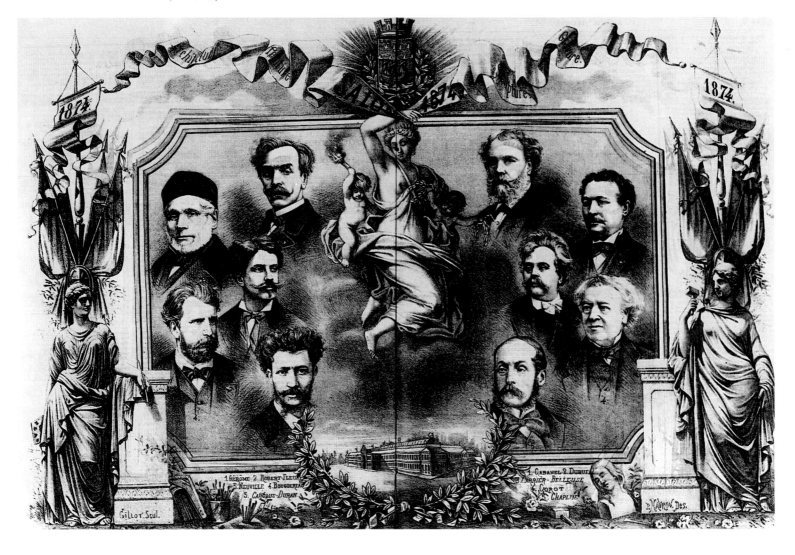

(*Below*) The 1874 Salon: general view of the indoor garden where the sculpture exhibition was held. The engraving was developed from a photograph taken by Marville, an exceptional "photo-reporter."

(*Opposite*) An engraving of the inauguration of the 1874 Salon. The public at large was not then ready to accept the innovations of the Impressionists, but the general hostility by no means deterred them in their conviction that they had taken a step forward as regards the representation of nature in comparison with their masters. "Without hesitation, the Impressionists continued their daily creative work in complete isolation, like a cast of actors continuing night after night to play their roles before an empty theatre" (Rewald).

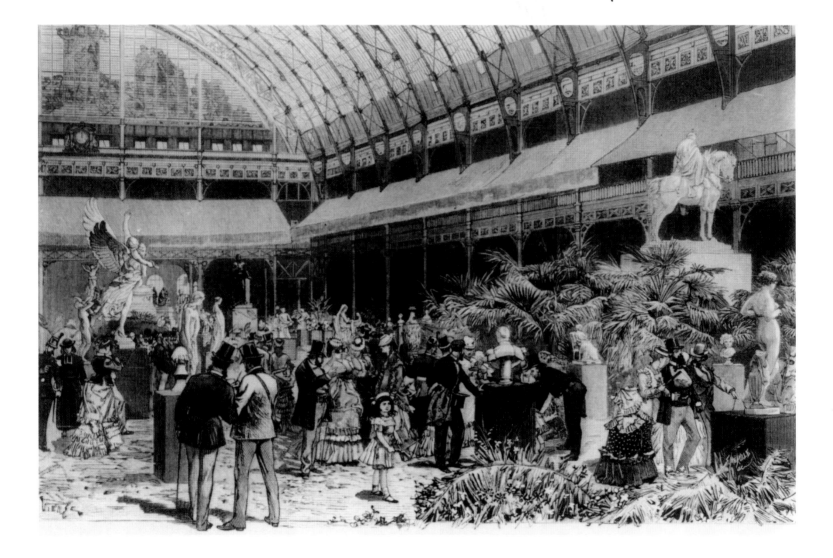

THE REACTIONS OF THE PUBLIC AND CRITICS

As already mentioned, the press gave broad coverage to the Salon, the Salon des Refusés and, as the years went by, even to the exhibitions of the Impressionists, engaging the great humorists of the period to make caricatures (Daumier, Nadar, Cham, Gill, and so forth), so much so that political satire went into a decline from which it only recovered with the liberal decrees of 1881.

Yet if the caricaturists found the hen that laid a golden egg in ridiculing the Impressionists, they equally portrayed a fundamental element that otherwise may possibly have passed unnoticed: the general public. The public at large can undoubtedly be glimpsed in the engravings of the inaugurations of the Salons, but we rarely ever hear its voice. Yet, in the second half of the 1800s, art aroused a wide range of emotions: from admiration to disgust, from irony to shock or incomprehension, not to mention iconoclastic fury (as was the case for Manet and his painting, *La Musique aux Tuileries*, exhibited in 1863). Visitors (400,000 at the 1874 Salon) came largely from the upper middle classes of the Third Republic and were looking for confirmation of their own values. But things did not stop there: there were the lower middle classes, students, soldiers, even countryfolk, workers (one article of the museum regulations forbade people to wear clogs inside the galleries), and children (provided they were accompanied by adults). A visit to museums or the Salon was an educational pastime as well as support for the State (Napoleon III was crowned in the Louvre).

There is a passage by Zola in *Opera*, a novel focusing on the life of the Impressionists and their beginnings, that describes the reaction of the public to a painting entitled *Plein Air* (which was actually *Déjeuner sur l'herbe*, exhibited by Manet at the Salon des Refusés in 1863). Zola's style, usually contained and realistic, here achieves such an uncharacteristic Baroque intensity that it is worth including the extract in its entirety: "The titters which seemed rather discreet when I entered echoed more and more intensely as I slowly moved through the halls. By the time I reached the third hall, it was no longer suffocated by ladies' handkerchiefs, and the men unbuckled their belts so they could laugh more freely. [...] The explosion continued and worsened into a rising catcall of laughter. When I reached the door, I saw the gaping jaws of the visitors, their eyes shrinking and their faces widening; I heard the tempestuous bellowing of fat men, the rusty whining of thin men, all dominated by the acute shrieks of the women. In front of the painting itself, children were bent double as if someone were tickling them. A lady had just collapsed on a bench, her knees clasped together, trying to recover her breath with a handkerchief pressed against her mouth. The gossip about such an absurd painting quickly did the rounds of the Salon and the crowds squeezed and crammed in, everyone wanting to be part of the scene. [...] Jokes flowed from left and right and the theme itself was an especial source of hilarity. [...] 'The lady is too hot while the man has put his velvet jacket on because he's worried about catching a cold. But no, the lady is already violet: the man has pulled her out of a pond and is recovering at a distance, blowing his nose.'"

A series of caricatures by Cham in 1869, when Impressionism was still called naturalist painting.

— Tu envoies un canard à l'Exposition? — Oui, mon cher, c'est un boursier qui me l'a commandé. s bêtes-là l'ont aidé à faire fortune.

Le plus bel éloge que l'on puisse faire du tableau envoyé cette année par M. Jadin.

— Monsieur, c'est une horreur, je veux que vous finissiez mon portrait avant de l'envoyer! Il me manque un bras; mettez-le! — Madame, je n'aurai jamais le temps de l'ajouter; vous me ferez manquer l'Exposition!

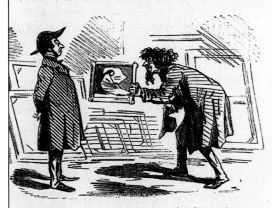

— Auriez-vous l'extrême bonté de vouloir bien présenter mon tableau au jury?... Croyez bien que si... votre portrait, celui de madame... ah! monsieur... ma reconnaissance serait éternelle

— Vous n'allez pas à la Bourse aujourd'hui? — Je viens de peindre un tableau de bataille, que je vais soumettre au jury. Je reviens ensuite jouer à la hausse ou à la baisse, selon que mon tableau aura été refusé ou accepté.

— Commissionnaire, vous apportez au jury les tableaux de M. Meissonnier? — Fouchtra! je les avais mis dans la poche de mon gilet; che m'aperçois que j'avais un trou dans la doublure!

— Ils ont refusé ton tableau; il péchait peut-être un peu par l'exécution... Il est bien maintenant; le voilà exécuté.

— Mon cher ami, si tu aimes ta femme, tu vas te battre en duel avec tout le jury de peinture : il a refusé mon portrait, et le peintre m'a assuré que cela ne pouvait être à cause de sa peinture, que cela devait

— Monsieur et madame, faites bien attention dans les escaliers, il y a dans la maison un peintre qui a eu tous ses tableaux refusés à l'Exposition.

One of Cham's many caricatures of Impressionist painting. It reads: "The Turks bought a lot of canvases at the Impressionist exhibition. They can use them if war breaks out."

BIEN FÉROCE!

Les Turcs achetant plusieurs toiles à l'Exposition des impressionnistes pour s'en servir en cas de guerre.

NOUVELLE ÉCÓLE. — PEINTURE INDÉPENDANTE.
Indépendante de leur volonté. Espérons·le
pour eux.

LA CHAMBRE A PARIS.

Eloigner les plus téméraires des abords de la Chambre en l'entourant des peintures
de l'école impressionniste.

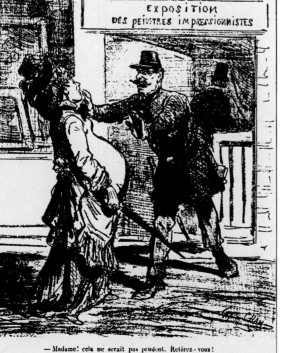

EXPOSITION
DES PEINTRES IMPRESSIONNISTES

— Madame! cela ne serait pas prudent. Retirez·vous!

(*Above, left*) "The new
school of Independent
painting. They want to be
independent. And let's
hope they are" (1871).

(*Above, right*) *The
Chamber.* "Keep the fool-
hardy away from the area
by surrounding it with the
paintings of the
Impressionists."

(*Left*) A pregnant
woman wishes to enter the
Impressionist exhibition:
"Madam!" says the care-
taker, "that would not be
prudent" (1877).

(*Right*) "The Impres-
sionist painters can double
the public impact of their
exhibition by playing the
music of Wagner" (1877).

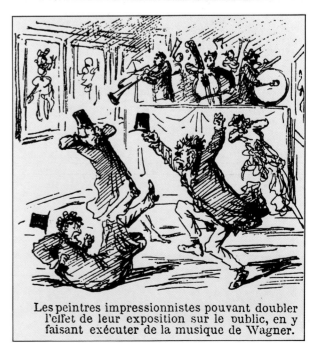

Les peintres impressionnistes pouvant doubler
l'elfet de leur exposition sur le public, en y
faisant exécuter de la musique de Wagner.

LE PEINTRE IMPRESSIONNISTE.

— Madame, pour votre portrait il manque quelques tons sur votre figure. Ne pourriez-vous avant passer quelques jours au fond d'une rivière?

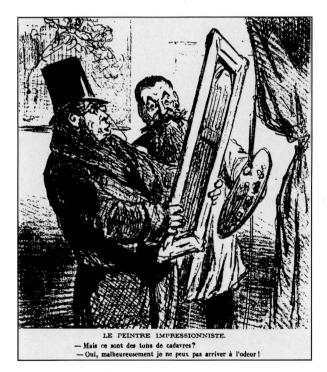

LE PEINTRE IMPRESSIONNISTE.

— Mais ce sont des tons de cadavres?
— Oui, malheureusement je ne peux pas arriver à l'odeur!

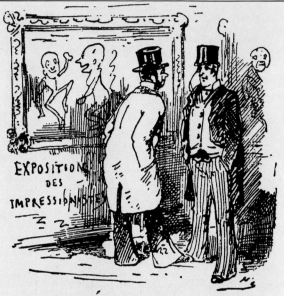

— Tiens! Vous ici?... Vous êtes donc amateur de l'impressionnisme?
— Moi? Pas du tout.. Mais quand je rentre à la maison après avoir regardé tous leurs portraits, ma femme me paraît un peu moins laide.

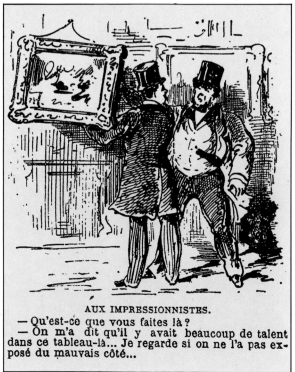

AUX IMPRESSIONNISTES.

— Qu'est-ce que vous faites là?
— On m'a dit qu'il y avait beaucoup de talent dans ce tableau-là... Je regarde si on ne l'a pas exposé du mauvais côté...

(*Clockwise*) "Madam, you are a little pale for your portrait. Could you not go and spend a few days on the river bed!" Cham, 1877.

"Goodness! Are you here? ... Do you like the Impressionists!" "You must be joking ... But when I go home after seeing their portraits at least I don't find my wife quite so ugly." Pif, 1880.

"What are you doing!" "I've been told there's a lot of talent in this painting ... I'm just making it sure it hasn't been hung upside-down ..." Pif, 1881.

"But these are the colours of a corpse!" "Of course, but I can't quite get the smell." Cham, 1877.

(*Opposite*) A sheet of caricatures by Draner, 1900. Published in *Charivari*. Even when the Impressionists had become internationally famous, satirists continued to make fun of them.

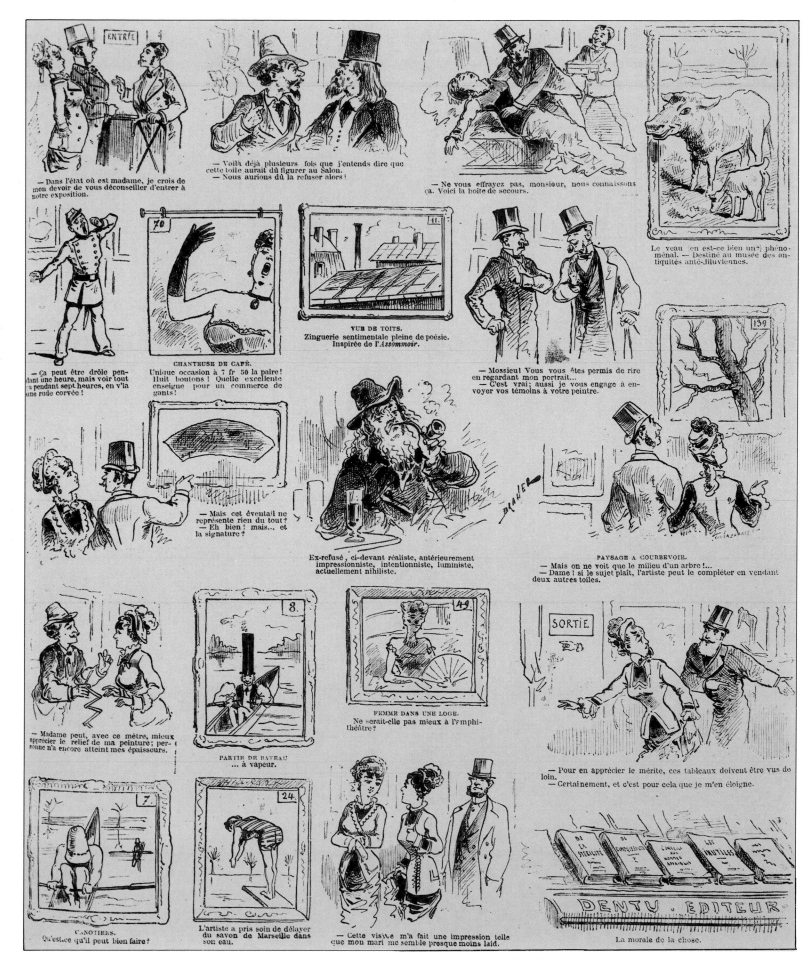

(*Left*) A photograph of Henry James studying a painting. At the time of the second exhibition of the Impressionists an article by James was published in the *New York Tribune* on May 13, 1876, in which he explained the new movement. "I found it decidedly interesting [...]. The young painters taking part in this exhibition are partisans of reality without frills and the fierce enemies of anything to do with adaptation, embellishment, or selection, unlike the artist who allows himself (as until now, since the dawn of art, artists have always found it more rewarding to do) to dedicate himself to the idea of beauty. For them, beauty is a metaphysical concept, which can only create confusion and which absolutely must not be touched. Don't touch it, they say, and it will come of its own initiative: the true field of the painter is simple reality, the substance of his mission to render an immediate impression of the casual and momentary appearance of any given reality."

(*Above*) Emile Zola in a photograph of the 1870s. Zola was the leading figure in literary realism and a friend of many of the Impressionists, especially Cézanne. Our thanks to Turgenev, he wrote in *Messager de L'Europe*, a Russian magazine published in St. Petersburg. It was Zola who informed the Russian public of the movement and its progress.

(*Below*) Stéphane Mallarmé and his lover, Méry Laurent (who had also been Manet's lover). In 1876, the London *Art Monthly Review* asked Mallarmé to explain the Impressionists to the English public. He wrote an article entitled "The Impressionists and Edouard Manet." "Since no artist has in his palette a transparent and neutral colour that corresponds to the open air, the desired effect is only obtained through lightness or intensity of touch or by modulating the shade. Now, Manet and his school use colours that are simple, fresh, or applied lightly, and the effect seems as if achieved at the first stroke, so much does omnipresent light fuse and enliven every single thing. As for the details of the painting, nothing should be defined precisely, since one should feel that the splendid light illuminating the painting, or the transparent shadow veiling it, have been caught at the moment of their coming into being precisely when anyone looks at the subject represented, and this, in that it is composed of harmonious reflected or mutable light, cannot always be created identical to itself, but palpitates with movement and the light of life."

(*Above*) August Strindberg photographed in Paul Gauguin's studio. Strindberg was already in Paris in 1876, before he was even thirty years old. He had not seen the Impressionist exhibition, but a painter friend had taken him to the Durand-Ruel Gallery. He wrote in an article published in a Stockholm newspaper, and later in a letter: "We saw some fine canvases mostly by Manet and Monet. But since I had other things to do in Paris ... than look at paintings, I glimpsed them with an air of calm indifference. The day after, however, I went back, without quite knowing why, and I found 'something' in these singular expressions. I saw people crowding a quayside but I didn't see the crowd; I saw a train running across the Normandy landscape, the motion of wheels on roads, the horrible portraits of ugly people who had never known what it was like to pose. Captured by these extraordinary paintings, I sent a review to a newspaper in my own country in which I attempted to translate the sensations which, as I felt, the Impressionists wanted to reproduce, and my article enjoyed certain success as something absolutely incomprehensible."

GALLERIES AND COLLECTORS

After the first exhibition in 1874, the Impressionists organized another seven over the next twelve years (in 1876, 1877, 1879, 1880, 1881, 1882, and the last in 1886). But they did not entirely turn their backs on official exhibition outlets. In a letter to Durand-Ruel in 1879, Sisley wrote: "The time when we can do without the prestige associated with official exhibitions is still a long way off. I have therefore decided to send a number of paintings to the Salon; if I should be accepted—and this time I feel I do have a chance—I could earn a lot of money." They continued to send paintings to the Salon, fully aware that they could not hope to receive official commissions (the format and thematic content of their paintings made this impossible), but they still wanted to make themselves better known to the public at large and be accepted by patrons and collectors. "In this regard," critic Duret wrote to Pissarro, "there is no alternative to auctions at the Hôtel Drouot and the major exhibition at the Palais de l'Industrie. By now you have a consolidated group of admirers and collectors who support you. Your name is known to artists, critics, and the initiated public. But you have to take another step forward and become famous." It was precisely the gallery owners and collectors, by now an integral part of the history of Impressionism, who helped them make this great leap, overturning in this way the rules by which the art market had until then been governed.

It should be said that it was precisely at this time that a new figure appeared who, much later, on the eve of World War I, when the majority of these artists were already dead, contributed to their success: the art merchant who speculated on the value of art. Emile Zola anticipated a portrait in his novel *Opera*: "He was a merchant, who revolutionized the art market. [...] A speculator, a Stock Exchange agent, who didn't give a tin whistle for good painting. He sniffed out success, identifying the artist worth launching, not the artist who might seem to have the genius of a great painter, but the one whose mendacious talent, full of false boldness, would appeal to the middle-class market. He thus turned the market upside down, turning away the old connoisseur of good taste to deal only with the rich, who know nothing of art, buying a painting as if it were stocks and shares, either through vanity or in the hope that its value would increase."

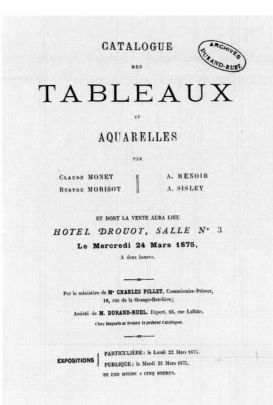

An auction at the Hôtel Drouot (the famous auction rooms in Paris) and the title page for the catalogue of the sale held on March 24, 1875. Following the relative failure of the 1874 exhibition in Nadar's studio, the Impressionists organized a sale of seventy-three paintings at the Hôtel Drouot; the outcome was a disappointment and the public, once again, was hostile and noisy.

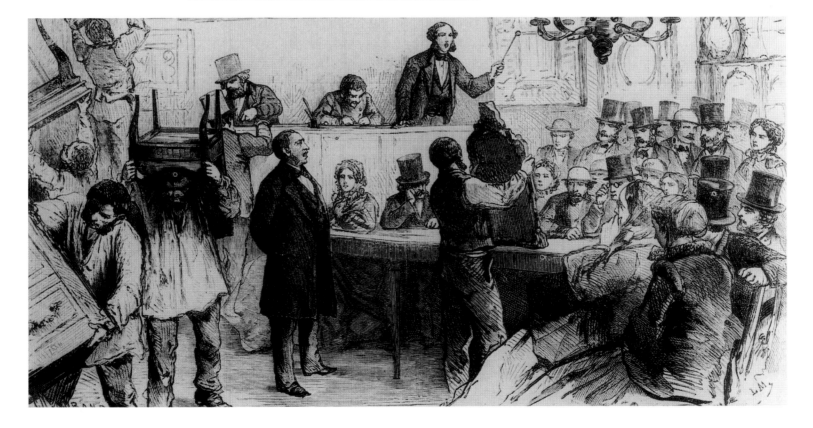

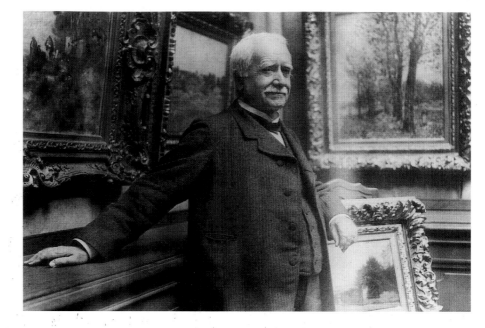

Paul Durand-Ruel in an unsigned photograph dated 1910. The accounts of the Durand-Ruel Gallery for February 15–17, 1873. "During those difficult years, Monet did not limit himself to encouraging his companions and, in particular, my father, but revealed to them the concepts of business organization that were to become, in our own times, the very basis of the existence of painting. I shall try to transcribe the substance of his reasoning as my father explained it to me. We must admit by now that the railways have taken the place of the coach and four, first and foremost because there aren't any coaches anymore. So, then, why do painters try to live by courting patrons since there aren't any patrons anymore? What do we get from our so-called patrons! A commission every now and then for a miserable portrait, which enables us to live for a few weeks, after which we go hungry again. Just as we travel on the railways, sitting on padded cushions and using monumental stations paid for by hundreds of passengers, then we should also sell our canvases to patrons whose sumptuous halls are paid for by hundreds of clients. The times of small-scale individual business and bartering are over; the era of big business is in full swing. And, as merchants look after art lovers, we shall paint, far away from Paris, anywhere, in China or Africa, wherever we find inspiration to stimulate us." (From the biography of Pierre-Auguste Renoir by Jean Renoir.) Paul Durand-Ruel was that merchant: he took over from his gallery-owner father, who had promoted the work of Decamps, Delacroix, Dupré, and Rousseau, and from 1870 was clearly very well disposed even toward the movement started by the young painters. In the same year, he opened a new gallery in rue Laffitte and was the first to exhibit the work of Monet.

(*Right*) The Durand-Ruel Gallery, 16 rue Laffitte, shortly before it was demolished in 1924. Paul Durand-Ruel was undoubtedly the gallery owner who changed the fortunes of the Impressionists, deeply influencing the development of the art market. And even if Monet became gradually emancipated from his patronage, in an interview with Thiebault-Sission in 1900 he admitted: "Durand-Ruel was our saviour. For fifteen years, perhaps more, my paintings and those of Renoir, Sisley, and Pissarro had no other outlet. The day came when Durand-Ruel had to tighten his belt, spread out his acquisitions. We thought this would be our ruin, but it was rather our success. Our work, offered to the various Petit and Boussod, found buyers [...]. That was the start. Today, everyone wants to have something to do with us."

(*Below*) An engraving dated 1879 by E. Bichon, *Exhibition of Watercolours in the Durand-Ruel Gallery.*

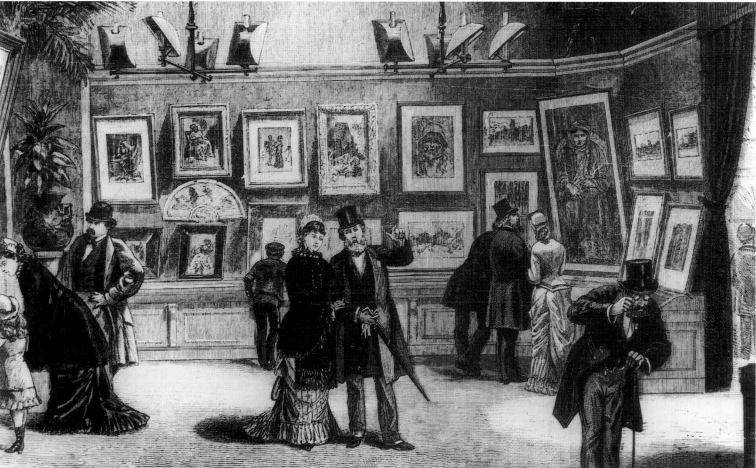

The house of Paul Durand-Ruel at 35 rue de Rome, Paris. (*Above*) the Grand Salon. (*Left*) One of the pairs of doors painted by Monet.

(*Opposite, above left*) The Petit Salon in Durand-Ruel's house. The first painting hanging on the left wall is *Cliffs at Belle-Ile* by Monet. (*Opposite, above right*) A view of Joseph Durand-Ruel's dining room at 37 rue de Rome. The majority of the paintings that can be seen are still-lifes of food. (*Opposite, below*) Another room in Joseph Durand-Ruel's house. The walls are hung with (*left to right*) *Poplars, The Japanese Bridge*, and *The Haystack*, all by Monet.

A Gallery of Impressionist Paintings

Edgar Degas (1834–1917)

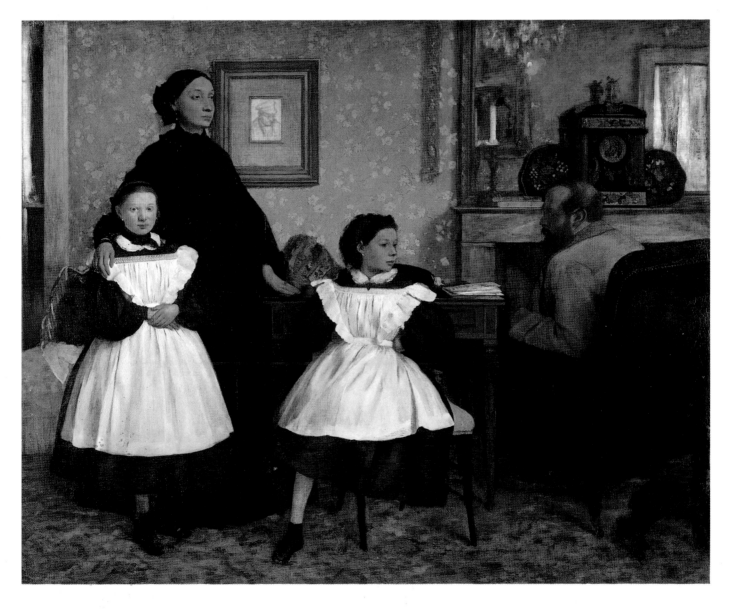

1. Edgar Degas, *The Family Belleli*, 1858–1867. Oil on canvas, 78³⁄₄" x 98⁷⁄₁₆". Musée d'Orsay, Paris.

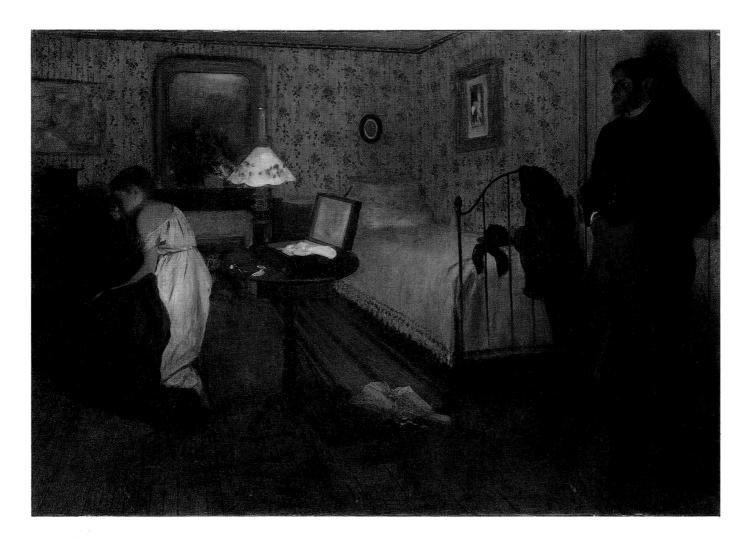

2. Edgar Degas, *Interior*, c. 1868–1869. Oil on canvas, 31⅞" x 45¹¹/₁₆". Philadelphia Museum of Art, The Henry P. McIlhenny Collection in memory of Frances P. McIlhenny.

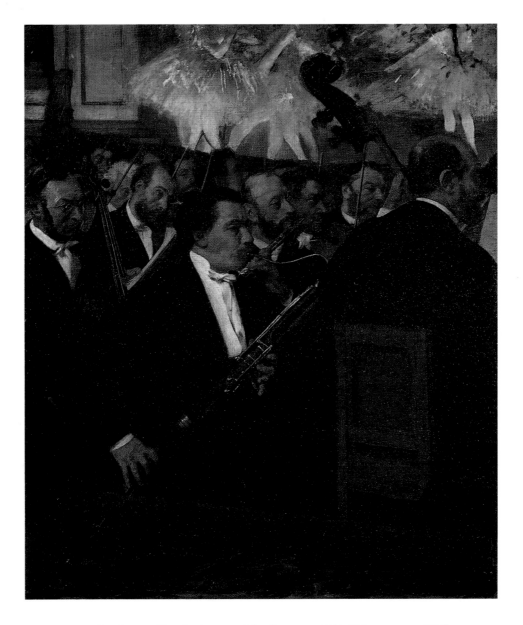

3. Edgar Degas, *The Orchestra of the Opera*, c. 1868. Oil on canvas, 18⅛"
x 22¼". Musée d'Orsay, Paris.

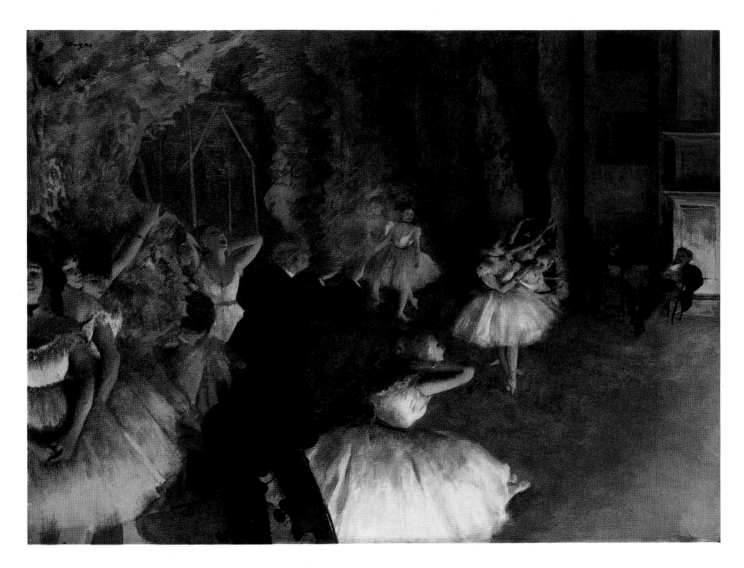

4. Edgar Degas, *Ballet Rehearsal on Stage*, c. 1874. Aquarelle and pastel on paper applied to canvas, 21⁵/₁₆" x 28³/₄". The Metropolitan Museum of Art, New York, H. O. Havemeyer Collection, Bequest of Mrs. H. O. Havemeyer, 1929.

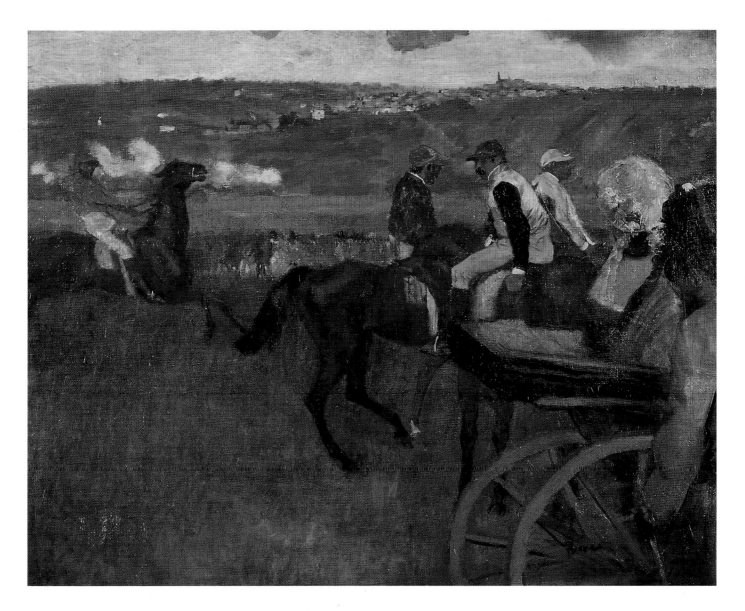

5. Edgar Degas, *The Racetrack, Amateur Jockeys*, 1876–1887. Oil on canvas, 26" x 31⅞".
Musée d'Orsay, Paris.

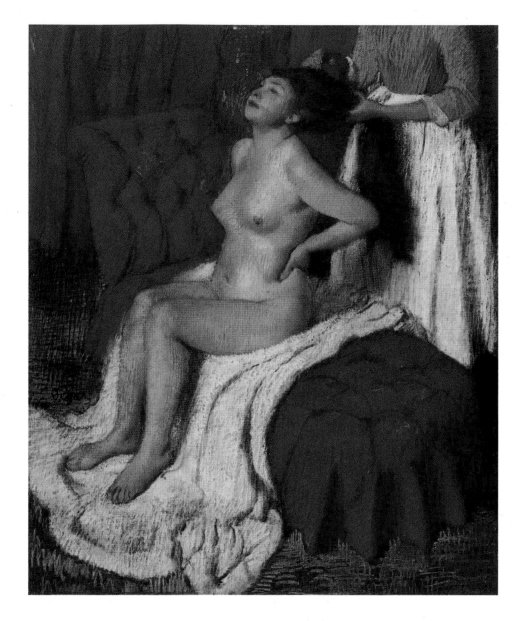

6. Edgar Degas, *Nude Woman Having her Hair Done*, 1886–1888. Pastel on paper, 29⅛" x 23⅞". The Metropolitan Museum of Art, New York, H. O. Havemeyer Collection, Bequest of Mrs. H. O. Havemeyer, 1929.

PIERRE-AUGUSTE RENOIR (1841–1919)

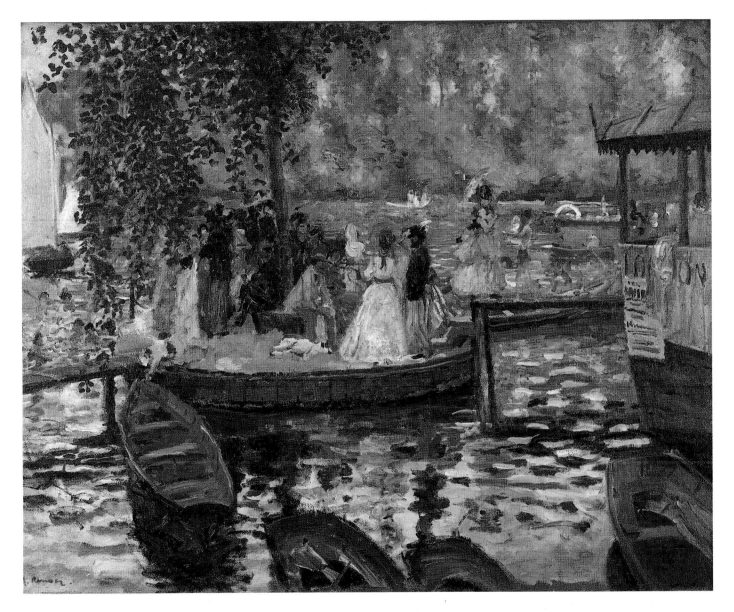

7. Pierre-Auguste Renoir, *La Grenouillère*, 1869. Oil on canvas, 26" x 31⅞". NationalMuseum, Stockholm.

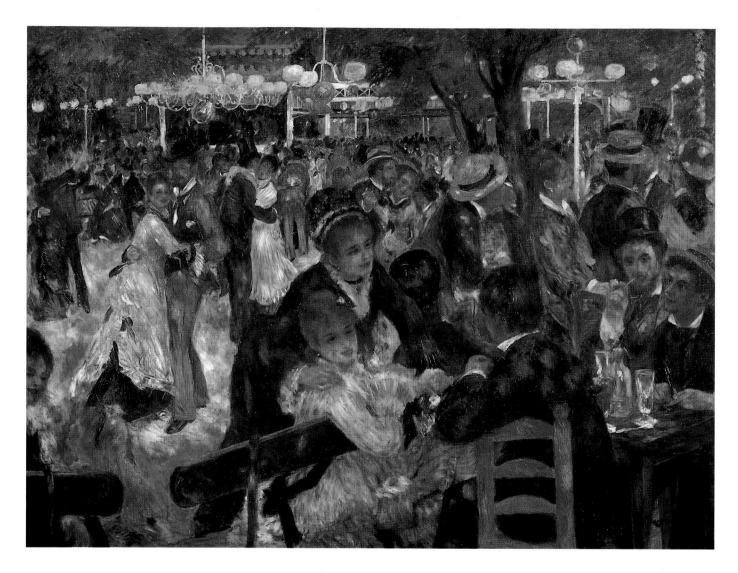

8. Pierre-Auguste Renoir, *Ball at the Moulin de la Galette*, 1876. Oil on canvas, 51⁹/₁₆" x 68⁷/₈".
Musée d'Orsay, Paris.

9. Pierre-Auguste Renoir, *Madame Charpentier and her Children*, 1878. Oil on canvas, 60½"
x 74⅞". The Metropolitan Museum of Art, New York, Catharine Lorillard Wolfe Collection,
1907.

10. Pierre-Auguste Renoir, *Marguerite (Margot) Bérard*, 1879. Oil on canvas, 16¹⁄₈" x 12³⁄₄". The Metropolitan Museum of Art, New York, Bequest of Stephen C. Clark, 1960. (61.101.15) Photograph © 1996 The Metropolitan Museum of Art.

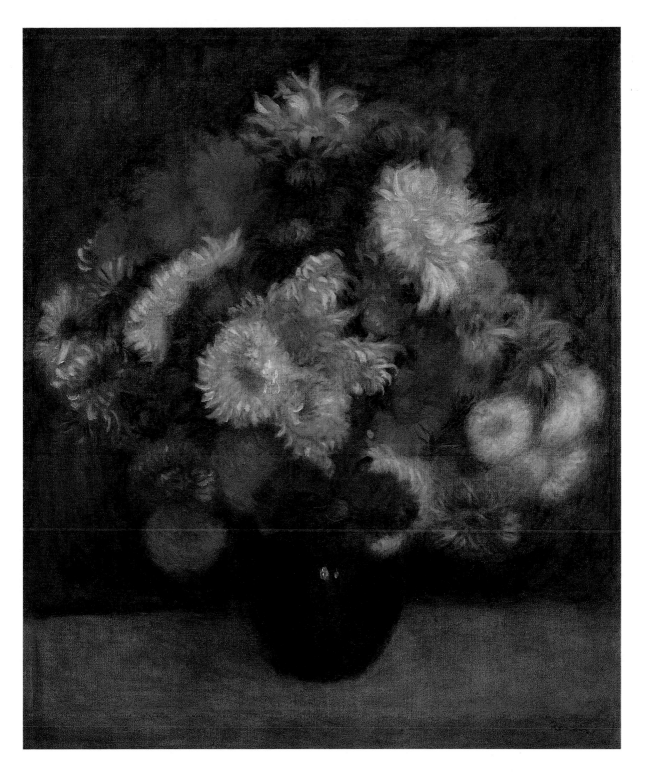

11. Pierre-Auguste Renoir, *Bouquet of Chrysanthemums*, 1881. Oil on canvas, 26" x 21⅞".
The Walter H. and Leonore Annenberg Collection. Photograph © 1994 The Metropolitan
Museum of Art.

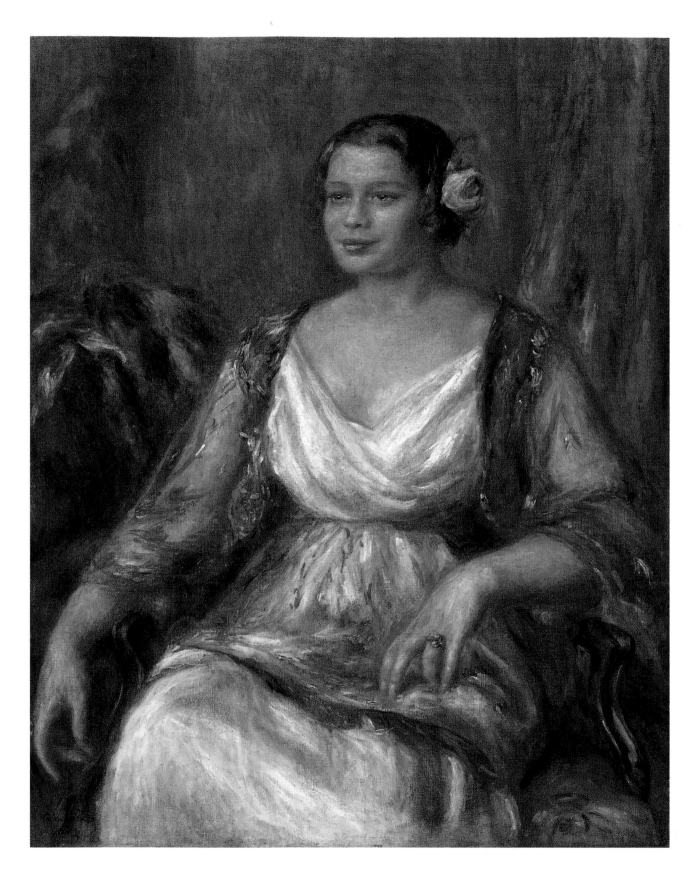

12. Pierre-Auguste Renoir, *Tilla Durieux*, 1914. Oil on canvas, 36¼" x 29". The Metropolitan Museum of Art, New York, Bequest of Stephen C. Clark, 1960. (61.101.13) Photograph © 1980 The Metropolitan Museum of Art. Renoir can be seen painting this portrait in the lower photograph on page 100.

PAUL CÉZANNE (1839–1906)

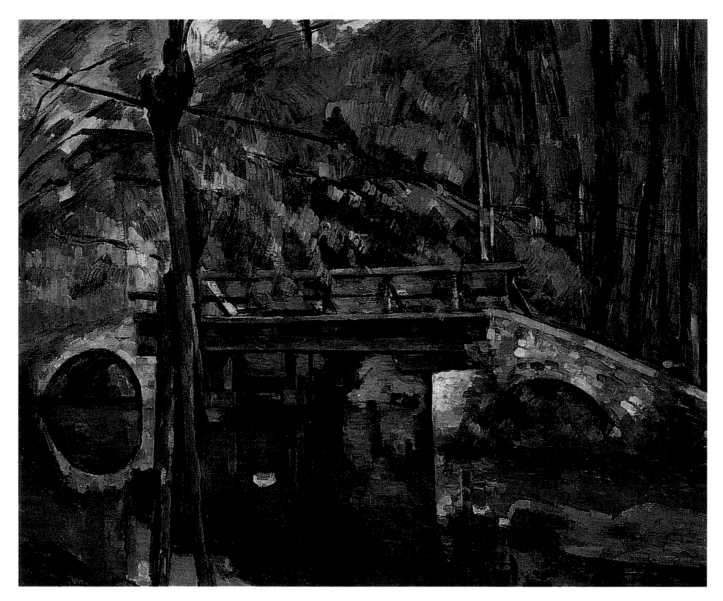

13. Paul Cézanne, *The Bridge at Maincy*, 1879–1880. Oil on canvas, 23" x 28½". Musée d'Orsay, Paris.

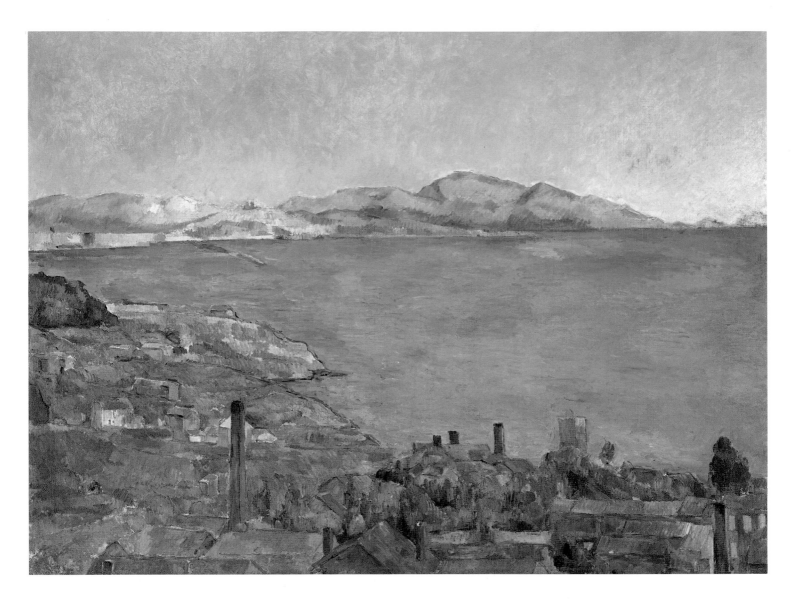

14. Paul Cézanne, *The Gulf of Marseilles Seen from L'Estaque*, c. 1882. Oil on canvas, 28³⁄₄"
x 39¹⁄₂". The Metropolitan Museum of Art, New York, H. O. Havemeyer Collection, Bequest of
Mrs. H. O. Havemeyer, 1929. (29.100.67) Photograph © 1991 The Metropolitan Museum of
Art.

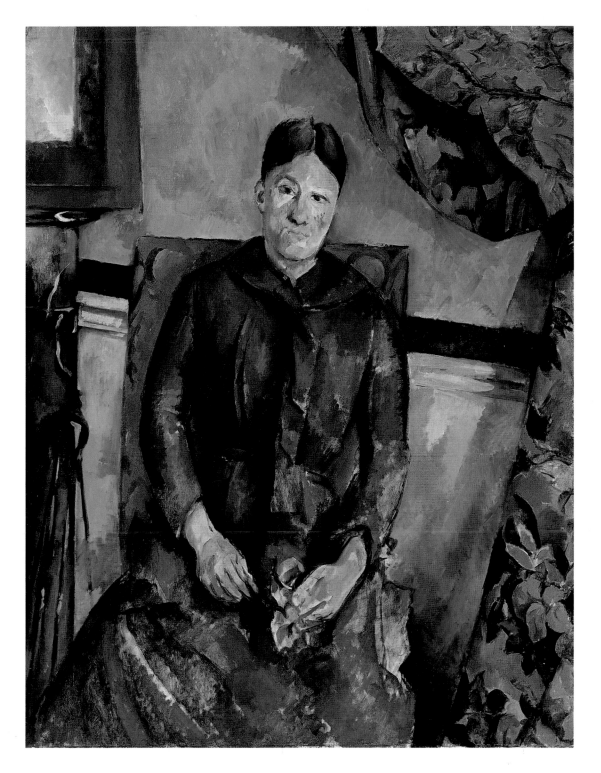

15. Paul Cézanne, *Madame Cézanne in a Red Dress*, c. 1890. Oil on canvas, 45⅞" x 35¼".
The Metropolitan Museum of Art, New York, The Mr. and Mrs. Henry Ittleson Jr. Purchase
Fund, 1962. (62.45) Photograph by Malcolm Varon. Photograph © 1984 The Metropolitan
Museum of Art.

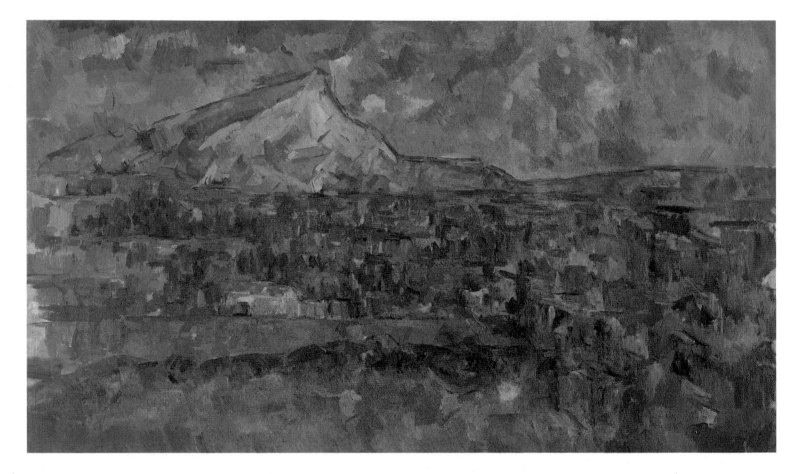

16. Paul Cézanne, *Mont Sainte-Victoire*, 1902–1906. Oil on canvas, 22¼" x 38⅛". The Metropolitan Museum of Art, New York, The Walter H. and Leonore Annenberg Collection, Partial Gift of Walter H. and Leonore Annenberg, 1994. (1994.420) Photograph © 1994 The Metropolitan Museum of Art.

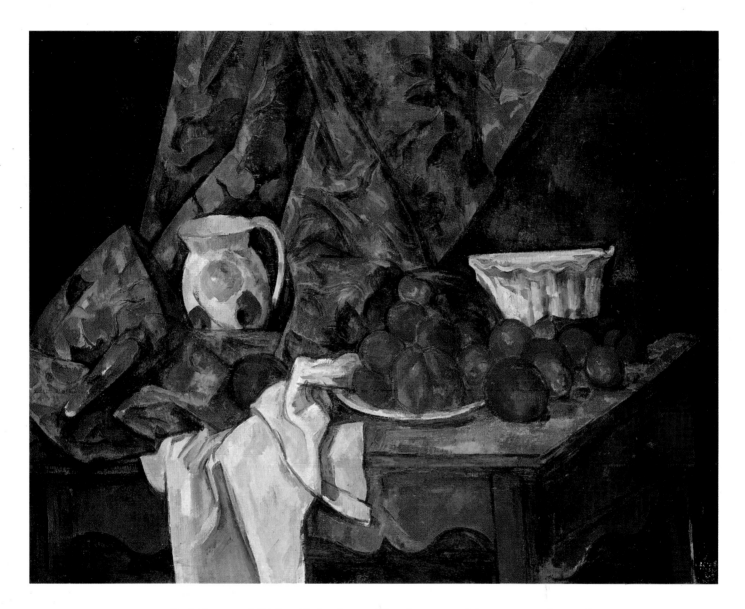

17. Paul Cézanne, *Still Life with Apples and Peaches*, 1905. Oil on canvas, 32" x 39⅝".
National Gallery of Art, Washington, D.C., Gift of Eugene and Agnes Meyer.

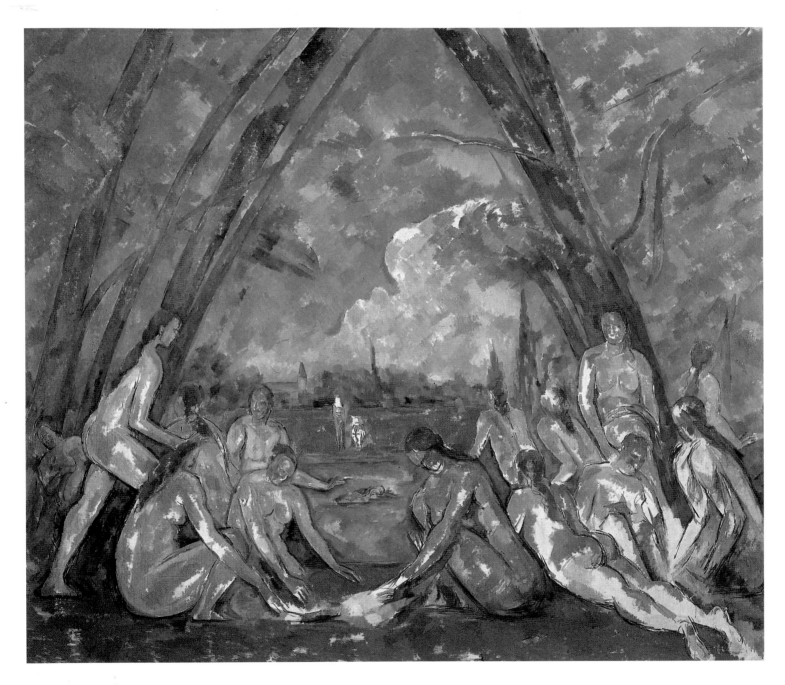

18. Paul Cézanne, *The Large Bathers (Les Grandes Baigneuses)*, 1906. Oil on canvas, 82" x 99". Philadelphia Museum of Art, W. P. Wilstach Collection. (W'37-1-1)

CLAUDE MONET (1840–1926)

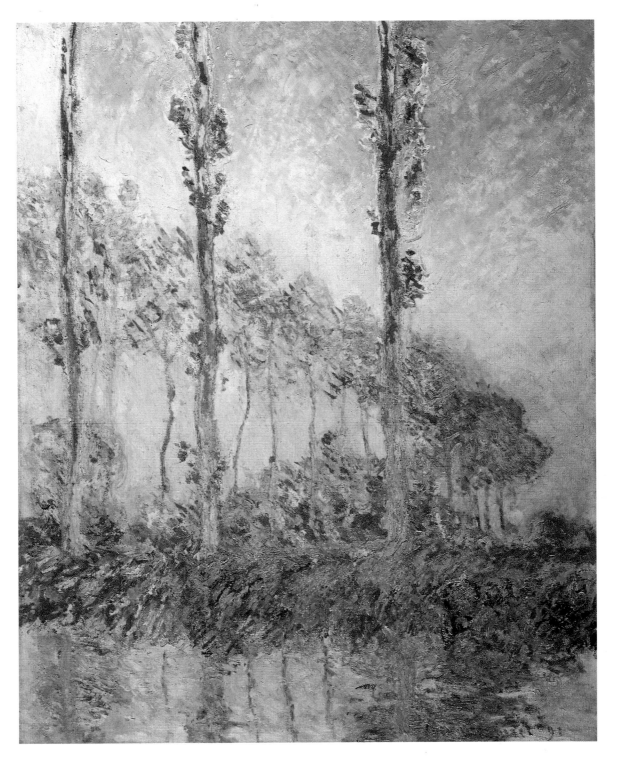

19. Claude Monet, *Poplars (Autumn)*, 1891. Oil on canvas, 36⅝" x 29³/₁₆". Philadelphia Museum of Art, Given by Chester Dale. ('51-109-1)

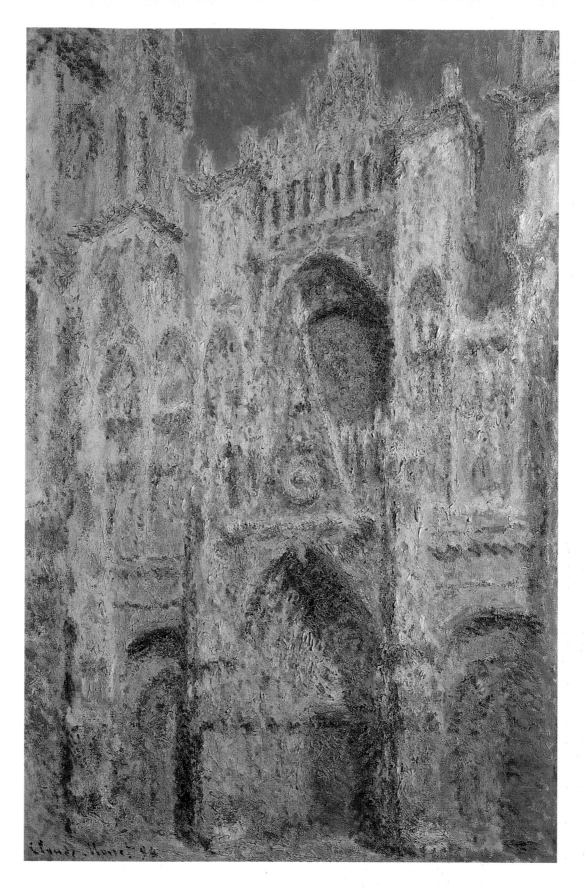

20. Claude Monet, *Rouen Cathedral: The Portal (in Sun)*, 1894. Oil on canvas, 39¼" x 25⅞".
The Metropolitan Museum of Art, New York, Theodore M. Davis Collection, Bequest of Theodore
M. Davis, 1915. (30.95.250) Photograph © 1996 The Metropolitan Museum of Art.

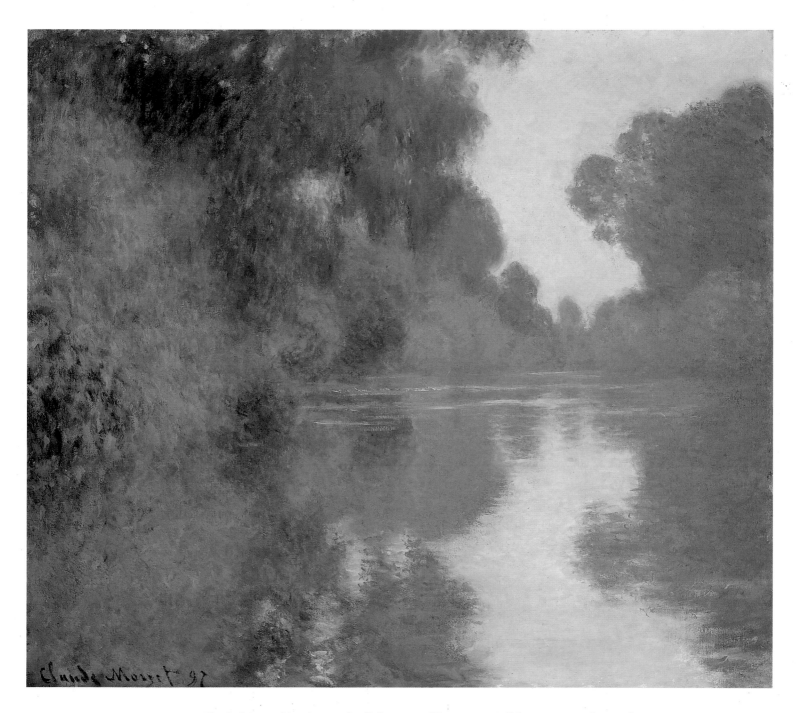

21. Claude Monet, *Morning on the Seine, near Giverny*, 1897. Oil on canvas, 32" x 36½".
Museum of Fine Arts, Boston; Gift of Mrs. W. Scott Fitz.

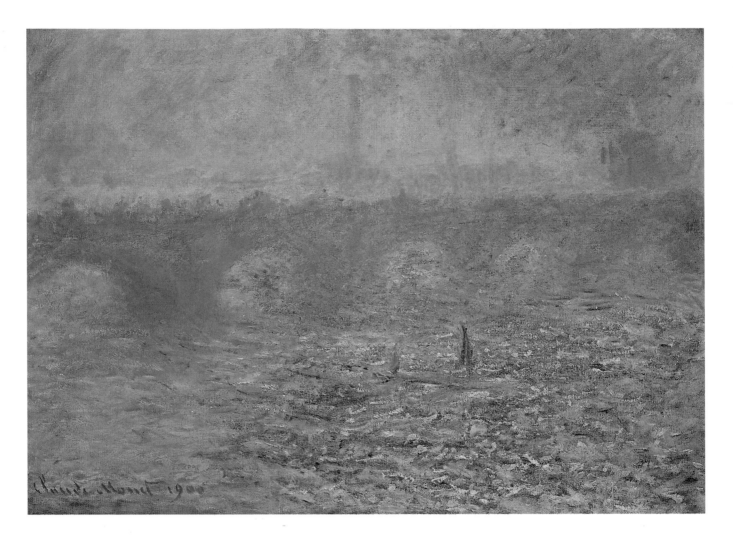

22. Claude Monet, *Waterloo Bridge*, 1900. Oil on canvas, 25³/₄" x 36¹/₂". Santa Barbara Museum of Art; Bequest of Katherine Dexter McCormick in memory of her husband, Stanley McCormick.

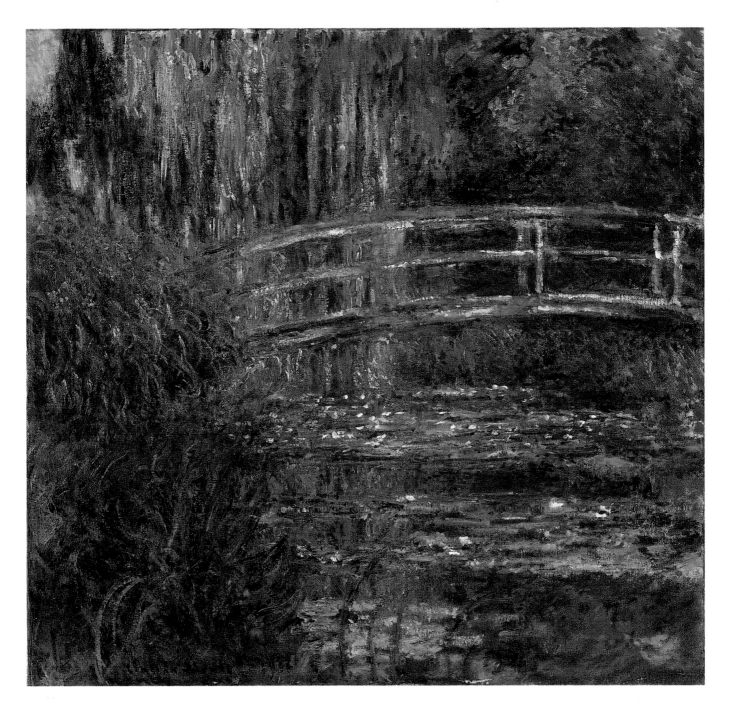

23. Claude Monet, *The Water Lily Pond (Japanese Bridge)*, 1900. Oil on canvas, 35⅛" x 36½". Museum of Fine Arts, Boston; Given in memory of Governor Alvan T. Fuller by the Fuller Foundation.

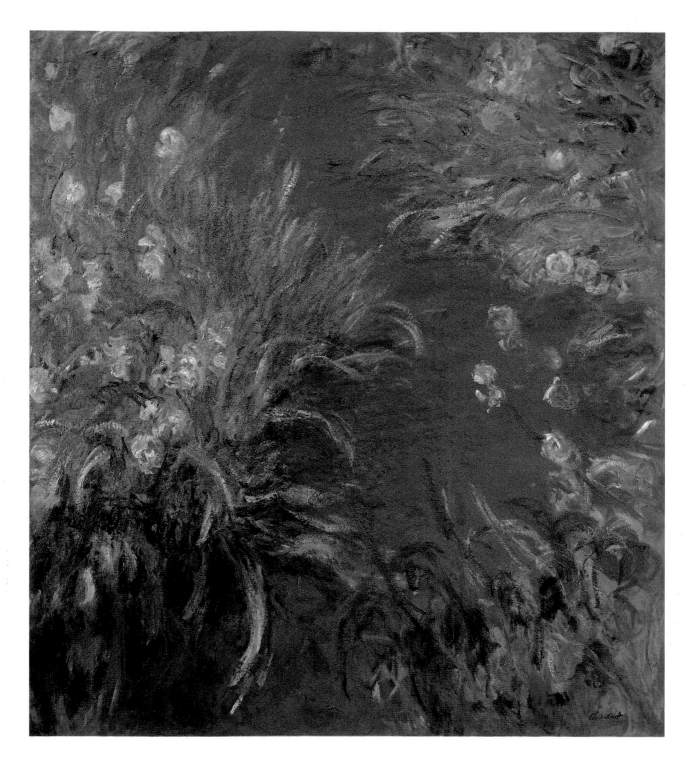

24. Claude Monet, *The Path Through the Irises*, 1914–1917. Oil on canvas, 78⅞" x 70⅞". The Walter H. and Leonore Annenberg Collection. Photograph © 1994 The Metropolitan Museum of Art.

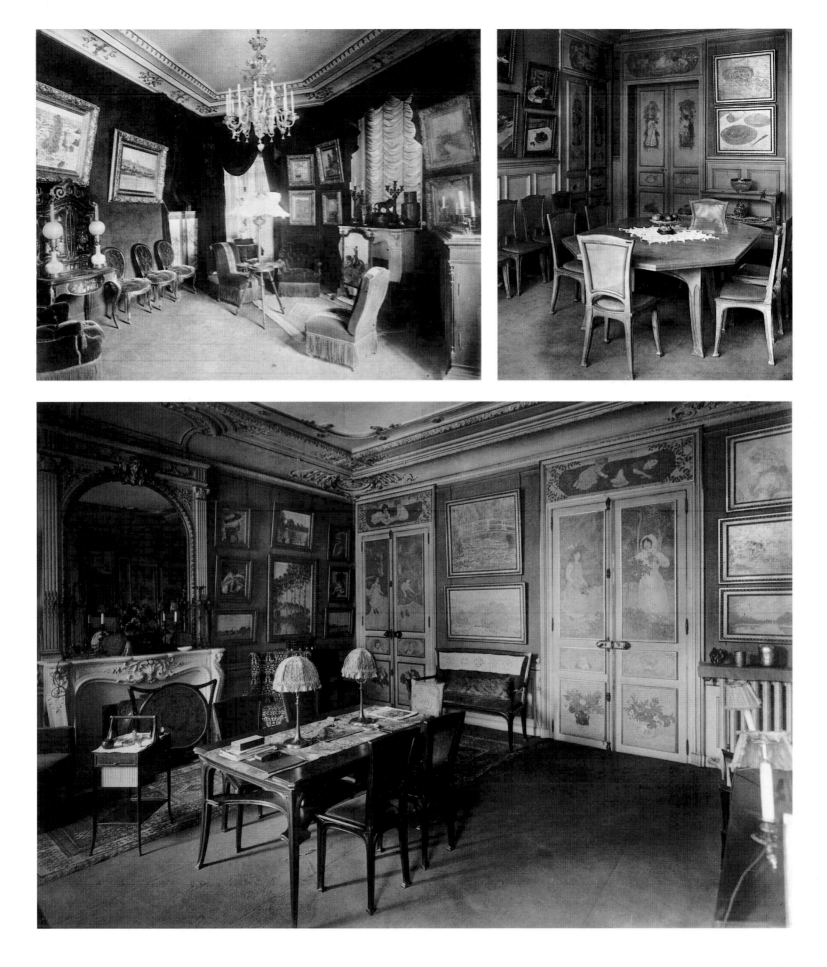

Charles Le Coeur, his wife, and son Joseph in a photograph of the 1870s. (*Below*) Inside Charles Le Coeur's house at the beginning of the century. Several paintings by Renoir are recognizable: in the background, hanging over the couch, *Bunch of Spring Flowers*, in the middle of the second row the portrait of Madame Darras, and at the right, above the bookcase, a portrait of Joseph Le Coeur. Charles Le Coeur was one of the very first collectors of Renoir in the period before he became famous. Charles Le Coeur and Renoir met in 1865, and their friendship lasted until 1874. Renoir made two portraits of Le Coeur.

(*Above*) A photograph of Georges de Bellio. (*Right*)
The apartment of Georges de Bellio. Born in Bucharest
in 1828, De Bellio moved to Paris in 1850, having
taken a degree in medicine. Despite not having to work
for a living, he treated Manet, Pissarro, Monet, Sisley,
and Renoir with homeopathic remedies free of charge.
De Bellio was an art enthusiast; he drew up a ledger
beginning with the engravings that he saw in maga-
zines such as *L'Art pour tous* and *L'Illustration*. In
1864, he bought his first painting, a copy of Rubens that
had belonged to Delacroix. In 1874, he purchased a
painting by Monet, *The Seine at Argenteuil*, during
the first exhibition of the Impressionists; and later, in
1878, *Impression: Soleil Levant (Sunrise)* for just
210 francs, as well as paintings by Renoir, Sisley,
Pissarro, Berthe Morisot, Degas and, later, Cézanne and
Gauguin. He died in Paris in 1894. His daughter,
Madame Dunop de Monchy, donated some of his 150
paintings to the Musée Marmottan to avoid having to
hold a public auction that would have caused the artists
great problems.

(*Above*) Georges and Marguerite Charpentier in two photographs dated 1875. (*Right*) Marguerite Charpentier and some of the paintings in their collection in a photograph taken in 1895. Georges Charpentier was born in 1846. In 1838, his father Gervais, a publisher invented the Bibliothèque Charpentier, a series of books costing 3.5 francs (a quarter of the standard price for books in those days), thereby creating popular publishing. When Georges took over the publishing house, he asked Zola to become literary director. Subsequently, he published Flaubert, Daudet, the Goncourt brothers and others.

The Charpentiers held open-house on Fridays, inviting politicians, authors, artists, and actors to meet the Impressionists and see the paintings hung in their home. They began their collection in 1875, purchasing three Renoirs, followed immediately by paintings by Monet, Manet, and Sisley. Charpentier launched a new magazine, *Le Vie Moderne*, in 1879 and also opened a gallery. Thanks to the articles published in the magazine, the Impressionists were able to reach a more refined public than that of the Salon, and one-man shows (an innovation for the period) were organized in the gallery: Renoir (the couple's favourite artist) in 1879, Manet and Monet in 1880, Sisley in 1881. After financial troubles and the death of his twenty-year-old son, Charpentier sold his publishing house to Fasquelle. Marguerite Charpentier died in 1904, followed a year later by her husband.

(*Below*) The atelier of Henri Rouart in Paris at 34 rue de Lisbonne. *Amazon at Bois de Boulogne* by Renoir (the huge composition refused by the Salon in 1873) can be seen at the top, and (top left) *Seaside: Governess Combing a Girl's Hair* by Degas.

(*Right, above*) Henri Rouart as an old man. (*Right, below*) Alexis Rouart, the younger brother.

Henri Rouart (1833–1912) was not only a great friend of Degas and one of the most important collectors of the Impressionists from 1874 but, like Gustave Caillebotte, took part as a painter in all the Impressionist exhibitions between 1876 and 1886. And like Caillebotte, he helped the artists financially in the difficult early years. When he died in 1912, his collection of 900 drawings and paintings was sold.

Alexis (1839–1911) was less important than his brother. He was mainly interested in

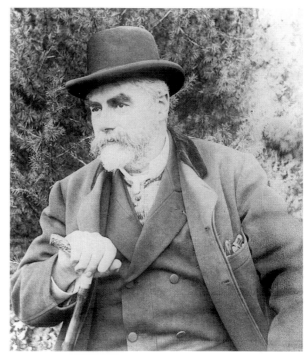

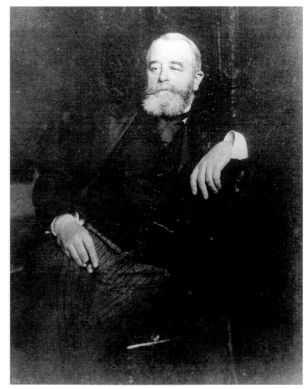

prints and engravings, to the extent that he even bought shares in the Manzi-Joyant company that later printed the lithographs of Toulouse-Lautrec.

Ernest May in his apartment in Faubourg Saint-Honoré in the last years of his life. (*Opposite*) Ernest May's bedroom around 1920. The walls are hung with several studies for *The Cradle* by Degas that portray Mrs. May and her son. Born in Strasbourg in 1845, May was a close friend of Degas but was equally interested in other artists. Like De Bellio and Caillebotte, Ernest May was another figure the artists turned to in times of difficulty. Before he began to purchase Impressionist paintings, May—like many other collectors—was fond of Corot and Millet. He died in 1925.

Success in America

The introduction of the Impressionists in the United States marked the true success of the group and coincided with their last exhibition in 1886. Many people were involved in this breakthrough. First and foremost, there were the three American painters who knew the Impressionists well, became their friends, and were more or less influenced by their work: James Abbott MacNeill Whistler, Mary Cassatt, and John Singer Sargent. Next came the French gallery owners who organized exhibitions in the United States: Paul Durand-Ruel was the forerunner, joined by Georges Petit, whose international exhibitions in Paris were extremely tempting for American collectors, and Ambroise Vollard, the man who first organized a one-man show by Cézanne in 1895 and later discovered Picasso. They were followed by the American painters (including Winslow Homer) who knew the works of the Impressionists, and the collectors, who bought their paintings for massive sums of money and donated them on their deaths to major American museums. Last, came the art critics: in 1894, Hamlin Garland defended Impressionism in his book *Crumbling Idols*. He explained that the technique had radically changed the concept of vision and taught everyone to see colour everywhere.

Their success was so impressive that they even appeared in a famous crime story by S.S. Van Dine, *The Strange Death of Mr. Benson*, written in the 1920s. "This Vollard," remarks Philo Vance, the hero of the story, "has been rather liberal in our country suffering from art phobia. The Cézanne collection he has sent over is truly wonderful. Yesterday, I observed the watercolours with reverence and, I might add, a certain nonchalance, since Kressler was keeping an eye on me; I marked those I intended to buy as soon as the gallery opens this morning. [...] These delicate scrawls, with all this white paper background, probably seem quite pointless to you. [...] And you may even think that some of them are hung the wrong way round ... one is, actually, but even Kressler didn't realize. These are undoubtedly things of some worth, and reasonably priced if you think what they will cost in a few years time." The exhibition Philo Vance alludes to was held in Alfred Stieglitz's Photo-Secession Gallery in 1911.

NATIONAL
ACADEMY OF DESIGN.

SPECIAL EXHIBITION.

Works in Oil and Pastel
BY
THE IMPRESSIONISTS
OF PARIS.
MDCCCLXXXVI.

EXHIBITION UNDER THE MANAGEMENT OF
THE AMERICAN ART ASSOCIATION
OF THE CITY OF NEW YORK.

(*Right*) The title page to the catalogue of the first Impressionist Exhibition in New York in 1886. (*Below*) The Durand-Ruel Gallery, 315 Fifth Avenue, New York. The American Art Association, New York, inaugurated the first exhibition of the Impressionists, organized by Paul Durand-Ruel, on April 10, 1886. It comprised 300 paintings: twenty-three by Degas, thirty-eight by Renoir, forty-eight by Monet, forty-two by Pissarro, and fifteen by Sisley. Following the success of the exhibition, it was extended in the halls of the National Academy of Design. Critics were decidedly favourable. American museums did not buy any paintings, but some collectors paid up to $18,000, thus convincing Durand-Ruel that America was his salvation, and he opened a gallery in New York two years later.

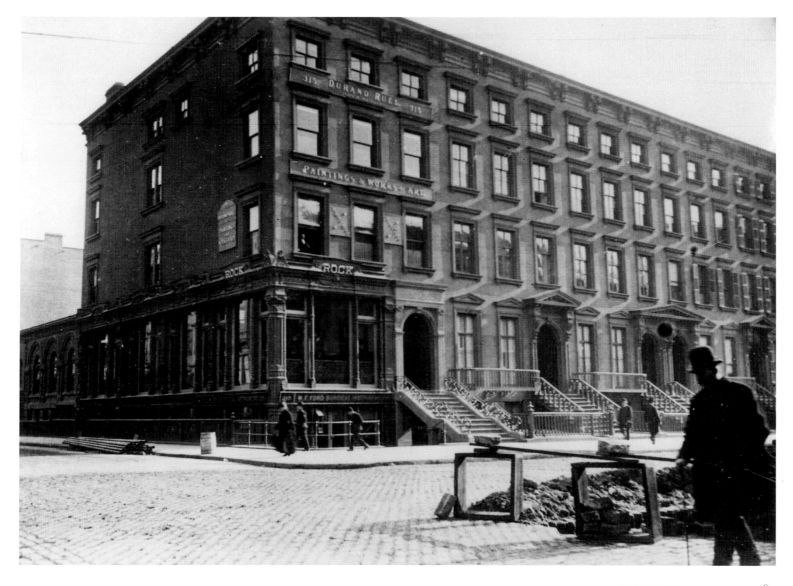

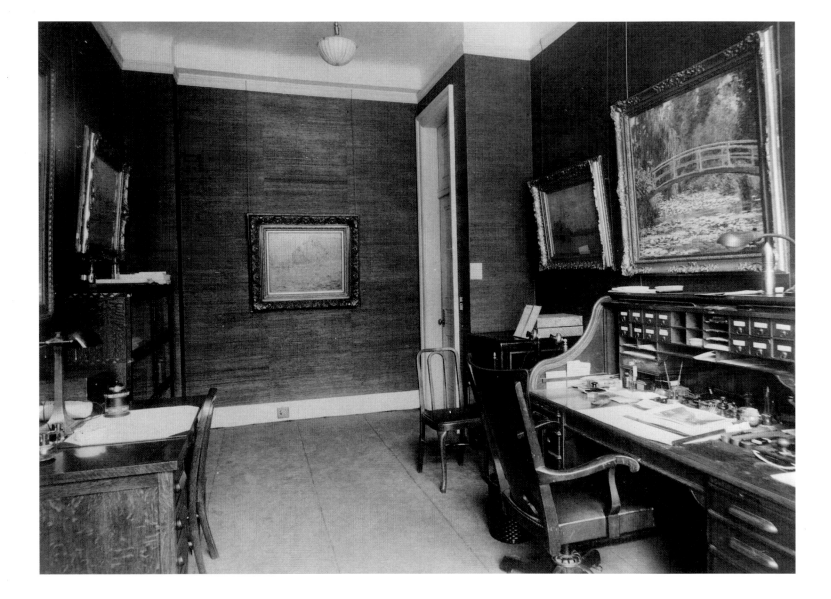

(*Opposite*) An office in Durand-Ruel's gallery in New York. *Japanese Bridge* by Monet hangs over the desk. (*Below*) Inside the Durand-Ruel gallery, New York. One of the key figures in the history of the Impressionists in the United States was art merchant Ambroise Vollard. He appeared late on the art scene when, aged 25, he opened his own gallery in 1890. But just six years later, he was the sole dealer of the work of Cézanne and Gauguin. It was to him that most American collectors went when they wanted to buy the canvases of the Impressionists.

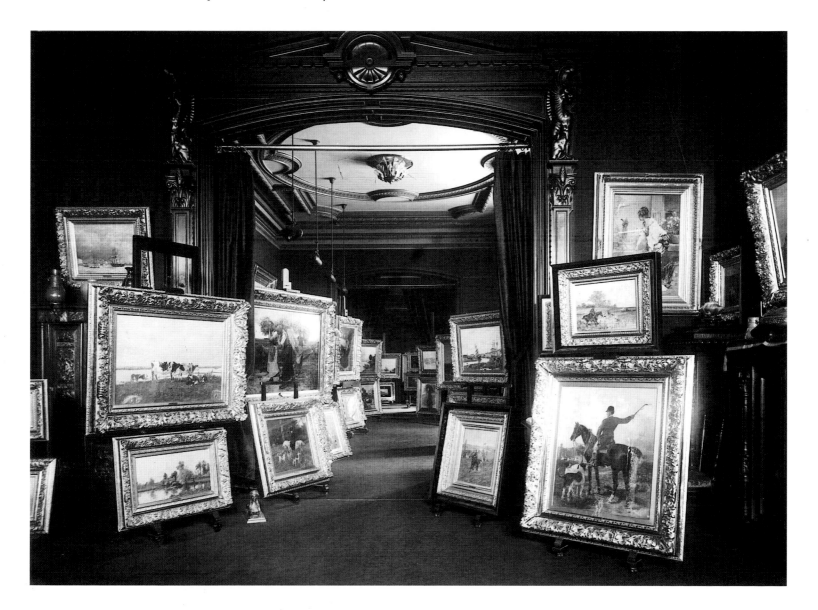

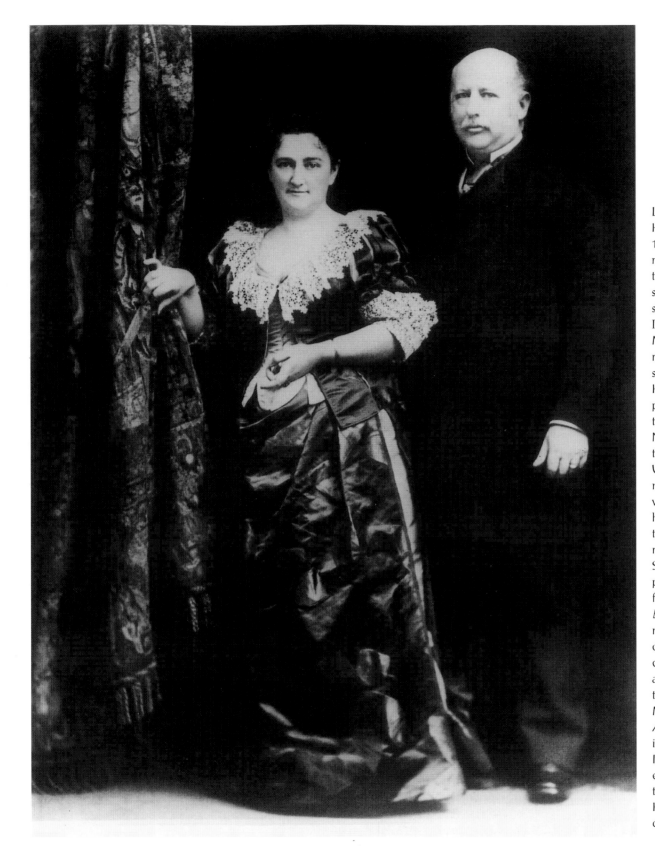

Louisine and Harry Havemeyer in Paris in 1889. Louisine Waldron met Mary Cassatt during a trip to Paris in 1874, when she was nineteen. In 1875, she bought a pastel by Degas and a painting by Monet. In 1883, she married Harry Havemeyer, a sugar magnate. In 1886, the Havemeyers loaned these paintings for the first exhibition of the Impressionists in New York. In 1889, they travelled to Paris for the Universal Exposition and met Paul Durand-Ruel, who became their agent. To house their growing collection, they decided to build a residence at 1 East 66th Street. In 1912, Louisine paid half a million dollars for *Ballet Dancers at the Bar* by Degas, setting a record for a living artist. She died in 1929. Her children carried out her last wishes and donated a large part of the collection to The Metropolitan Museum of Art in New York, including fifty paintings by the Impressionists. From the end of the last century, the enthusiasm of the Havemeyers spread to other American collectors.

Alice B. Toklas and Gertrude Stein in rue de Fleurus, Paris, in 1922. The photograph was taken by Man Ray. Above Gertrude Stein is the portrait of Madame Cézanne by Paul Cézanne. A list of the Cézanne paintings in the Stein family collection has never been drawn up; it is known for certain that they owned seven watercolours and at least seven paintings, many of which were purchased in 1905. Their house was open to Americans passing through Paris, not to mention figures such as Roger Fry, Clive Bell, and the great Russian collectors of contemporary art, Sergei Schukin and Ivan Morosov. Although there is no proof, it seems that

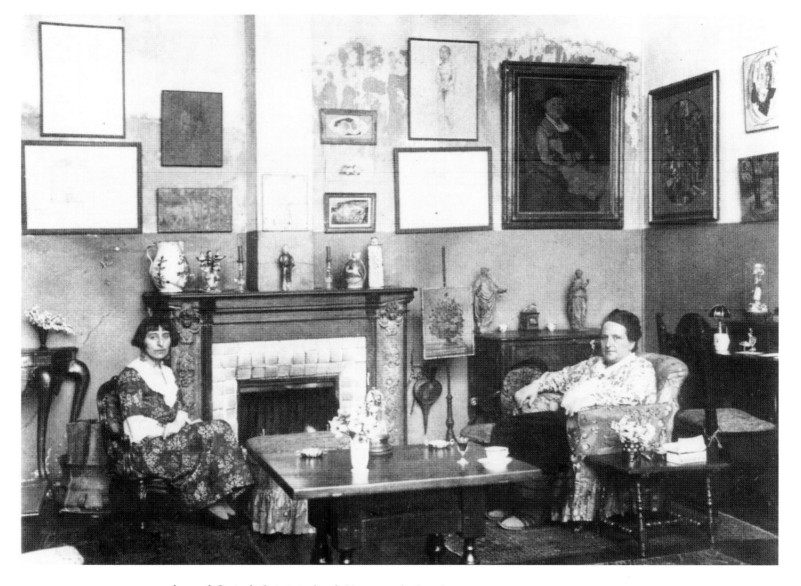

Leo and Gertrude Stein introduced Cézanne to the famed collector Albert Barnes. In addition to Cézanne, the Steins also acquired works by Renoir, Gauguin, Maurice Denis, Matisse, and Picasso. It is has been said that the famous portrait of Gertrude Stein painted by Picasso in 1906 shows the influence of Cézanne's portrait of his wife.

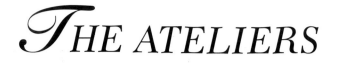

THE ATELIERS

The atelier of the Impressionist painters was above all nature, as they themselves stated over and over again. However, this does not mean that they did not have one or more studios in the places most dear to them—Giverny for Monet, Aix for Cézanne, Cagnes for Renoir, Eragny for Pissarro—where they could escape on rainy days, add the finishing touches to paintings made en plein air, create portraits or still lifes, or simply display their work to visitors or buyers. Unlike the studios of the academics that were stuffed with Gothic or Oriental knick-knacks in keeping with the fashion of the times, the studios of the Impressionists were severe and monkish—few pieces of furniture other than those needed to work, large windows to let in plenty of light, many paintings and sketches hung on the walls. The Impressionists were rarely photographed, whereas the academics—just see the next chapter—were only too happy to pose for the various "photo-reporters" of the period. Only those who had long lives, such as Monet and Renoir, who were successful in their own lifetimes, were immortalized in their studios and even filmed; there is even a documentary by Sacha Guitry, *Ceux de chez nous*, filmed in 1914–1915, in which the famous director interviews a number of the leading artists of the time, including Monet and Renoir. Curiously, no photographs are known of the studios of Degas. Yet he was the first to establish an international reputation, as well as being a photographer himself; the few photos taken in his studio are of people and give no idea of the setting.

In describing a painter's studio, mention must also be made of the paint and canvas merchants. These apparently secondary figures were nevertheless part and parcel of the history of Impressionism in that they, willingly or otherwise, were the first collectors of these paintings, for it was often the case that artists, strapped for cash, paid for their wares in kind. Mention need only be made of Père Tanguy who, around 1860, began travelling to supply his clients where they were working, initially at Barbizon, then at Honfleur, Louveciennes, and Argenteuil. He met Pissarro, Rouart (who won clemency for him after the Paris Commune), and especially Cézanne—he owned a small collection of Cézannes—and Van Gogh, who painted his portrait in 1877 and was always supplied with paints free of charge.

Monet in his first studio at Giverny. "After lunch, when he did not entertain his guests in the garden, he went to the large room he called his 'atelier.' It was the room (one of three) where he never worked; instead, it was a gallery containing the paintings he never wanted to sell, or he had bought back. It often happened that he purchased a canvas he needed, either to preserve a memory or, at any price, for the satisfaction of lacerating it; something that occurred on many occasions. Out of dignity. Respect for himself. Pride. In this large, well-lit room there were photographs and snapshots of his friends among the furniture and objects he loved, but the walls were hung only with his own paintings. Of all periods. [...] It was in this room, at dusk or in the evening, that he read. Often out loud. On the other hand, his bedroom was full of works by people he admired the most among his contemporaries.

He lived joyfully with these paintings. The visitors who were allowed into this room saw him immobile in front of a Delacroix or a Cézanne, silent as he indicated the painting with a gesture of his hand or a nod of the head, or else they saw him smiling in front of a Renoir" (Thadée Natanson, *Peints à leur tour*).

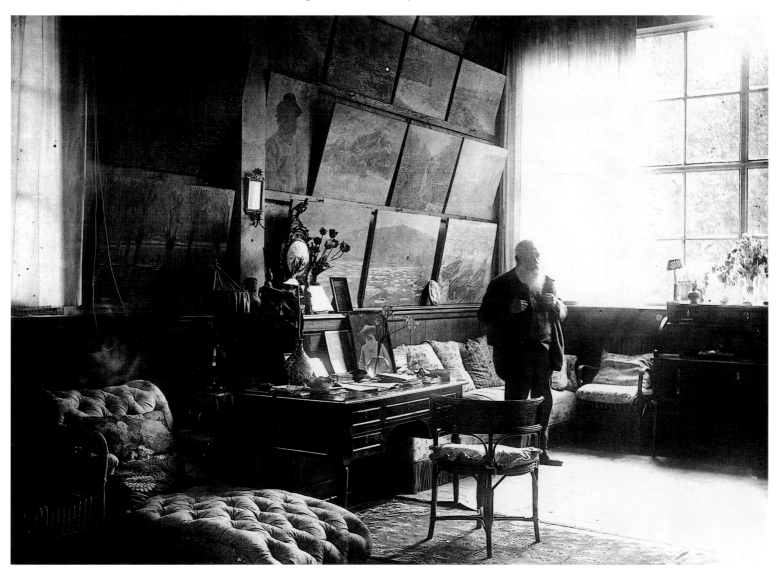

Monet in his second studio at Giverny. The second photograph was taken in 1900. Here, he devoted himself in the 1890s to paintings depicting the water lilies in the pond in his garden. "He observed nature, where there still sleeps the treasure of genius which the breath of man has never awakened; he lived in nature, bewitched by the inexhaustible magic of its brightly coloured forms, its unheard music, and allowed the vision to run, to wander on the flimsy, magical dream of light enveloping all living things and bringing back to life all the dead things of the enchanting life of colours. He wanted no other teacher" (Octave Mirbeau, *Des artistes*).

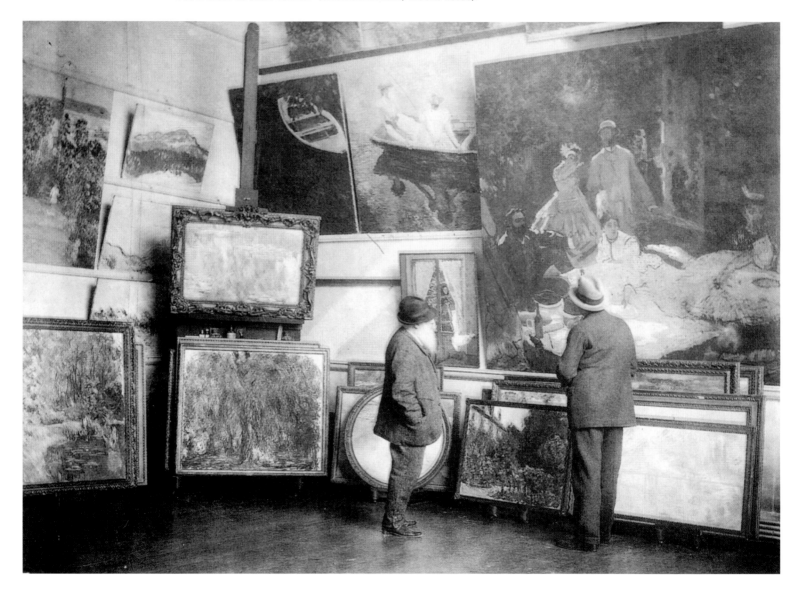

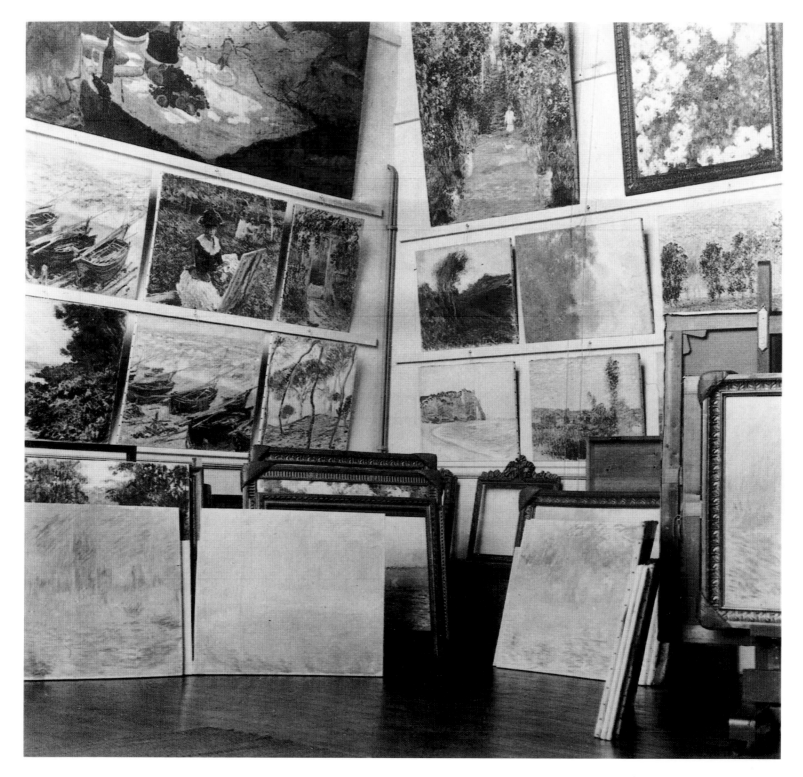

Monet in his third studio at Giverny. The photographs were taken by Durand-Ruel in November 1917. The artist used this studio exclusively to paint the panels destined for the *Grandes décorations de nymphéas,* exhibited for the first time in 1926 at the Orangerie des Tuileries. The studio was lit from above. He painted eight panels here.

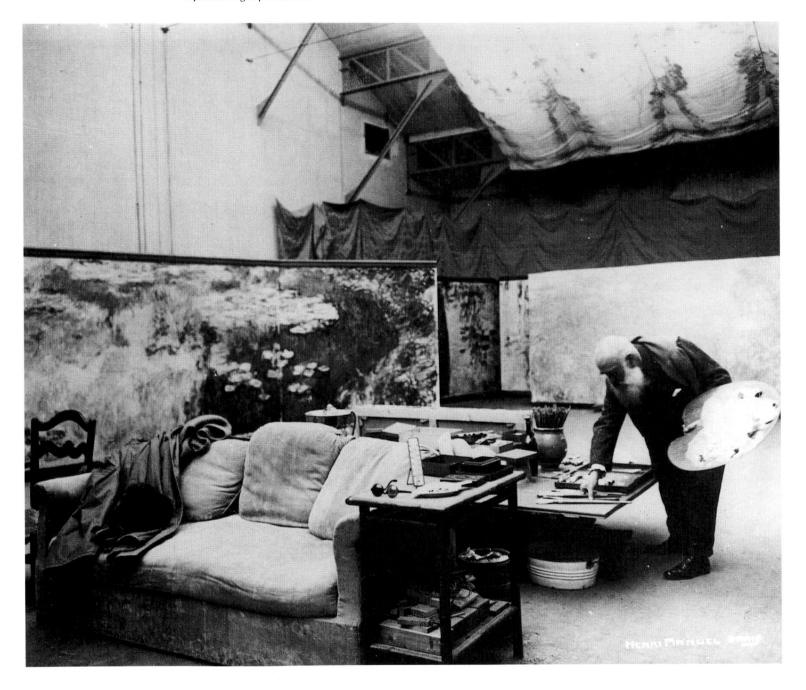

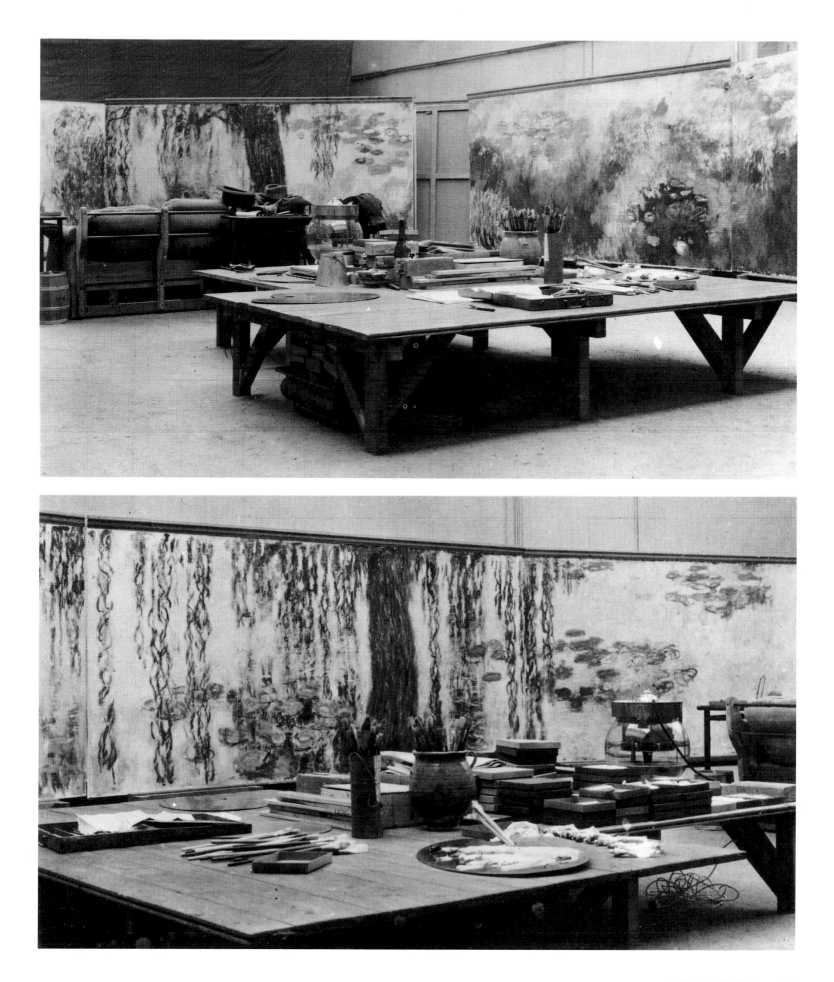

(*Right*) Two photographs of Renoir painting the portrait of actress Tilla Durieux in 1914 (see color plate 12). "I firmly believe that a painter would benefit if he were to make up his own paints or if the task was done by an apprentice. But since, today, there are no more apprentices, and I enjoy painting more than mixing powders, I buy them from my old friend Mullard, from his shop at the end of rue Pigalle, who prepares them on my behalf. [...] And I even use paints in tubes. These tubes of paint are easy to carry around; they even made it possible for me to paint from life in as complete a way as possible. Without tubes of paint, no Cézanne, no Monet, no Sisley, no Pissarro and none of anything the journalists called Impressionism."

"Over the last few years, he rarely used canvas already stretched on drums. One of the few advantages of the success that he enjoyed was being able to paint what he liked and in the format that best suited his imagination. He purchased canvas in huge rolls, usually a metre wide, and cut off a piece with tailor's scissors and fixed it to a backing board with drawing pins. He also had larger rolls for the 'big things.'" (From the biography of Renoir written by his son.)

(*Opposite*) One of Renoir's favourite models in his studio around 1912. Gabrielle Renard was a country girl, a cousin of Renoir's wife. She arrived in Paris in 1894 to help out in the house. She remained until Renoir's death.

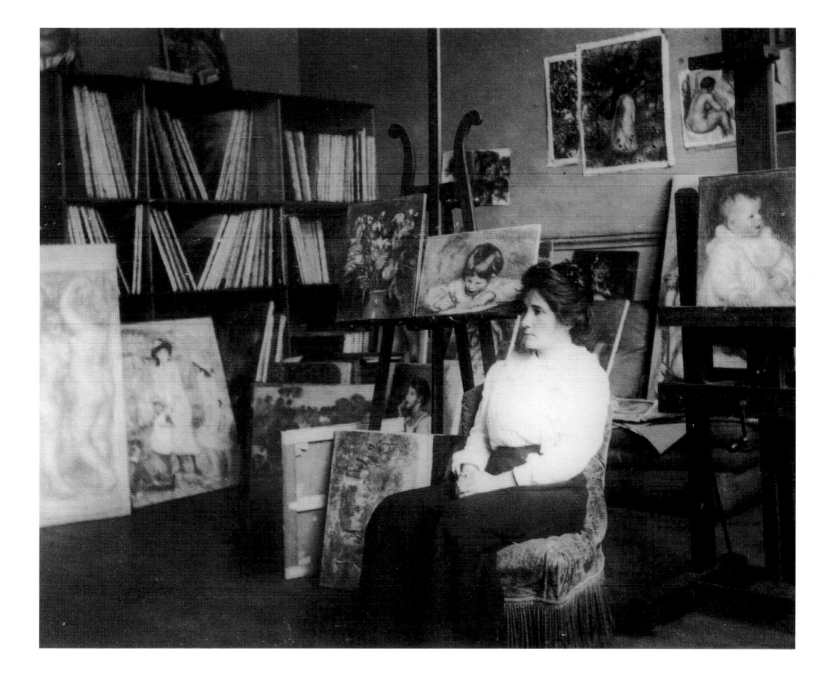

Two views of Cézanne's studio in Aix-en-Provence. The photographs were taken after the artist's death in 1906. "I paint still lifes. Models frighten me. These loose women are there waiting for a weak moment. You always have to be on the defensive and the subject escapes you!"

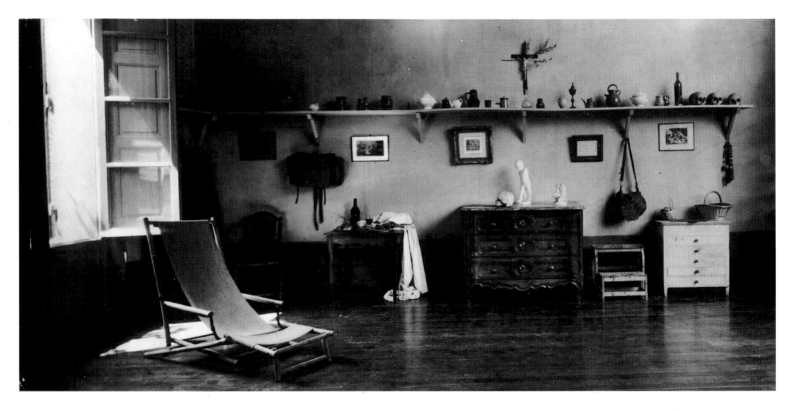

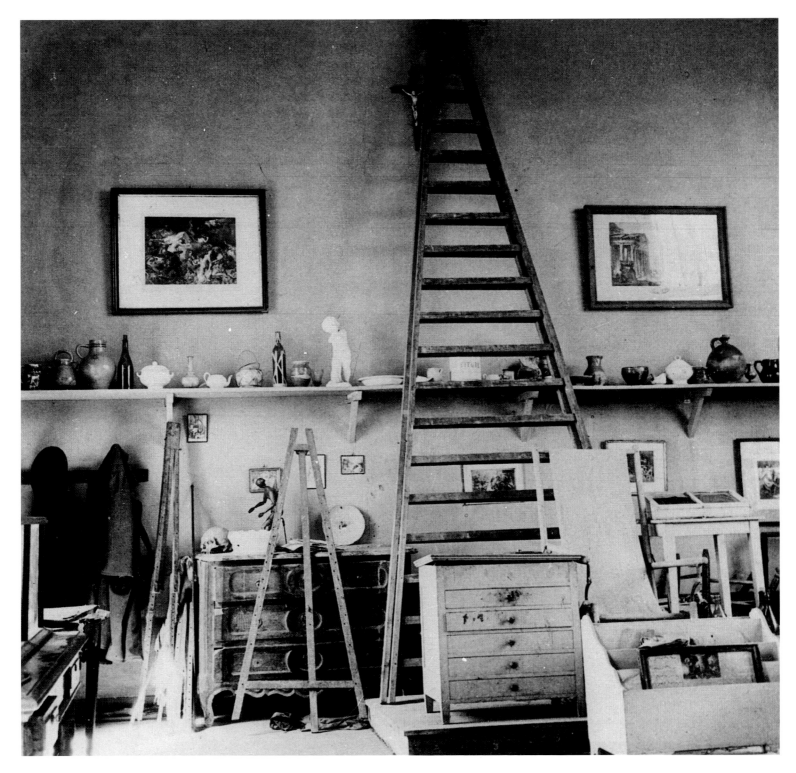

ANTAGONISM OF THE ACADEMICIANS

The master-teachers—the major beneficiaries of the most important commissions—were considered to be high officials of the State, and were over-burdened by their mission. This concept seems to have given one of them the odd idea of drawing up a code to define their privileges: "The corporation of painters shall only admit as members those who, after a technical examination, have clearly demonstrated their skills. Only these painters will have the right to apply the official mark used to indicate professional quality to the public, in exhibitions or auction galleries...."

These privileged persons, well aware of their special standing, were animated by a gregarious spirit that encouraged them to form groups and even live close to each other. For the most part, they lived in the 17th arrondissement, one of the most sought-after bourgeois quarters. Detaille and Meissonier lived near Boulevard Malesherbes, Benjamin Constant in rue Ampère, Roybet in rue de Prony. Alphonse de Neuville, the painter of scenes celebrating military episodes, Henner, Gervex, Lhermitte ... also lived in this suburb, where most of the famous figures in literature and the performing arts also lived.

The studio interiors of the academicians reflected the taste of the period for the kind of knickknacks sold in bazaars. In *Gil Blas*, Octave Mirbeau—one of the most constant supporters of the Impressionists and a man who despised pomposity—provides a description of one such studio: "The studio of painter Lois Jambois is without doubt one of the most bizarre. There are two dressers, some rare tapestries, two Carpaccios, three Botticellis, studies by Rossetti and Burne-Jones; a sledge that once carried Empress Catherine over the ice of the River Neva, a sedan-chair used to carry Marquise Polignac to the mullioned shadows of Versailles, Persian embroidery, Arab swords, a prodigious quantity of Byzantine Madonnas and Italian ceramics, opaque, bluish pewter alongside splendid Japanese vases with fat bellies and thin necks, decorated with weird flowers and sacred animals, an aquarium with humpbacked fish from the coast near Orissa swimming amidst the algae. Then there were the very wide sofas, covered with the hides of still-born black bears or tigers, and cushions with gold filigree embroidery, high-standing, eight-panelled screens draped with the mannered folds of cloths forming, here and there within the large room, mysterious and intimate little corners. At the base of these screens there were little sofas, low pouffes and flimsy tables in Chinese lacquer or Assyrian mosaics ..." Bearing in mind Mirbeau's humorous exaggeration, this could nevertheless easily have been the interior of Bonnat's studio, a passionate collector, or—better still—Gérôme, the obstinate defender of the privileges of the Institute and relentless enemy of the Impressionists.

Jean-Louis Ernest Meissonier (1815–1891). A genre and historical painter, Meissonier was famous all over the world in his own lifetime. His art was influenced by Dutch painting and his devotion to detail was the antithesis of Impressionism. In 1861, he became a member of the jury and doggedly opposed the Impressionists, whose rapid and allusive brushstrokes clashed with his own sense of precision. His paintings were worth their weight in gold. American critics are beginning to rediscover him.

(*Left*) A photo-portrait of Fernand Anne Piestre, known as Cormon (1845–1924). He was a painter of biblical and prehistoric scenes. Professor at the Ecole des Beaux-Arts, he became a member of the Institute in 1898. Unlike Meissonier, he was more open-minded about Impressionism. A friend of Degas, he was also the teacher of Toulouse-Lautrec between 1883 and 1886 (who spoke in a letter of "the wind of Impressionism blowing through Cormon's studio"), as well as Van Gogh and Gauguin. (*Below*) a view of Cormon's studio. (*Opposite*) The artist's sitting room.

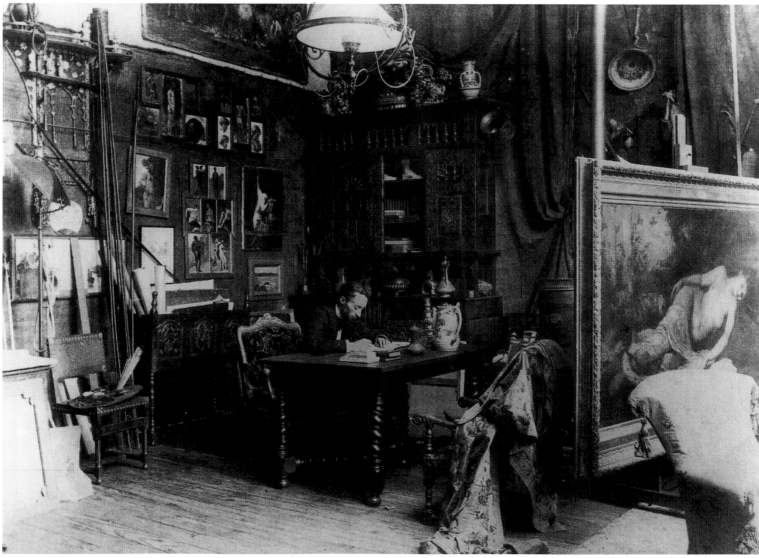

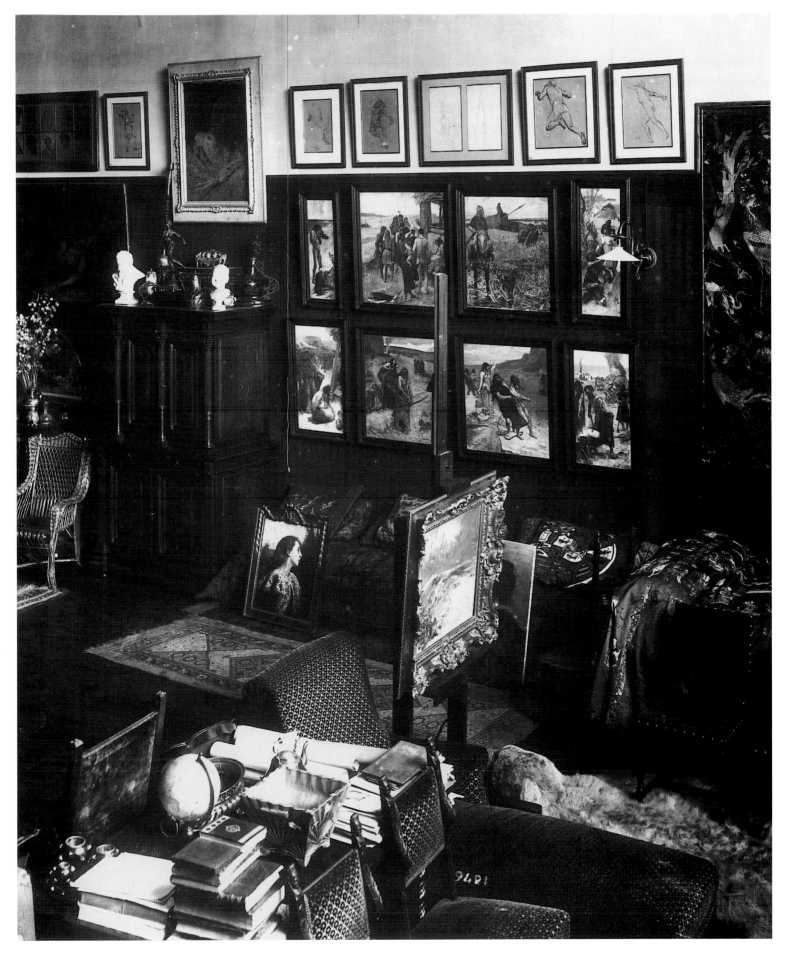

Gustave Clarence Rodolphe Boulanger (1824–1888) in his
studio in rue de Boulogne, Paris. He lived in Rome
between 1849 and 1856, where he became impregnated
with the culture of Antiquity to the extent that his painting
was defined as being "neo-Greek." A friend of Gérôme, he
was professor at the Ecole des Beaux-Arts and at the
Académie Julian; in 1885, he wrote a pamphlet in which he
"rebelled against the rebellion."

Jean-Léon Gérôme (1824–1904) in his studio. He was considered one of the main defenders of the end-of-the-century academic style and was the most virulent enemy of the Impressionists. He opposed Manet teaching at the Ecole des Beaux-Arts in 1883. He travelled widely in Turkey, Egypt, the Crimea, and Palestine. As in the case of Boulanger, his painting was also defined as "neo-Greek." His studio in Boulevard de Clichy was crammed with works of art, bronzes, precious objects, and souvenirs of his exotic travels. The stairs leading up to the studio were a Chinese ramp, the walls were covered with majolica, and the windows had Japanese glassware. In a letter dated 1869, Bazille wrote: "Gérôme is the origin of all our troubles; he has always treated us like a gang of idiots and has publicly declared that it is his duty to do everything in his power to prevent us exhibiting our paintings."

(*Right*) A photograph of the jury of the painting Salon at the end of the century. The man seated is Cormon. (*Below*) An engraving depicting the jury of the 1885 Salon. As well as Cormon, other recognizable figures are William Bouguereau and Henri Gervex. Bouguereau was one of the best-loved artists of the Third Republic. A painter of religious scenes and nudes on an immense scale, he ferociously opposed the admission of the Impressionists. The member of the Guerbois café group coined the term "bouguereauté" to define a particularly fawning painting. Gervex, on the contrary, was friends with Manet and posed for Renoir.

Another photograph of the jury; the caretakers are bringing in the paintings for their assessment.

Gérôme did everything possible to prevent the Impressionists gaining access to the Salon and the Musée du Luxembourg. In 1894, he fiercely opposed the purchase of the Caillebotte Collection by the State (since he was a friend of the Impressionists), defining the paintings as "disgusting," and headed a group that threatened to resign from the Beaux-Arts if the bequest were accepted. In 1900, he was a member of the commission that organized the Universal Exposition and reacted violently to the news that the new movement had been admitted: "Not those damned Impressionists again ... no, no, not them, not that garbage!"

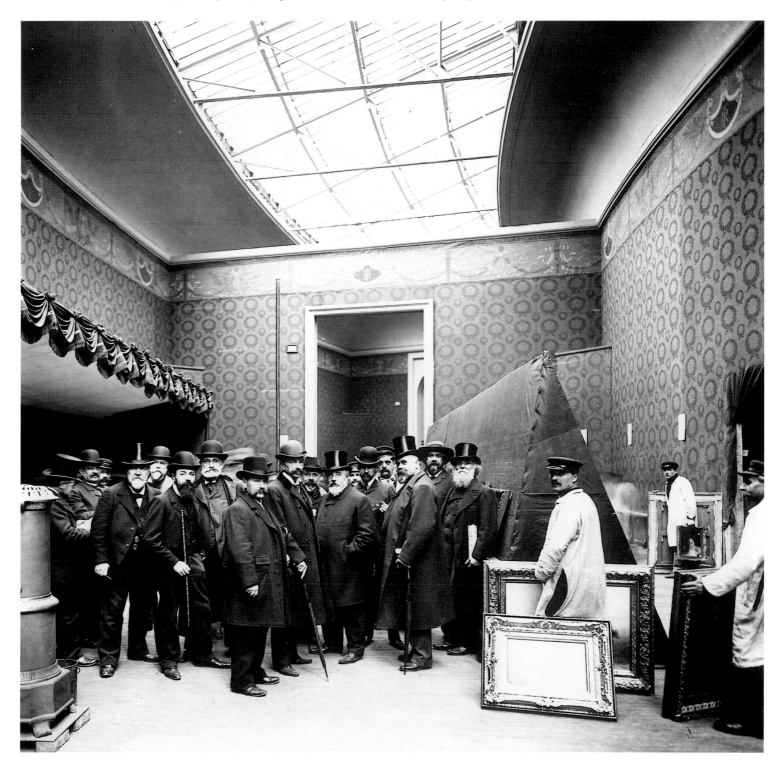

(*Left and above*) Various scenes of the preparations for a Salon at the end of the century.

As early as 1868, Emile Zola had expressed his hope in the *Tribune* for an open Salon, without medals or juries. "There is only one thing to be done: open the doors of the Palais de l'Industrie. The only argument put forward to oppose this kind of solution is that open exhibitions are contrary to the dignity of art. What a ridiculous statement. We hope for open shows where genius in all its manifestations, however strange, has equal access."

It had been hoped for some time that the Salon des Refusés might play this role; however, in 1884 the Salon des Indépendants was founded as an open Salon with no jury.

Here, rejected painters, painters whose work was also accepted for the official salon, and the work of painters who had never exhibited before were all accepted. As time went by, this became the Salon of the Avant-Garde, so much so that the work of the neo-Impressionists (such as Signac and Seurat), the cubists (Braque and Delaunay) and the abstract artists (Kandinsky and Kupka) was exhibited. It should be noted that Cézanne and Van Gogh often took part.

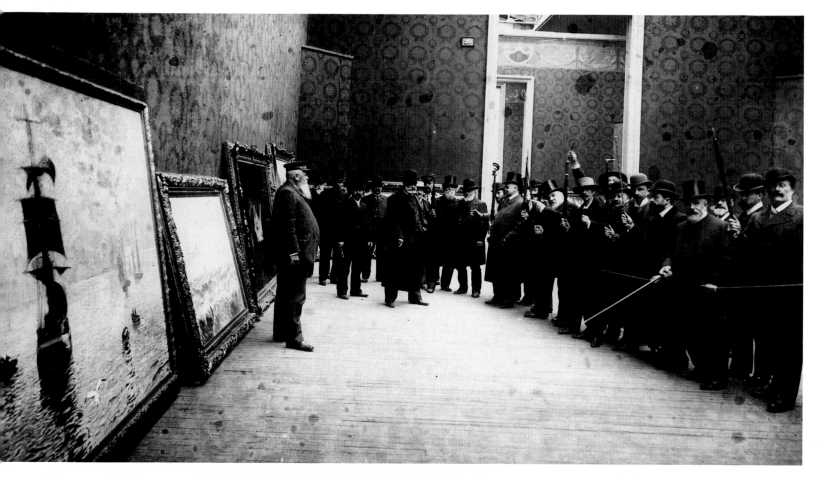

(*Above and right*)
Another exhibition gallery competing with the Salon appeared in 1903: the Salon d'Automne. Its objective was to welcome advanced trends in post-Impressionist painting. The members of the committee of the Salon d'Automne paid homage to their predecessors by organizing retrospective and one-man shows: Cézanne and Gauguin in 1904, Renoir, Toulouse-Lautrec and Manet in 1905; Bazille in 1910; and Pissarro in 1912. The Fauvists (Bonnard, Vuillard, and Vallotton) also exhibited here, as well as Rousseau and Matisse.

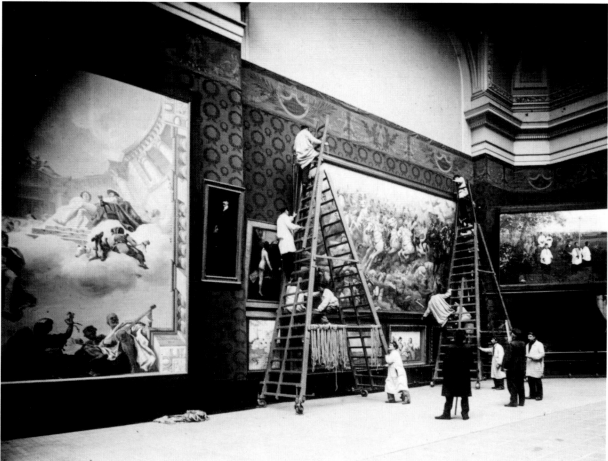

ANTAGONISM OF THE ACADEMICIANS 113

(Below) A member of the jury writing up a list of the works on show at the 1903 Salon. (Opposite) The inauguration of the 1900 Salon at the Grand Palais; the Palais de l'Industrie had been demolished to make way for Avenue Alexandre III. By the turn of the century, the Impressionists had come to be accepted more or less everywhere, so much so that in the last years of his life even Meissonier, who had been one of the most fervent opponents of the movement, ended up painting a series of landscapes of Paris and Antibes that clearly illustrate the influence of Impressionism.

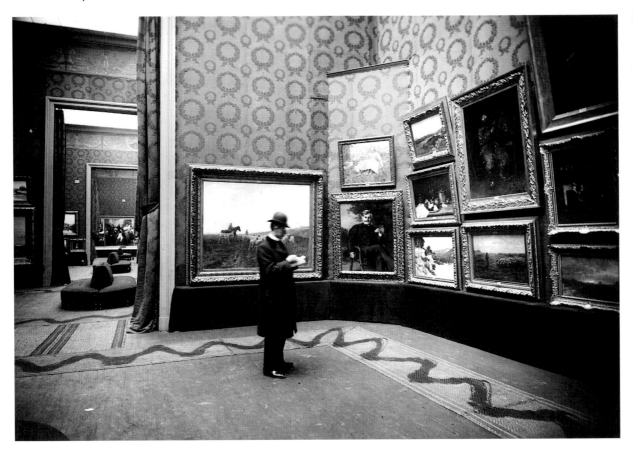

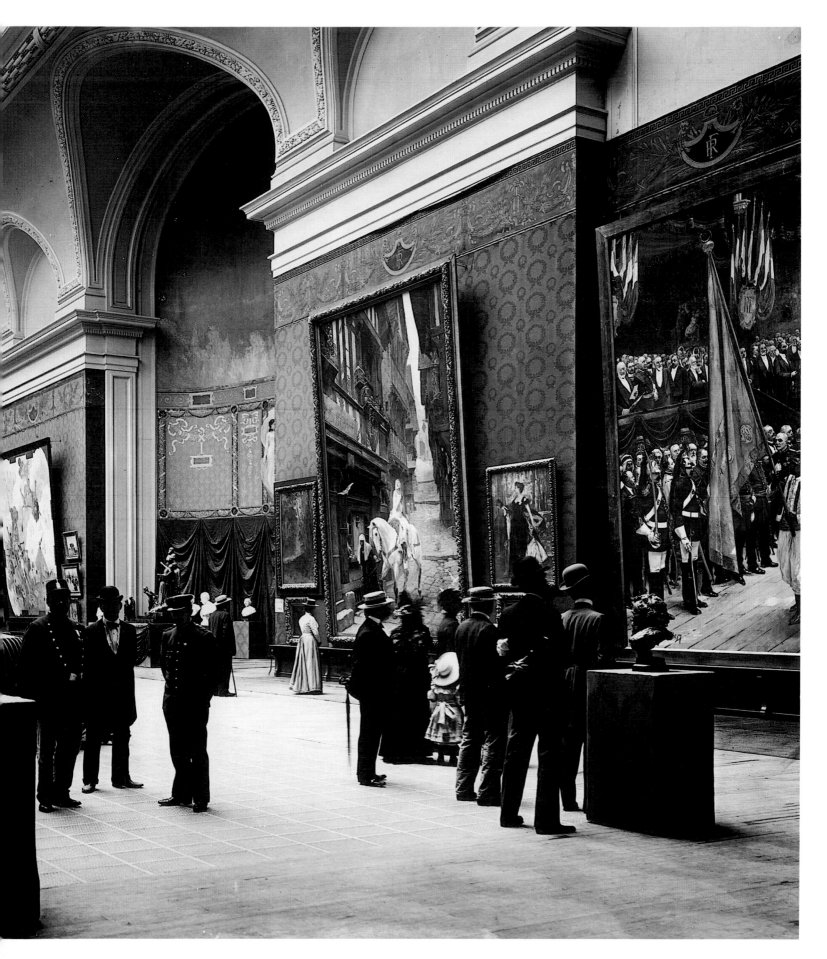

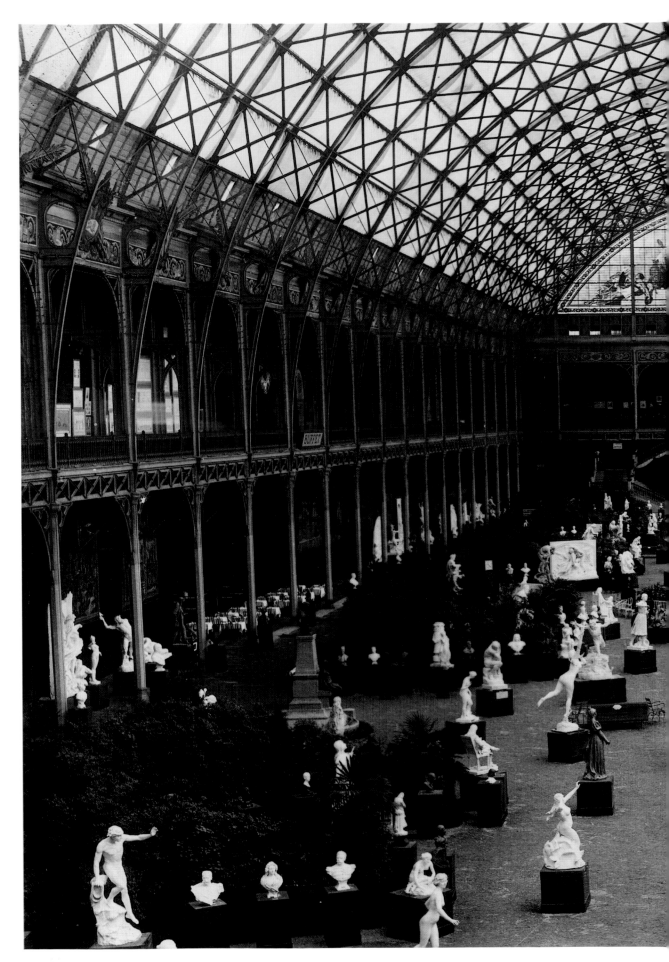

A photograph of the interior of the Palais de l'Industrie in 1896. Sculpture was displayed on the ground floor, while paintings were hung along the gallery above.

Prior to 1870, a study for a painting was sold for 40–50 francs. In 1979, Sotheby's sold Renoir's *Fisherman* for £610,000 ($976,000). It was originally purchased by publisher Georges Charpentier in 1874 for 180 francs).

Christie's in New York sold *Paysan en blouse bleue* by Cézanne for $3,900,000 in 1980, as well as a pastel by Degas, *L'attente*, for $3,400,000 and Renoir's *La Coiffure* for $3,125,000.

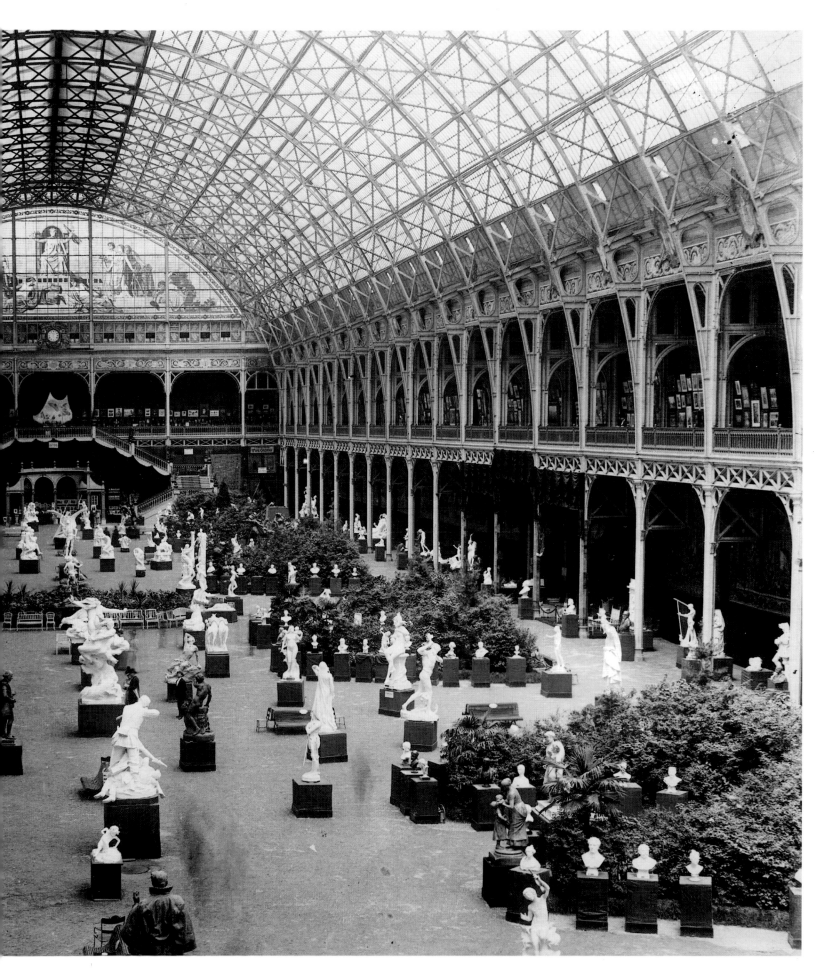

DEGAS

From a certain point of view, Edgar Degas was the least "impressionist" of the Impressionists. He wasn't interested in painting en plein air, but preferred portraying individuals in their working environment or private intimacy. He was more interested in design than colour ("I have always suggested that my colleagues should search for new solutions within the scope of design, which I consider more fertile than colour. But they never listened to me and took other directions"). He was never convinced by the cult of the impression and its representation on canvas, so much so that in 1879 he insisted that the title of the Impressionist exhibition be changed to "Independent Painters." He felt that the Impressionists, as a result of their principle of never wishing to change what they saw and depict only the fleeting sensations they perceived, were the slaves of nature and light ("It is all very well to copy what you see but it is much better to portray what you no longer see except in memory. This transformation is assisted by both memory and imagination. You limit yourself to reproducing only what has struck you, that is to say what is necessary. In this way, memory and imagination are freed of the tyranny exerted by nature"). To the very end, his admiration of Ingres, the founding father of Neo-Classicism and the great antagonist of Delacroix, remained unbounded. His separation from the Impressionist movement was such that it was perhaps to him that Monet alluded when, at the end of his life, he said that he was sorry that "I inspired the name given to a group of artists who, for the most part, had nothing to do with Impressionism."

Yet in his women ironing, his ballerinas, or his women bathing (where the nude is no longer a genre but viewed "as if through the keyhole"), or caught in everyday gestures, Degas encompasses the *hic et nunc* that is the underlying basis of Impressionism itself.

A photograph of Degas as a young man. In his notebooks toward the end of the 1860s, Degas outlined a plan: "Transform the *têtes d'expression* (the academic style) into a study of modern sentiments; depict all kinds of every-day objects arranged and combined in such a way that they contain the whole life of men and women, such as corsets only just unlaced and taken off, for example; which, in some way, are still permeated with the life of the body, etc. ... No one has ever made monuments and houses seen from below, from underneath, from close-up, as they really are when walking past them." (This recalls Le Corbusier who, fifty years later, was to write that no one had ever shown houses seen from above.)

He compiled a list of contemporary subjects to be studied: musicians and their instruments; bakery shops viewed from every angle, with still lifes of bread and cakes of every kind; smoke (cigarettes, locomotives, chimneys, steamboats, etc.); people in evening dress with all possible imaginable blacks, veils, gloves; undertakers; and other subjects such as dancers, focusing on their bare legs studied in movement, the hands of their hairdressers, endless impressions, cafés at night with "the various shades of lamps reflected in people's eyes ..."

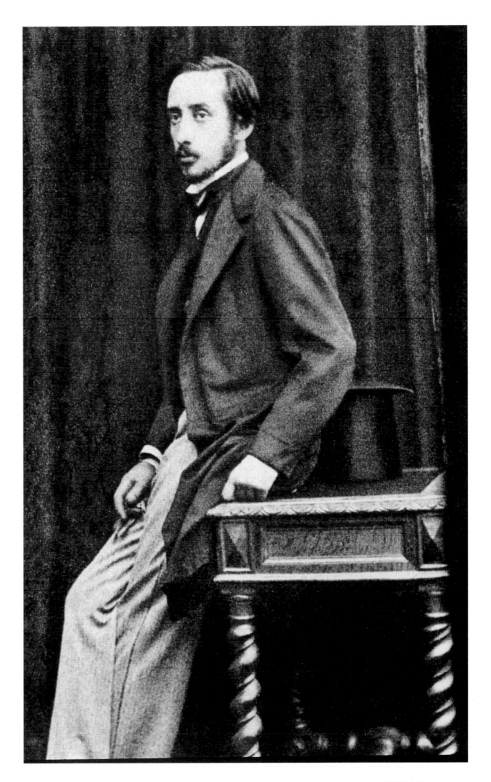

The apotheosis of Degas photographed by Barnes in 1885. The three Muses are interpreted by Rose, Catherine, and Marie Lemoinne, while the two boys on either side of Degas were Elie and Daniel Halévy. Degas was not entirely pleased with the photograph, which he thought was not very clear. Surprising as it may sound, Degas was a great collector of works of art, especially of the drawings of Ingres, the founding father of the Neo-Classic School, so much so that many of his own paintings, especially *The Benelli Family*, clearly show this influence. The photograph is a parody of a painting by Ingres in 1827, *The Apotheosis of Homer*, in which Degas mockingly poses as the poet.

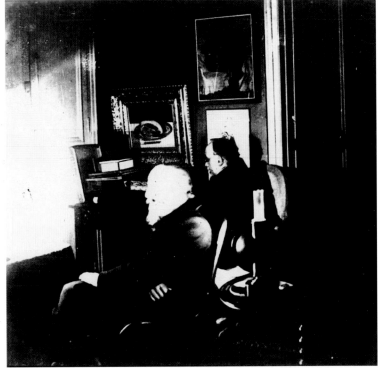

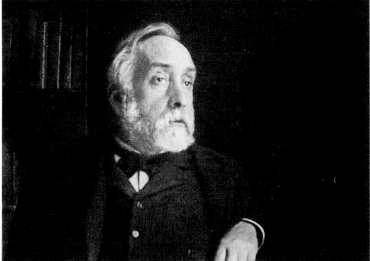

(*Top*) Degas meditating in front of a statue around 1898–1900.
(*Above*) Degas in his library, 1895.
(*Top right*) Degas and his sculptor friend Bartholomé, 1898–1900.
(*Right*) Degas and his housekeeper Zoé reading the newspaper, 1890–1900.

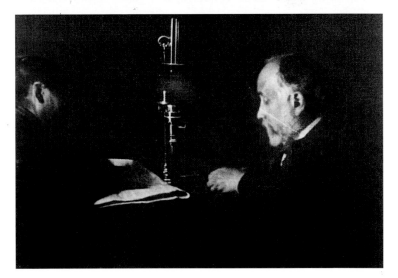

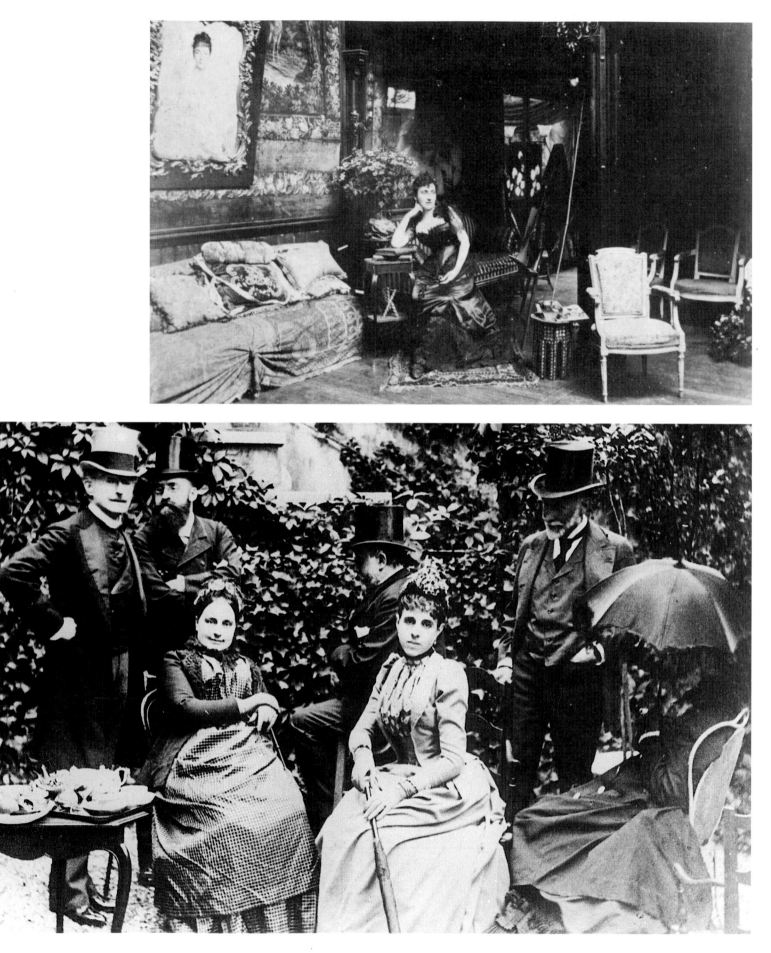

Unlike the majority of Impressionists, Degas also moved in aristocratic circles.

(*Opposite, above*) Geneviève Straus in her sitting room. Born Halévy, her first marriage was to Georges Bizet. She was famed for her intelligence. She was the main model for the Duchess of Guermantes in Proust's *Remembrance of Things Past.*

(*Opposite, below*) Degas standing on the right, looking at Madame Straus. Charles Haas, the model for Swann in *Remembrance*, is standing on the left.

(*Below*) Degas with Monsieur and Madame Fourchy miming playfully in the park of Château Ménil-Hubert in 1895.

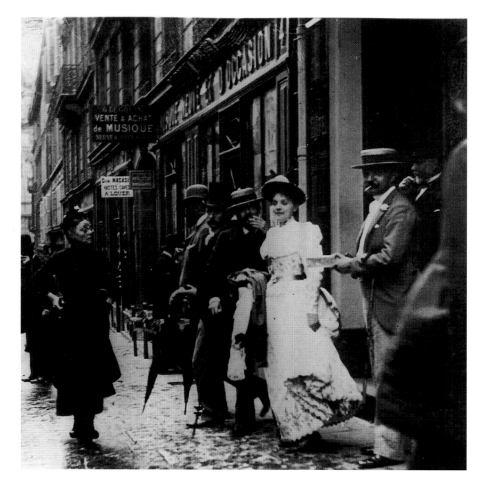

Paris, July 25 or 26, 1889: two photographs taken by Count Primoli. (*Left*) Réjane (1856–1920), one of the finest French actresses of the late nineteenth century, leaving a door in rue de Rougemont, near the Boulevard du Conservatoire, accompanied by admirers, including Degas (the last figure on the right, just emerging from the doorway).

(*Below*) Edgar Degas coming out of a *pissoir*. The photograph was taken on the same day on which Degas accompanied Réjane and Count Primoli to the competitions at the Conservatory.

(*Opposite*) Réjane in a stage photograph for *Lys Rouge* by Anatole France.

Degas strolling along Boulevard Clichy in 1914. He had
moved to this quarter in 1912 but was no longer working,
since his eyesight had become too weak. "Degas lived like a
hermit in the centre of Paris, complaining continually about
his poor eyesight (Degas had suffered from eyesight problems
since the time of his military service in 1871 and lamented
that he only had a few good years left). He no longer even
felt the need to exhibit his paintings; after 1866, he appeared
before the public only once, with a series of pastel
landscapes, put on show by Durand-Ruel in 1892" (Rewald).

One of the last photographs of Degas, in the garden of sculptor Bartholomé. He died of a heart attack in 1917, aged 83. His weak eyesight forced him to abandon painting; he devoted himself to sculpture and "modelling clay and wax, entrusting to his hands what he could not do with his eyes" (Rewald). In his growing solitude, he realized that he had offended many friends and colleagues and his character changed. He made a moving confession to an old friend, Evariste de Valernes: "I ask your forgiveness for something that often crops up in your conversation and even more often in your thoughts— that I have been or seemed to be, in our long friendship, rather harsh with you. I have been even like this with myself. Bear this clearly in mind since you have come to criticize it in me and surprise yourself that I could have such little faith in myself. I seemed to be harsh with everyone, as if overwhelmed with impatience when doubtful or in a bad mood. I felt so unprepared, so weak, whereas my calculations about art seemed so right. I was against everyone and against myself. I ask your pardon if I ever wounded your noble and intelligent spirit, perhaps even your heart."

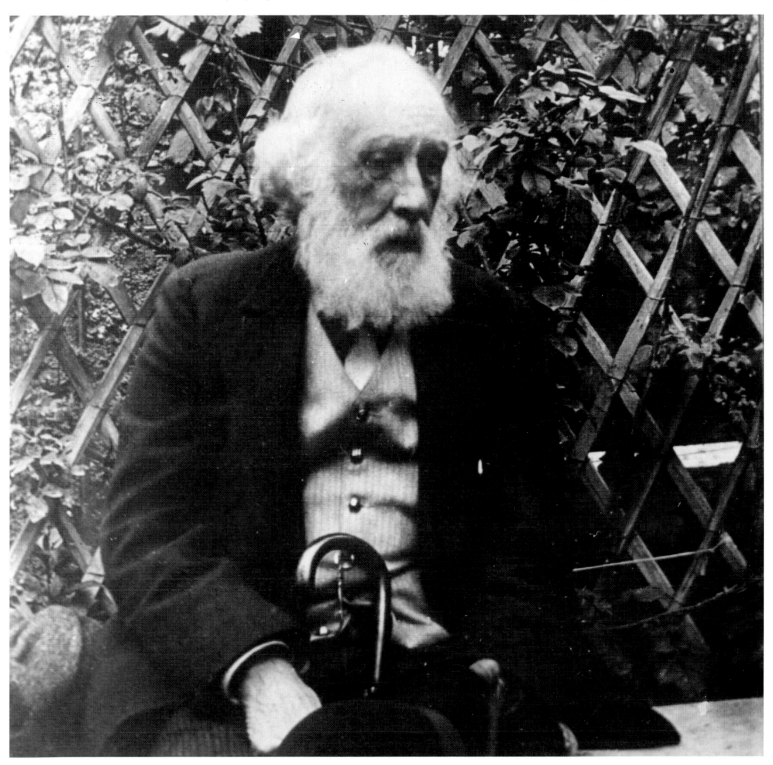

RENOIR

Pierre-Auguste Renoir was considered to be one of the leading exponents of the Impressionist movement. He was the first to become internationally famous and enjoy the support of gallery-owner Durand-Ruel. Critics were rarely hostile, and he received fewer rejections from the Salon than his colleagues. His art, which more than anything else expresses grace and happiness, was not imitated, unlike that of Monet and Cézanne. "He did not understand the ambition and pride of Manet because he was neither ambitious nor proud. He did not experience the torment of doubt that afflicted Cézanne nor the inner struggles of Monet, the neurotic self-awareness of Degas, or the solemn commitment of Bazille, because he was neither introspective nor introverted. He was joyful and carefree, notwithstanding the poverty of his early years, because he found happiness in his work" (Rewald). He tried many different styles, ranging from those of Courbet to more or less academic modules, because he felt that he was free to search for new solutions anywhere when what he had already done did not satisfy him. He developed a personal style in which he painted female nudes caressed by the sun, flowers, and children. His canvases were a combination of whirling brush-strokes and dots of colour to create shading, without a single definite outline. The definition of Impressionism he gave to a friend—"deal with a subject through its shades, not with the subject itself"—is more appropriate to him than to any other artist.

A photograph of Renoir taken in the early years of this century.
"Like Monet, Renoir was never one to raise his voice during
group discussions. As a boy, he taught himself by reading books
night after night, then he studied the masters in the Louvre.
Although unable to compete with Manet and Degas, his natural
intelligence helped him grasp the substance of every problem.
He had a fine sense of humour, was bright, shrewd, never
impetuous but difficult to convince. He was able to listen to a
debate and recognize that other people's ideas were flawless,
but nevertheless felt himself free to stick to his own ideas even if
no one else agreed with him" (Rewald).

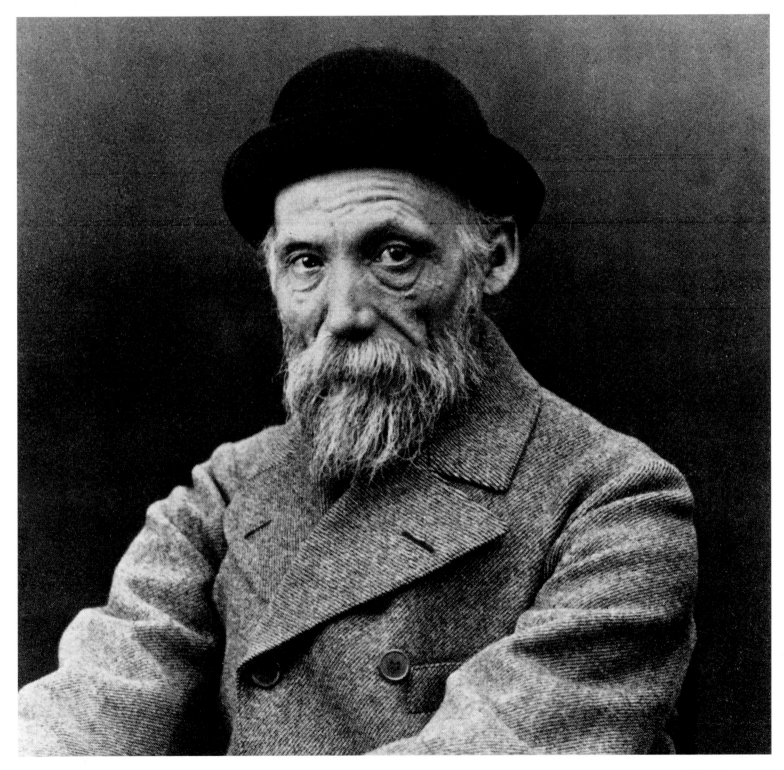

(*Left*) Renoir's house at Montmartre. The Renoir family moved here in 1889. The quarter was largely ignored by artists and taverns and was almost exclusively inhabited by the workers of the Saint-Ouen plains. Renoir was allowed by the owners to knock down a dividing wall and create a studio in the attic underneath the roof of the apartment. The Château des Brouillards, as Renoir's house was called, became a landmark in his life. The rooms measured four metres by five. "In the dining room, Renoir painted transparent mythological subjects on some of the windows. I don't know what became of them," wrote his son.

(*Below*) A photograph dated 1912, showing Renoir with his wife Aline and third son Claude.

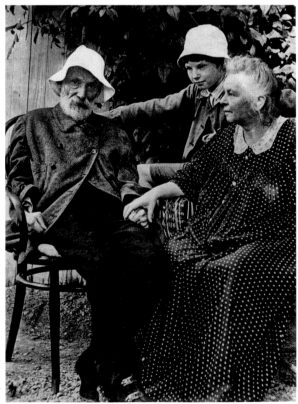

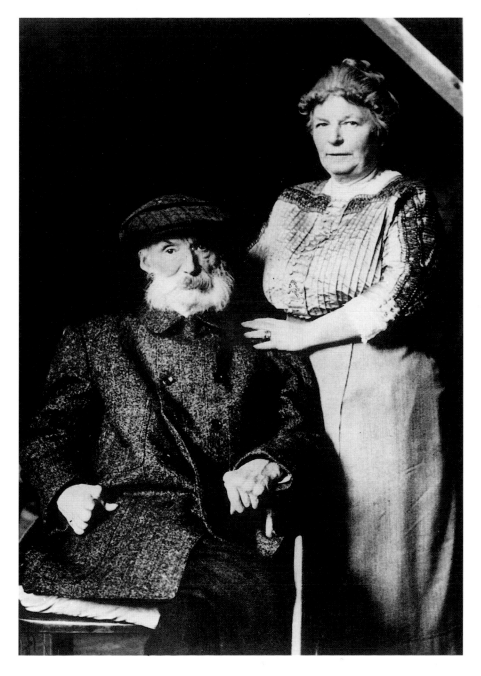

(*Left*) Renoir and his wife at the beginning of the century.
(*Above*) Renoir and his son Jean.

From Renoir's notebooks: "The artist who makes less use than the others of what is called imagination will be the greater. To be an artist, you have to learn the laws of art.

"The eye has lost its habit of seeing.

"Just look how the Japanese painted birds and fish ... The system is delightfully simple. They sat in the country and watched birds flying for a long time. By dint of watching them, they finished by understanding their movements; the same is true for fish.

"I propose that we set up a company ... This company should be called the Company of Irregulars ... An irregular should know that something round must never actually be round.

"It is impossible in any given period to do what has already been done in another. The aims, the ideas, the tools, the touch of painters have all changed ..."

Renoir in Cagnes in 1907. "There are many photographs of Renoir in his old age, portraits of a rather upsetting truth. They give a clear idea of his physical appearance and of how shockingly thin he had become. His body gradually became more and more petrified, his hands gnarled and incapable of grasping anything. It has been said and written that brushes had to be strapped to his hand. This is not entirely correct. The truth is that his skin had become so tender that touching the wooden stems of paintbrushes tore his flesh. To get round this, he had someone place a thin piece of canvas in the palm of his hand. His deformed fingers clamped rather than held the brush. But his arm remained steady to the very end, as firm as a young man's, and his eyes were as sharp as ever," wrote Jean Renoir in the biography of his father.

(*Opposite*) Collettes, the house at Cagnes, and the studio.

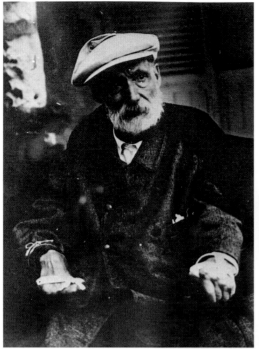

(*Opposite*) A photo-portrait of Renoir with his bandaged hands and the wheelchair he had to use in the last years of his life.

(*Below*) A hall of the exhibition organized in Paris in 1920 of Renoir's work painted between 1915 and 1919. Renoir died on December 3, 1919. That morning, he asked for a box of paints and brushes, and painted some anemones that his maid had cut for him. He immersed himself with the flowers for several hours and forgot the pneumonia that confined him to his room. He then nodded that he wanted to take up his brushes again and said: "I think I'm beginning to understand something."

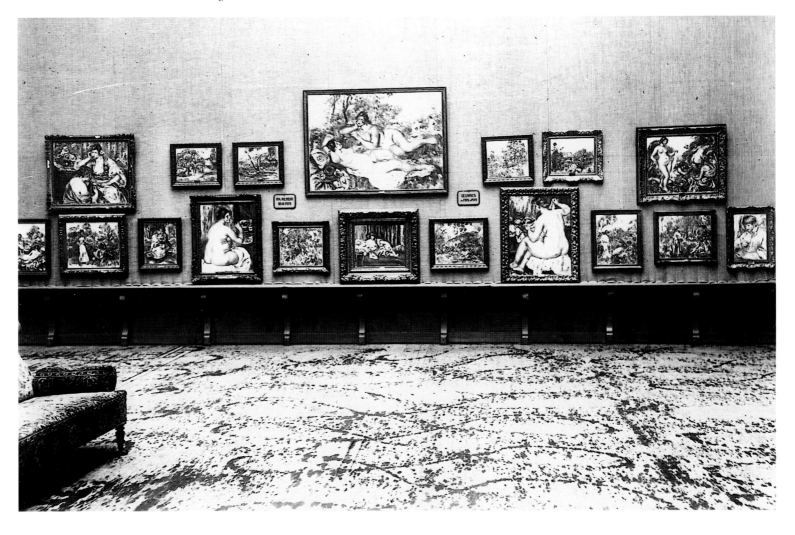

CÉZANNE

Of all the Impressionist painters, Paul Cézanne was the one whose art opened the way for the most significant developments in painting; all subsequent artistic movements somehow looked back to him, from the Symbolists like Emile Bernard and Maurice Denis, to the Fauves, the Cubists, and, later, the artists interested in geometrical abstraction. Unlike his Impressionist colleagues, he was more interested in the construction of fleeting visions than their vibration ("in nature, we should see cylinders, spheres and cones, setting every single thing in the right perspective so that each side of an object or a plane is directed toward a central point"). Cézanne revealed the structure underlying variously articulated surfaces, and knowingly went beyond the appearances where Monet stopped short. "For them [the Symbolists], Cézanne was a kind of myth. The younger generation rediscovered the primacy of structure that for Seurat, Van Gogh, and Gauguin was beyond discussion. In Cézanne, they recognized the only one of the old Impressionists who, despite retaining the technique, had broken with Impressionism to investigate spatial relationships and return forms to their primary components." Cézanne safeguarded the fundamental role of sensitivity but thinking took the place of empiricism. He appeared "as the ultimate outcome of Classical traditions and the product of the great crisis of freedom and light which rejuvenated modern art. He was the Poussin of Impressionism."

"Cézanne was tall and thin; he had knotty joints, a strong, bearded head, a very fine nose lost amidst his hirsute beard, and small, bright eyes ... Yet, underneath his gaze, his eyes were immensely tender. His voice was deep ... He stooped a little and his nervous gestures eventually became chronic. He didn't go very often to the Guerbois Café, partly because he spent half the year in Aix, where he was born, and partly because he didn't care for debates and theories.

"The rare occasions on which he became interested in the things taking place around him, he sat in a corner and listened in silence. When he did speak up, his words had the impetus of deep convictions, but it was often the case, when others expressed opinions diametrically opposed to his own, that he simply stood up and left without saying goodbye" (Rewald). His work was systematically rejected by the Salon, but the financial well-being of his family and his own obstinacy meant that he did not have to rely on the tastes of collectors and merchants, but could follow his convictions through to their culmination.

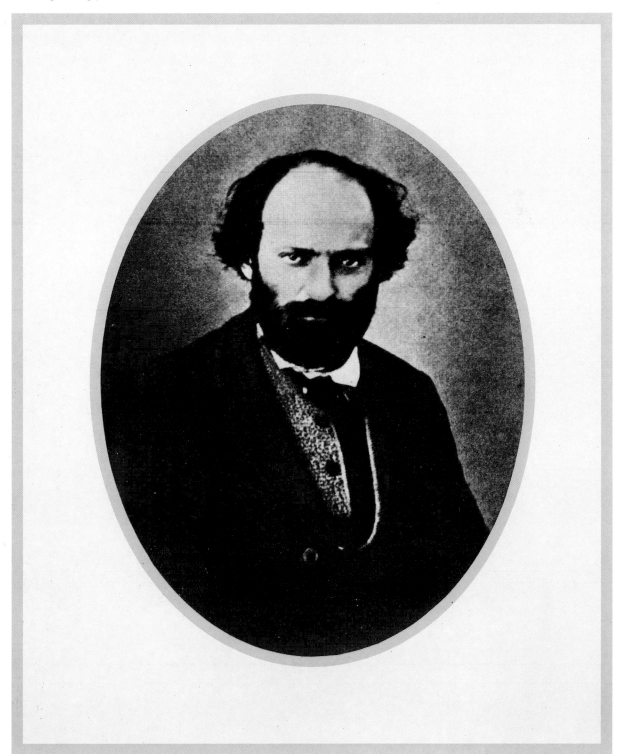

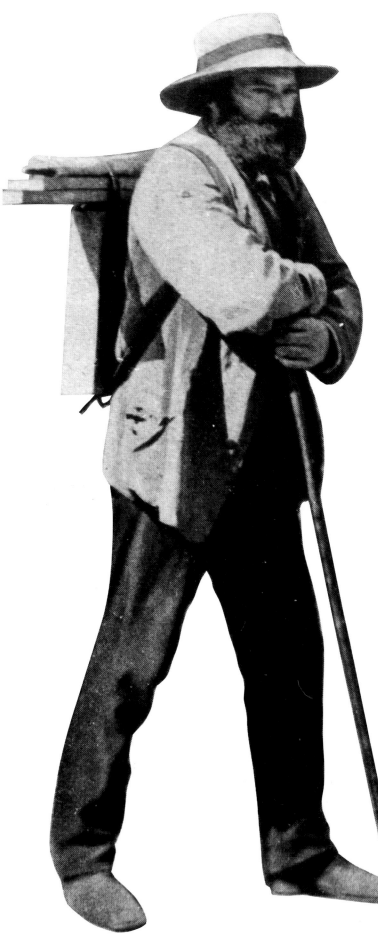

Cézanne in 1874 and, below, a photo-portrait of Emile Zola. Cézanne and Zola met each other at school in Aix-en-Provence in 1852. They became friends in art. When Cézanne moved to Paris some years later to study at the atelier, Zola was already living in the capital and had made friends with the other painters; he became their determined supporter in the newspapers, finding in their art the germ of naturalism that he favoured in literature. The feud between Zola and Cézanne began around 1880. Zola, who was a little ashamed of his rather wild friend, took him to task over the lack of expression in his subjects. Cézanne later took his revenge: "Do my buttocks express anything!" Their falling out was stigmatized by Zola in his novel, *Opera*,

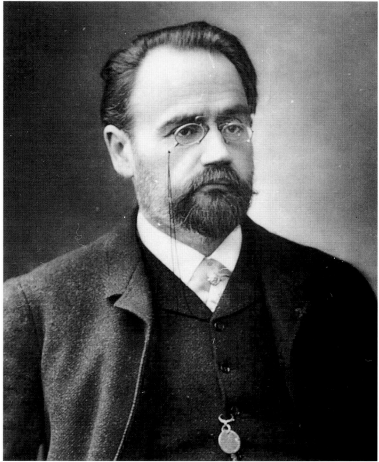

written in 1886. The main character is a gifted painter who is unable to bring his ideas to fruition: "My great friend Cézanne had the spark. But even if he had the genius of a great painter, he didn't have the will to exploit it. He let himself get lost in dreams, dreams that were never to become reality. To use his own words, he was at the mercy of illusions," Zola was to say much later during a conversation with merchant Ambroise Vollard.

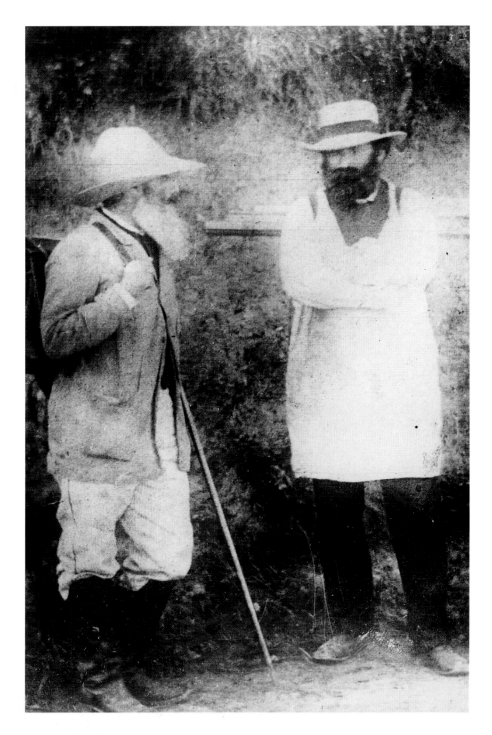

(*Above*) A photo-portrait of Ambroise Vollard. "If any great merit is due to Ambroise Vollard, it is that of having trusted Pissarro [in the photo at right, with Cézanne] and gone ahead with the one-man show organized in 1895 of a painter that no other merchant, Durand-Ruel in particular, dared to handle: Paul Cézanne. Without the mediation of Vollard, and the consequent accumulation of Cézanne's work—from the studio in Fontainebleau to the attics in Aix—this art may never have been recognized as anything other than the obstinate output of a provincial man who was sufficiently well-to-do not to have to worry about selling his paintings, nor to pander to the tastes of the buying public. Vollard took a huge risk with Cézanne, but it proved to be well worth taking; he was backed in this by an intuition that led him to prefer an avant-garde collection (painters Pissarro, Manet, and Gauguin were among the first buyers of Cézanne's work, soon followed by Picasso and Matisse) over wealthy and more traditional buyers." (From the preface by Maria Mimita Lamberti to *Memoirs of an Art Merchant* by Ambroise Vollard.)

(*Opposite*) Cézanne's studio in Aix-en-Provence and three photographs (*above and right*) of him at work in the open air shortly before he died. The artists who travelled to visit him in Aix found a tall and often excessively courteous man who, at times, could shift brusquely from cordiality to coldness. With no interests other than art, he loved talking about painting, but became visibly irritated if anyone asked him to formulate theories. He accompanied visitors to the hills around Aix, where he worked, and repeated that "so much is spoken of painting but, perhaps, it is so much the better when we are faced with its motivation than when pronouncing purely speculative theories, in which we all so often get lost ... Everything, especially in art, is a theory elaborated and applied in contact with nature."

(*Below*) Cézanne in front of one of his *Bathers* in his studio at Lauvres in 1904. The photograph was taken by Emile Bernard.

(*Opposite*) Two photographs of the installation at the Armory Show at The Art Institute of Chicago, 1913. The exhibition was one of the most important of its time, comprising 2,000 works by modern European artists: "a collection of paintings from Ingres to the Italian Futurists, including French, Spanish, English and German artists."
 The photographs show two self-portraits by Cézanne, a

portrait of Madame Cézanne, *The Woman with a Rosary, Landscape near Auvers-sur-Oise,* and *Four Bathers.*

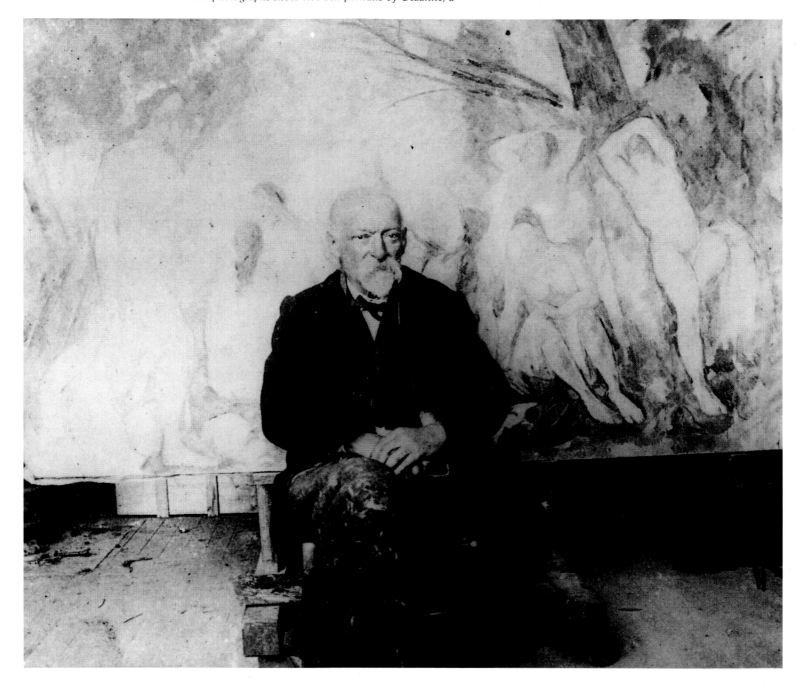

MONET

The meeting with painter Boudin was a fundamental experience for Monet. They met in Le Havre where Monet lived with his family as a boy. "Boudin came up to me. He congratulated me and said: 'I always enjoy your drawings [Monet was then known as a caricaturist]: they are always amusing, quick and bold. You are gifted, you can tell it immediately. But I hope you won't stop here. It's fine as a beginning, but you'll soon tire of caricatures. Study, learn how to see and how to paint and draw, do landscapes: everything is so beautiful, the sea, the sky, animals, people, trees, just as nature made them, with their own personalities and authenticity, in the light, in the air, just as they are.' I took his advice," Monet was to say later in a letter dated 1920, "and together we took long walks during which we continually painted real-life scenes. This was how I came to understand nature, and how I learned to love it passionately, and how I became interested in the luminous painting Boudin practiced. It shouldn't be forgotten that he had taken lessons from a master, Jongkind, whose works—especially watercolours—were, together with Corot, the inspiration of what came to be called Impressionism. I have said and repeat again: I owe everything to Boudin and I am grateful to him for my success." This love of nature led him to give up the vain attempt to search for reality and dedicate himself to the task of conveying his impressions of light. In 1903, he began a series of paintings entitled *Nymphéas - Série de paysages d'eau* in which matter, colour, light, and the various parts of the subject were blended into a single, voidless image, without any empty air between one part and another. This research led him to produce the series of *Grande Décoration* panels exhibited at the Orangerie des Tuileries, which can be legitimately considered as the origin of Abstract-Expressionist art, founded in the 1940s in the United States with Pollock and Rothko, to the extent that in 1944 Picasso stated that "the place of Monet in art is perhaps even more important than that of Cézanne."

Monet aged twenty. "He passed his adolescence rather like a vagabond, as he himself remarked much later, climbing hills and swimming rather than going to school. He was unruly by nature and school seemed like a prison to him; to amuse himself, he scribbled all over the blue paper of his exercise books and even drew very irreverent sketches of his teachers. He soon became very adroit in this game; by the time he was fifteen he was known all over Le Havre as a caricaturist, and his reputation became so well-established that he received commissions from near and far. His caricatures were proudly exhibited, five or six at a time, in the only picture-frame shop in the town" (Rewald). It was here that he met Boudin.

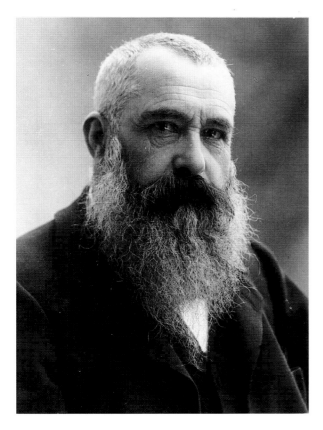

(*Above*) Monet in a photo-portrait by Nadar.

(*Right*) Two photographs of Monet on his property at Giverny, a few miles outside Paris. When Monet set himself the objective of translating the effects of light independently of the subject or its forms, the search for a context became a relatively secondary question. Although he continued to travel a great deal, for some years he progressively reduced his universe to within the bounds of his garden at Giverny, a village in the Eure that he discovered in 1883, and settled there permanently in 1890. Against this background, he attempted to achieve "something impossible, blades of grass undulating beneath the surface of the water." To this end, he had the garden specially laid out and installed pipes to take water from the River Epte to feed a pool where he could grow aquatic plants, arousing the anger of neighbouring farmers. The garden and pool almost became his exclusive subjects until the end of his life.

(*Opposite*) Monet working at his easel.

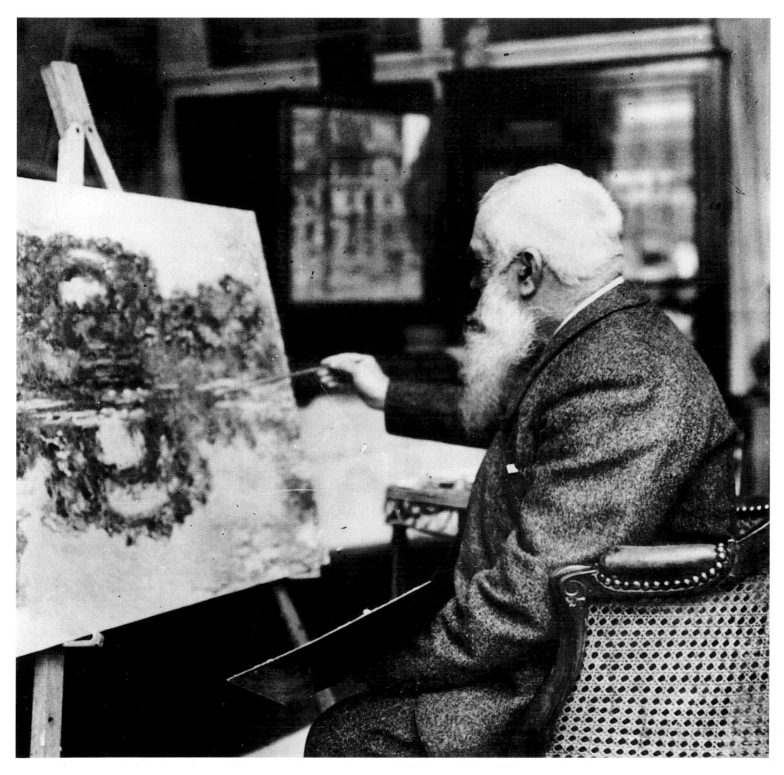

Several photographs taken at the beginning of the century in the surroundings of Giverny, Monet's natural studio; the bridge over the River Epte, a mill, a country lane, and the River Epte again.

(Below) Monet photographed in his home sitting next to an Oriental statue.

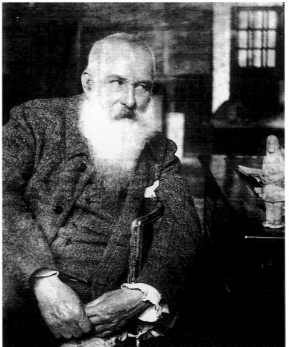

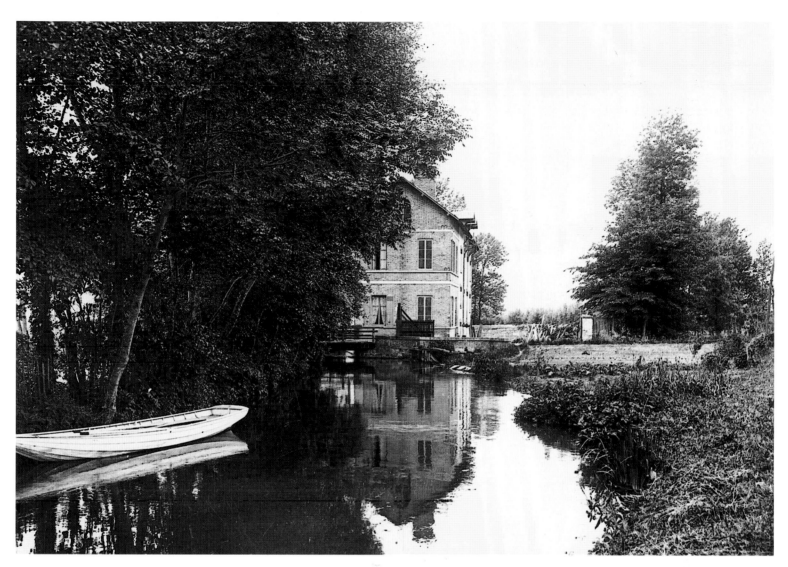

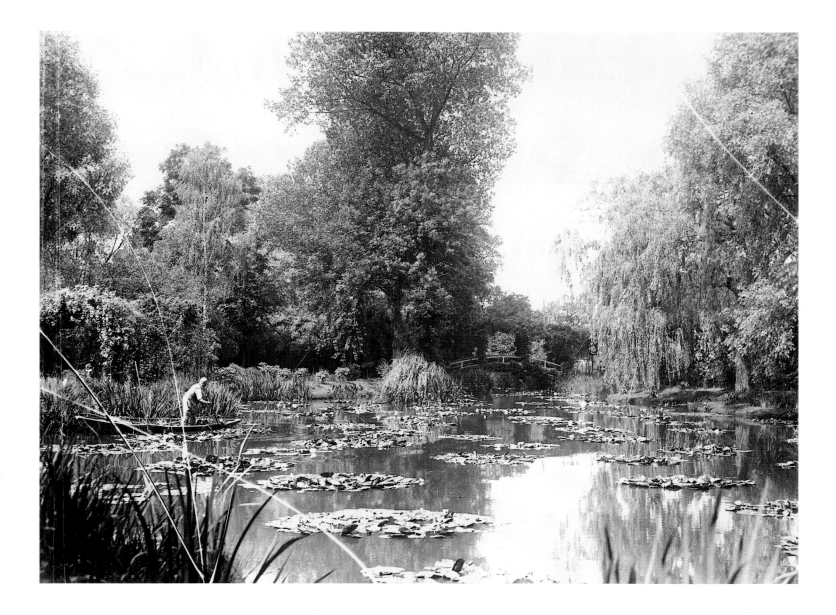

(*Opposite*) A view of the garden at Giverny and the pool with its waterlilies and the Japanese bridge in the background.

(*Below*) Two photographs of Monet posing in front of his *Grandes Décorations de Nymphéas* that he considered donating to the French State immediately after the armistice in 1918. The idea originally underlying the series of panels "was that of painting on the water of the pond everything which surrounds it or lies on top of it and its reflections: trees, bushes, the banks and, above all,

the sky. The surface of the pond occupies the whole painting, trees and the sky enter the water through reflection, provoking an inversion of space, so that what is really on top now lies underneath; the sky loses all sense of reality and becomes spots of colour, a diffused current of light, limitless and without recognizable form. Whereas the elliptical islands of leaves on the surface of the water and the lively, fleeting colours of the lilies, like a glorious offering, seem as if suspended in air by means of some arcane levitation" (Roberto Tassi).

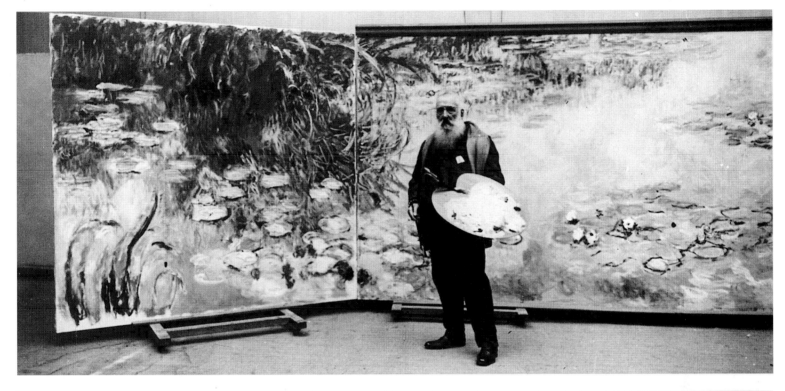

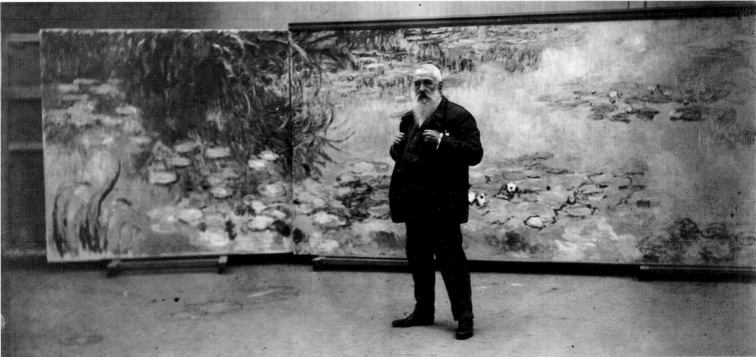

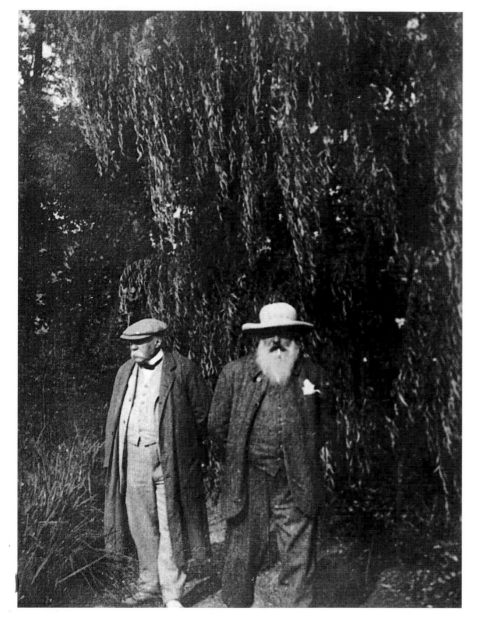

Two pictures of a visit to Giverny by statesman Georges Clemenceau in the summer of 1921. The woman standing next to Monet at the left is his daughter-in-law, Blanche Hoschédé Monet. Monet and Clemenceau had already met in 1895, when the future statesman still wrote art reviews. In a letter dated 1899, Clemenceau wrote to Monet: "I have seen in you that the man is worthy of the artist, by no means something of small account. You cut out small pieces of sky and throw them in the face of the people. Nothing would be more stupid than to thank you for this: you can't say thank you to a ray of sunshine."

In 1918, Monet proposed to Clemenceau that he might donate two panels of his waterlilies to the State to celebrate victory. After lengthy negotiations, a deed of donation was signed on April 12, 1922 involving eight panels that would be hung in an oval arrangement in the Orangerie des Tuileries. In these years, Clemenceau continued to encourage the painter, who was often tempted to abandon the great enterprise because of a cataract (he was finally operated on in 1923).

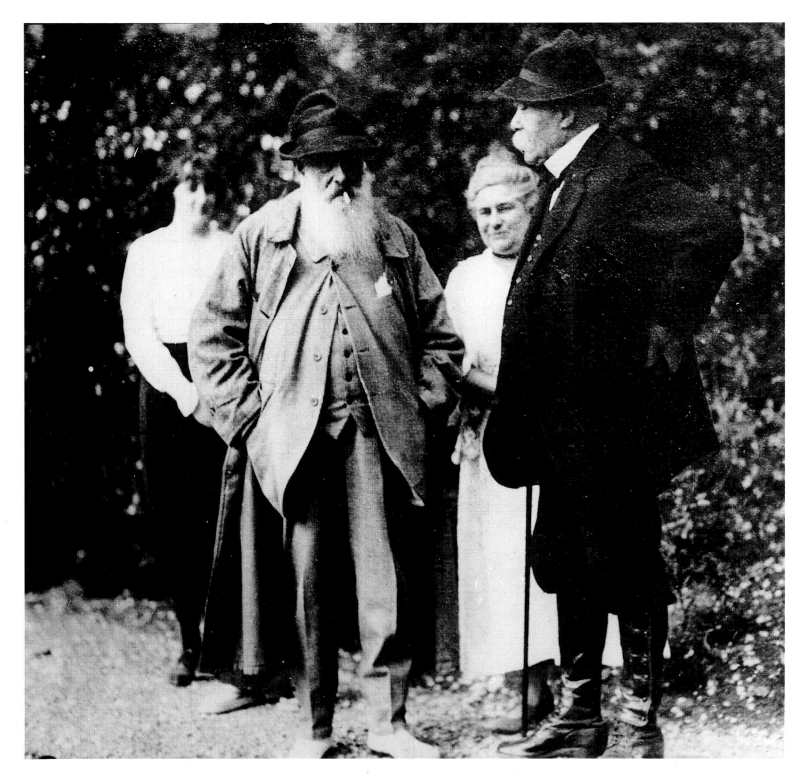

(Below) Monet's funeral (Clemenceau is in the right foreground, next to Blanche Hoschédé Monet). (Opposite) Two photos of the hall in the Orangerie des Tuileries. Monet died on December 5, 1926 at 86. Since he had refused to consign the Grandes Décorations during his lifetime, the twenty-two panels were finally exhibited on May 17, 1927 at the Orangerie des Tuileries, in accordance with his arrangements. "These panels, which should be considered as a single work, are probably the historical culmination of the relationship between painting and nature, from when landscapes first came to be painted much earlier than we usually think. The huge canvases embraced immense and inconceivable innovations. Above all, it is their sheer size, which emerges like an impulse to express the cosmic immensity of the world. [...] Monet encompassed Time in this work; he did not paint the moment, mutability, fleeting sensations, but the deepest meaning of Time, its movement beneath the surface, within matter and the elements, the way it becomes nature. He totally liberated form from every constriction. He had already painted the informal" (Roberto Tassi).

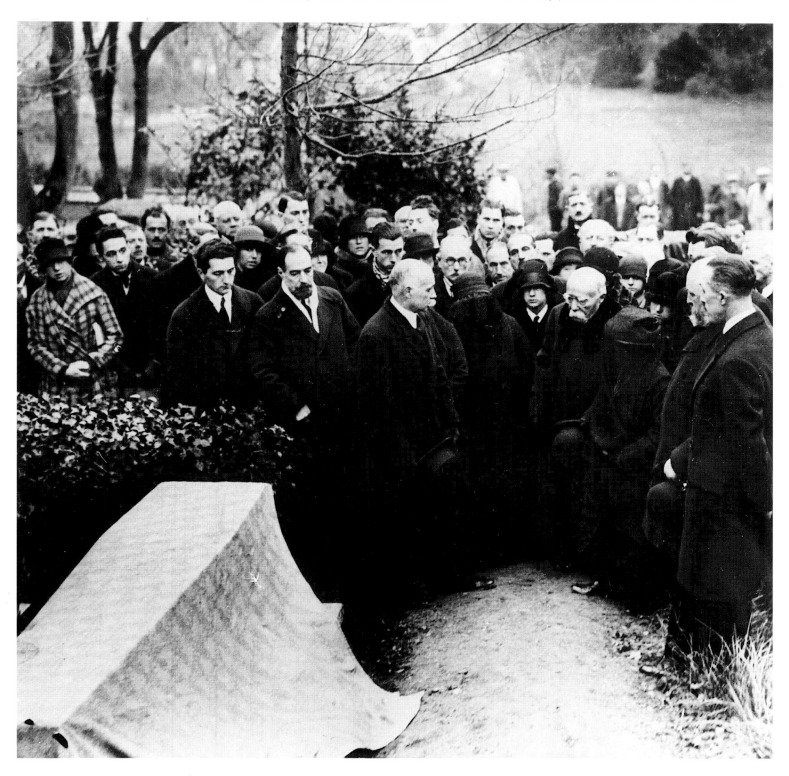

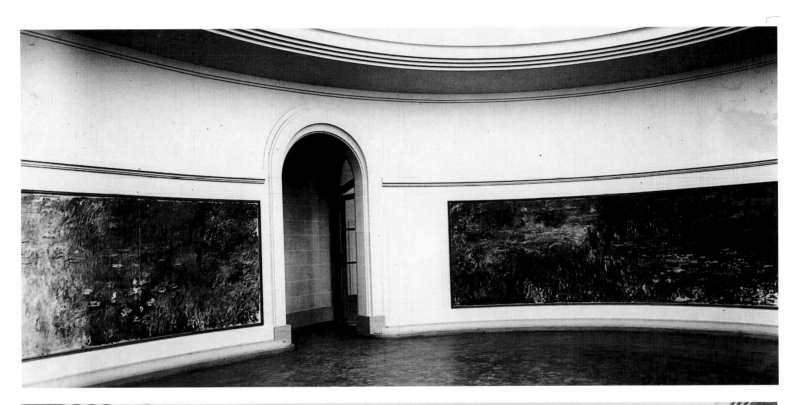

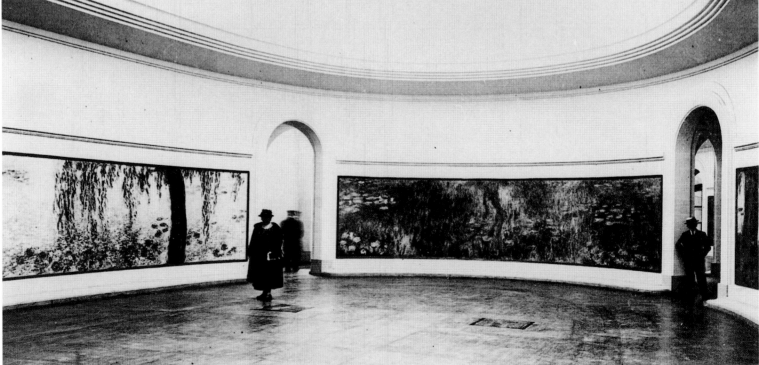

CHRONOLOGY

1848—February 22–24: revolution and the establishment of the Second Republic.

1850—Manet (1832–1883) began studying at the studio of Thomas Couture. He remained there for six years.

1852—The Second Republic got underway.

1856—Degas (1834–1917) left for Italy, where he met Bonnat and Gustave Moreau. At Le Havre, where he lived with his family, Monet (1840–1926) met Boudin.

1859—Monet and Pissarro (1830–1903) attended the Académie Suisse in Quai des Orfèvres. Paul Cézanne (1839–1906) studied drawing in Aix-en-Provence.

1860—Monet met Jongkind.

1861—Cézanne met Pissarro at the Académie Suisse. Degas and Manet met in the same year. Renoir (1841–1919) became friends with Alfred Sisley (1839–1899), having met at Gleyre's studio. Frédéric Bazille (1841–1870) enrolled there in November.

1863—Bazille and Monet painted in the forest of Fontainebleau. On May 15 the Salon and the Salon des Refusés opened simultaneously; Manet's *Déjeuner sur l'herbe* at the latter show caused a stir. Baudelaire published *The Painter of Modern Life*.

1864—Cézanne was rejected by the Salon, but Manet, Berthe Morisot (1841–1895), Renoir, and Pissarro were accepted.

1865—Berthe Morisot, Pissarro, Renoir, Degas and, for the first time, Monet, exhibited at the Salon. Critics mercilessly attacked *Olympia* by Manet. During the summer, Monet painted his own *Déjeuner sur l'herbe*.

1866—Manet, Renoir, and Cézanne were rejected by the Salon, but Berthe Morisot, Bazille, Degas, Pissarro and Sisley all took part. *Camille* by Monet was well received by the critics. On that occasion, Emile Zola wrote the first review of the Salon; he attacked the jury over its decision to refuse Manet.

1867—Bazille welcomed Renoir and Monet to his studio in rue Visconti. Sisley joined them every now and then. Alongside the Universal Exposition and the Salon, which saw the exclusion of Bazille, Cézanne, Pissarro, Renoir, Sisley, and Monet, Courbet and Manet had two pavilions built to exhibit their own works.

1868—Monet, Bazille, Degas, Pissarro, and Sisley were accepted by the Salon. Cézanne was rejected. Renoir triumphed with *Lise*.

1869—At the beginning of the year, the Salon rejected *The Execution of Maximillian* by Manet. Zola denounced the jury's abuse of power in *Tribune*. Monet, Sisley, and Cézanne were rejected, unlike Renoir, Bazille, Degas, and Pissarro.

1870—The French army was defeated at Sedan. Degas and Manet enlisted. Cézanne sought refuge in the south of France, while Pissarro and Monet went to London; they took part in the first exhibition organized by Durand-Ruel. Bazille died on September 28 in the battle of Beaune-la-Rolande.

1871—March 18–May 28: the Paris Commune. Pissarro returned from his exile in London and went to live in Louveciennes. Monet settled in Argenteuil.

1872—Durand-Ruel continued to organize exhibitions in London comprising the work of Degas, Monet, Sisley, and Pissarro. The Salon that year only accepted Manet and Mary Cassatt.

1873—Mac-Mahon became President of the Third Republic.

1874—On May 15, the studio of photographer Nadar in Boulevard des Capucines saw the inauguration of the first exhibition of the painters whom Louis Leroy, in a review dated May 25, christened "the Impressionists." Manet did not agree to exhibit his own paintings because he was worried that this would turn the jury of the Salon against him.

1876—On April 1, Durand-Ruel organized the second exhibition of the Impressionists. On April 15, Manet presented an exhibition of his paintings in his own studio.

1877—Third Impressionist exhibition.

1878—Two auctions at the Hôtel Drouot involving the collections of baritone Faure and Ernest Hoschédé. The outcome was disastrous.

1879—Fourth exhibition of the Impressionists. Degas presented his followers Mary Cassatt, Rouart, Zandomeneghi, and Forain. This intrusion meant that Cézanne, Renoir, and Sisley decided not to take part.

1880—Monet, Renoir, and Sisley did not take part in the fifth exhibition of the Impressionists, where Degas and his group dominated the scene. Monet, Renoir, and Manet exhibited at the Salon.

1881—The Salon accepted Manet and Renoir. Renoir, Cézanne, Monet and Sisley did not participate in the sixth Impressionist exhibition.

1882—Thanks to the intervention of Durand-Ruel and his friend and collector Gustave Caillebotte, the seventh exhibition brought together all the members of the original group. Cézanne was accepted by the Salon for the first time.

1883—Manet died on April 30. Renoir and Monet, who had moved to Giverny, visited Cézanne in Aix-en-Provence.

1885—The paintings of Monet and Degas began to sell well.

1886—Emile Zola published L'Opera. The friendship between the novelist and Cézanne, who recognized himself in the main character, Claude Lantier, came to an end. The last exhibition of the Impressionists opened on May 15; of the original group, only Degas, Pissarro, and Berthe Morisot took part.

The first exhibition of the Impressionists in the United States was held.

1888—Durand-Ruel opened a gallery in New York.

1889—At the exhibition of the Centenary of the French Revolution held within the Universal Exposition, Cézanne, Monet, and Pissarro displayed their work, while Degas and Renoir decided not to take part.

1890—Some artists (including Monet, Degas, and Caillebotte) purchased Manet's Olympia and donated it to the State.

1891—Monet's Haystacks series enjoyed a huge success.

1894—Caillebotte died on February 21. He donated sixty-nine paintings in his collection of the Impressionists to the State.

1895—Two exhibitions that were to prove fundamental in the history of Impressionism were held: Monet's Cathedrals series at Durand-Ruel's gallery, and the first one-man show by Cézanne at the gallery of art merchant Ambroise Vollard. Berthe Morisot died.

1899—Sisley died in January.

1903—Pissarro died in November

1906—Cézanne died; the following year, fifty of his paintings were exhibited at the Salon d'Automne.

1917—Degas died.

1919—Renoir died on December 3.

1926—Monet died on December 6; the inauguration of his Water Lilies at the Orangerie des Tuileries was held on May 17, 1927.

\mathcal{P}HOTOGRAPHY CREDITS

Bibliothèque Nationale, Paris: pages 11, 12 (left), 16, 17, 19, 20, 21, 27 (bottom), 29, 42 (left), 49, 62, 63, 64, 65, 66, 67.

Roger-Viollet: pages 23, 27 (top), 33, 36, 40, 41, 42, 43, 44, 45 (photo), 47 (photo), 75 (Mallarmé), 95, 96, 107, 110, 111, 112, 113, 114, 115, 135, 140, 141, 142, 146, 150 (Zola), 151 (right).

Ecole des Beaux-Arts: page 39.

Mondadori Archives: pages 12 (right), 13, 14, 15, 18, 26 (photo), 102, 103, 119, 126, 127, 129, 130, 131, 132, 134, 137, 138, 139, 143, 149, 152, 153.

Giuseppe Primoli Foundation: page 124.

Musée d'Orsay: pages 24, 25, 50, 51, 52, 53, 55, 58, 59.

Durand-Ruel Archives: pages 61, 77 (photo), 78, 79, 80, 81, 89, 90, 91, 97, 98, 99.

Private collections: pages 15 (photo), 24, 28 (bottom), 31, 46, 57, 82, 83, 84, 85, 86, 87, 92, 101, 120, 121, 122, 123, 151 (left), 154, 155.